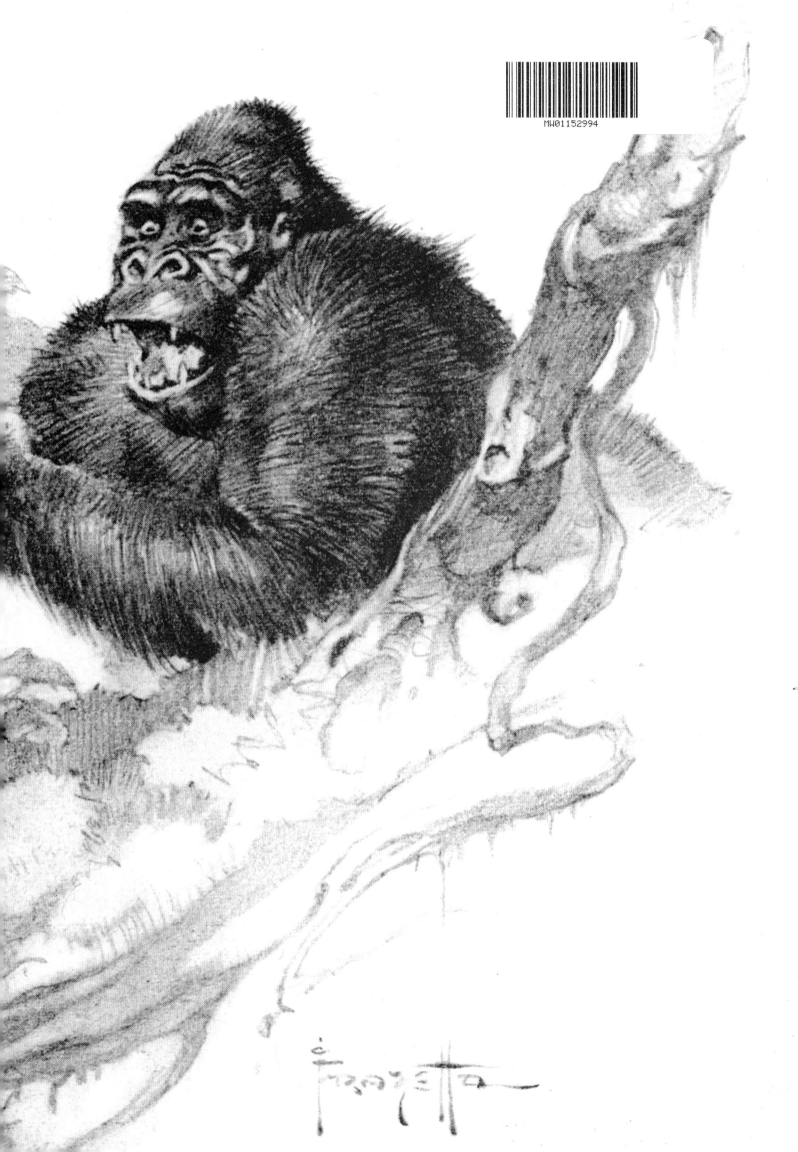

ICON

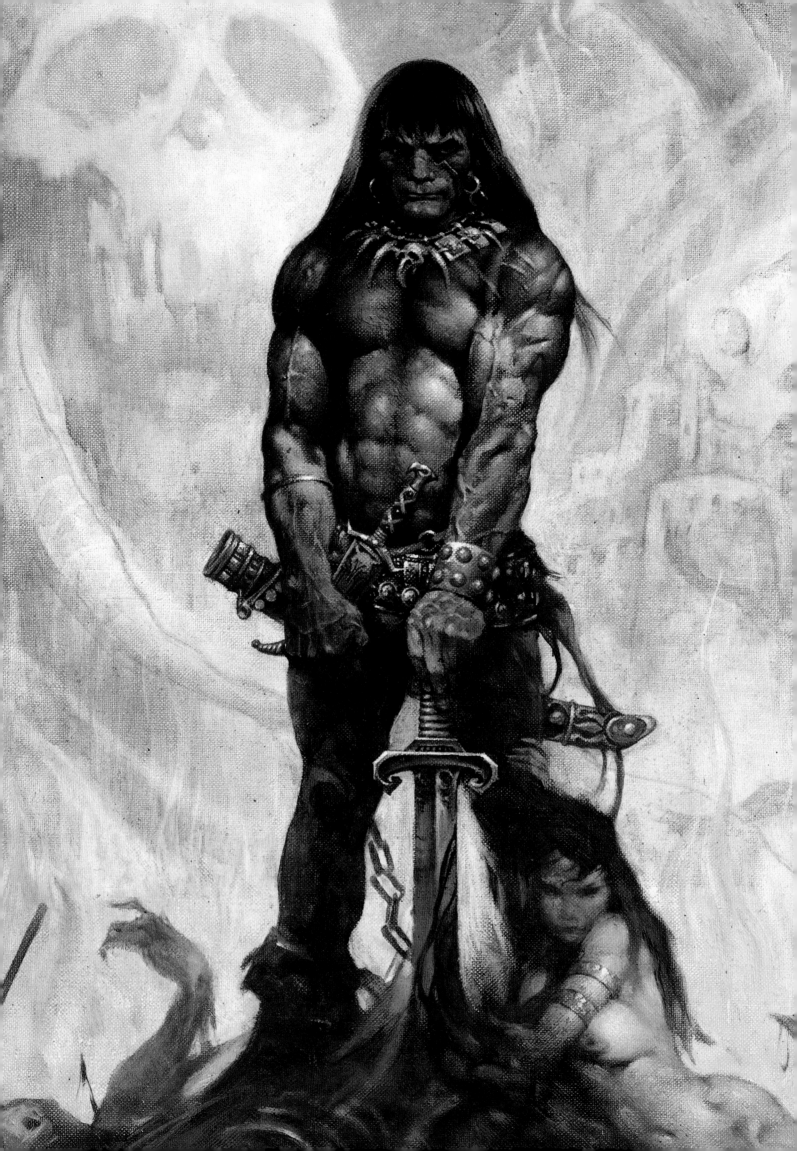

ICON

A Retrospective by the Grand Master of Fantastic Art

FRANK FRAZETTA

**Edited by
Arnie Fenner & Cathy Fenner**

UNDER
WOOD
BOOKS

Grass Valley, California
1998

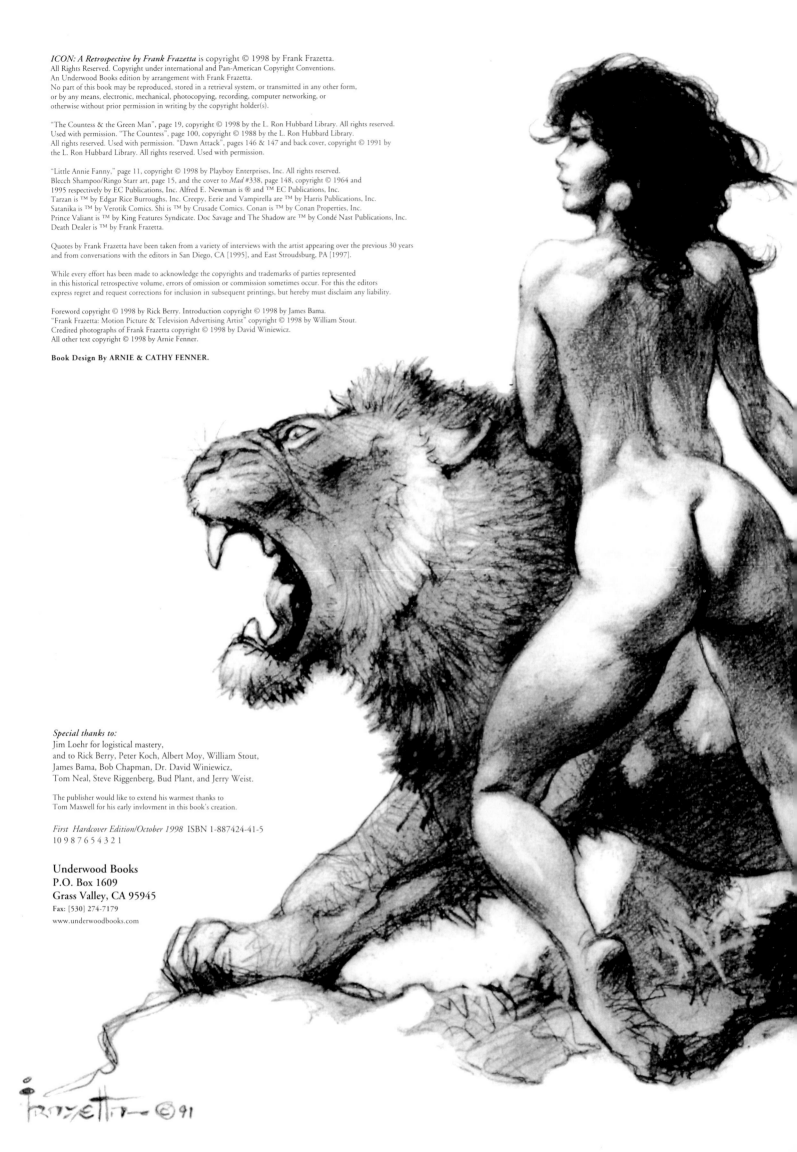

Special thanks to:
Jim Loehr for logistical mastery,
and to Rick Berry, Peter Koch, Albert Moy, William Stout,
James Bama, Bob Chapman, Dr. David Winiewicz,
Tom Neal, Steve Riggenberg, Bud Plant, and Jerry Weist.

The publisher would like to extend his warmest thanks to
Tom Maxwell for his early invlovment in this book's creation.

First Hardcover Edition/October 1998 ISBN 1-887424-41-5
10 9 8 7 6 5 4 3 2 1

Underwood Books
P.O. Box 1609
Grass Valley, CA 95945
Fax: [530] 274-7179
www.underwoodbooks.com

C O N T E N T S

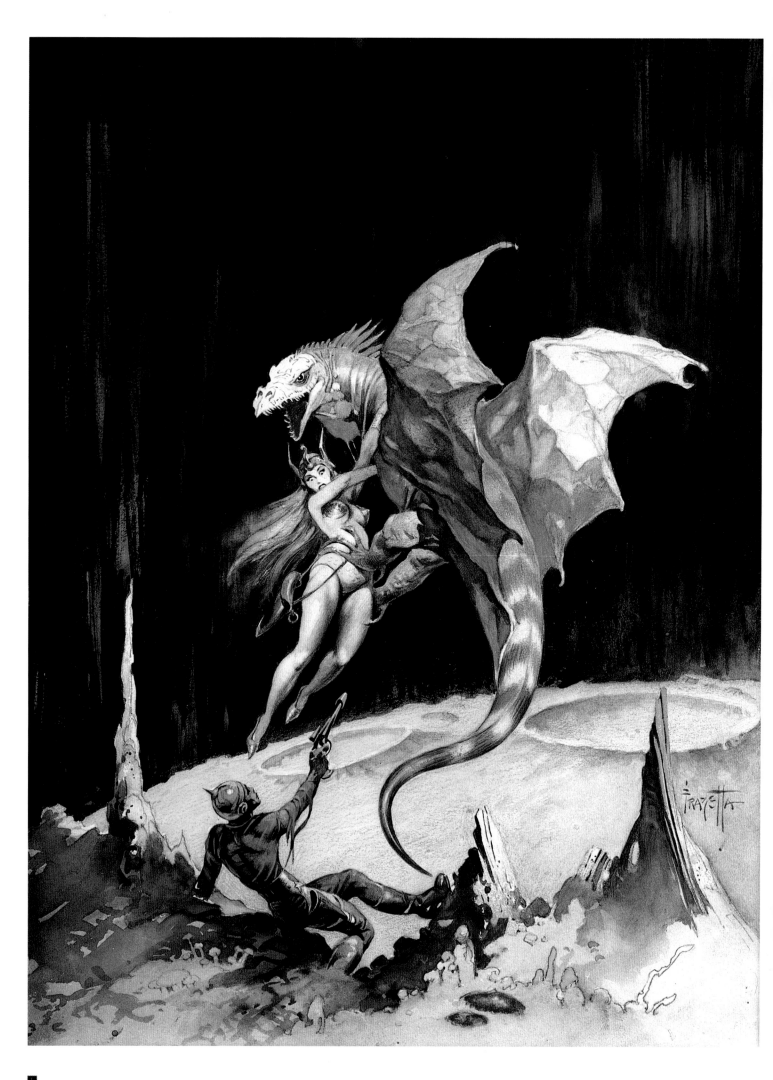

ICON: *A Frank Frazetta Retrospective*

FOREWORD

by Rick Berry

Proving that traditional painting could be successfully married to computer software, Boston artist Rick Berry helped propel the commercial art community into the digital age with his compelling imagery. As much of a maverick in the 1980s and '90s as Frank Frazetta was in the '60s and '70s, the forceful and brilliantly energetic Mr. Berry is still very appreciative of his fantastic art roots.

An artist talking about another artist. This is good and bad. Being able to sit in front of someone else's painting and imagine some things about its execution in an expert way is very helpful (the joy of playing really good air guitar). On the other hand, having enjoyed so much inspiration from this particular man's art puts my objectivity in question. I don't care.

Let's start with the "useful" part of our purview. Technique. Right out of the gate this artist leaves the majority of the field behind. Part of the reason will sound simple: thought and action are one. I don't think Frazetta plans his paintings. Not that he doesn't know what he's doing or where he's going; quite the opposite. Shooting at a target, you don't plan your shot or your aim. You may *practice* your aim, your dive, your throw, but you don't plan. With Frazetta, there is no setting up studio shots and slavishly rendering from the photo-prints (ridiculous outdoor tableaus with woodenly posed body-builders and false studio lighting bouncing off every freshly shaved surface—furniture polish on idiots). For the ignorant or naive this passes as excellent rendering of anatomy. But Frazetta's perception is *knowledge* based, not pantographic. He *sees* what is happening rather than plans it.

Nor is there a neurotic concern with "finish": Frazetta isn't building you coffee tables. He's not going to hold your hand the whole way; I don't think he'd suffer you the insult. He expects that the viewer brings with him or her the capacity to see. Beyond a certain point, finish just becomes a fussy insecurity and gets in the way of the action. Henry Miller once said: "The lazy reader does no one any good." Really successful art completes itself in the mind of the viewer. In this way Frazetta is able to take advantage of all the infinite associative detail already stored up in the viewer's mind. This is better done with deft suggestion rather than constraining and overwrought renders. Frazetta knows how to push your buttons because he knows how the thing which they're attached to works. Understanding very well this mechanism of art's miracle, he is a master of the brief elegant gesture and the blunt slashing stroke that give his work such economy of expression. It is just this economy of expression that allows his imagery to move unimpeded with such rapidity into your head. Frazetta is almost behind your eyeballs before you've understood what is happening. (Interesting note: This ability to invent out of vision may, at bottom, remain essentially mysterious. But it is not lost on me that a good many of the artists that exhibit this confidence of vision went through the hard school of comics. In that arena you are either able to come up with effective unreferenced figures and scenarios time after time or you fail.)

So, beyond technique.

Frazetta transcends illustration—to fine art. There will be those who, rolling their eyes, say, "Oh, come on! This guy paints winged demons, wizards, swordsmen, and mythological doodahs..." Certainly. So did daVinci, Michelangelo, Tiepolo, Goya, Picasso. What is always objectionable to some is commercial success in the popular culture. Or timing. The subject of great art is not this or that given subject, person, or thing. Great art is not afraid of venue.

The subject of great art is vision. The *artist's* vision, to see with his or her eyes the old or the new. To transcend time and space with idea and sight.

Then what is left is fine art.

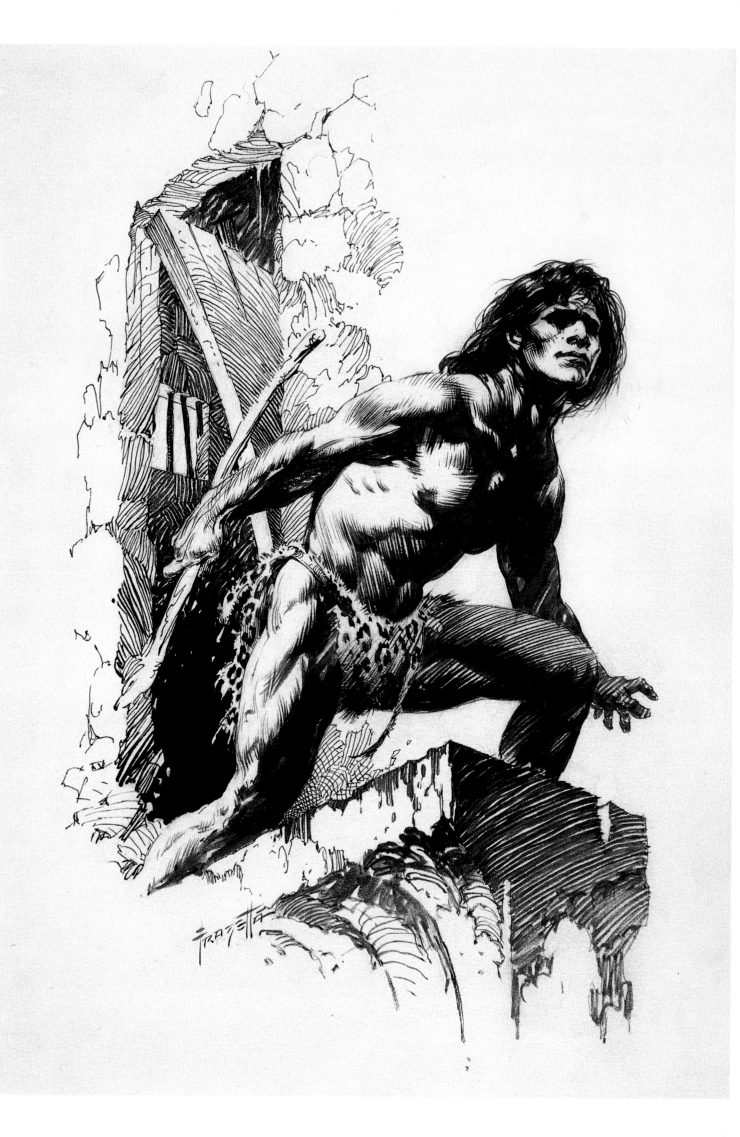

INTRODUCTION

by James E. Bama

Widely considered to be one of the 20th Century's finest painters, James Bama is revered by fans of fantastic art for his sixty Doc Savage paperback covers and for the Aurora monster model box art from the 1960s. Currently regarded as America's preeminent Western fine artist, he is the subject of a stunning documentary scheduled to air on PBS in 1998. As one of Frank Frazetta's contemporaries in the commercial art world of the '60s, Mr. Bama's introduction helps to put the influences on and of a generation of creative talent in perspective.

How does one write an introduction to a book, a large retrospective no less, when the artist has been so extensively written about in the last twenty-two years? This is the challenge with Frank Frazetta.

I, too, am an artist, only a few years older than he is, and also from a New York City neighborhood. I was an aspiring baseball player just as he was. I wanted to play for the New York Giants and he was offered the opportunity and turned it down. Were it nor for the second World War, I would probably have followed a similar path, doing comics and fantasy art.

The 1930s and '40s were an exciting time for young boys hoping to be artists.

The newspapers abounded with comic strips. *Flash Gordon* appeared in 1934 and *The Phantom* in 1936. Then there was *Buck Rogers in the 25th Century, Tarzan, Jungle Jim, Barney Baxter, Dick Tracy, Mandrake the Magician*, and many others. I still recall Lothar, Mandrake's giant servant, the Phantom's horse, Hero, and his wolf, Devil.

Alex Raymond, who did *Flash Gordon, Jungle Jim*, and *Secret Agent X-9*, and Hal Foster, who drew first *Tarzan* and then *Prince Valiant*, were giants in their field. They were superb draftsmen and story-tellers who inspired me as I am certain they did Frank.

He started doing comic art when he was sixteen. When I was seventeen, just after graduating from high school, I was offered two assistant cartoonist jobs with Hearst, but went into the Air Corps instead.

It was a patriotic time.

There were also comic books and Big Little Books. I believe they had a more prominent status than they do today, since they didn't have to compete with TV. *Superman* also appeared and was very popular.

The pulp magazines, started as an escape from the Depression and, subsequently, World War II, were in their prime. I remember *The Shadow, Doc Savage*, various detective, fantasy, and romance stories, and *Argosy* with its imaginative Virgil Finlay pen and ink drawings.

We had the radio to stimulate our imaginations: "The Shadow," "Johnny Dollar," "The Lone Ranger," "Chandu the Magician," "Renfrew of the Royal Mounted Police," "Jack Armstrong, The All-American Boy," "Inner Sanctum," and many others.

Finally, the movies and the twelve-episode matinee serials: *Frankenstein* and *Dracula*, *The Mummy*, *The Wolfman*, *The Invisible Man*, and *King Kong*. These were serious films and very frightening. Similar movies made today are "campy" in comparison. They have great special effects and are entertaining, but are not nearly as horrifying as the early ones.

This was the incubator in which we were nurtured. In the 1960s our careers finally intersected when Frank started doing covers for paperbacks. He worked for Ace in 1962 and then, in 1966, got his big opportunity doing those great *Conan* covers for Lancer.

Meanwhile, I was working for Bantam, Dell, and Avon. Of all the kinds of covers I did, *Doc Savage*, which was similar in many ways to the Conan concept, turned out to be the most popular.

By the 1960s paperbacks had come a long way from their beginnings as something cheap that you could stick in your pocket. They were becoming more expensive, using big-name authors, and being printed by the millions. There was a strong emphasis on realism and it was great exposure for the artists.

In 1975 Bantam Books embarked on a new venture—large-format softcover books of artists' works. The first of five they did of Frank's paintings came out that year, as did the one they did of mine. By that time I had left New York for Wyoming to pursue a career in fine art, but Betty Ballantine, the publisher of his books, was kind enough to send them to me. That was when I became fully aware of his large body of work and his great talent.

Frank's pen-and-ink drawings, in my opinion, are superior to those of Alex Raymond and Hal Foster,

This page: *A masterful 1936 dry brush illustration by Alex Raymond for a story entitled "Russian Roulette."* Opposite, clockwise from top right: Prince Valiant *by Hal Foster, circa 1939; George Rozen's cover for* The Shadow *[January 1942]; Alfred N. Simpkin's cover for the pulp* Black Mask *[September 1932]; Frazetta's drawing for the trading card tie-in to the 1996* Phantom *film; James Bama's dazzling cover for the Bantam "Doc Savage" book,* The Phantom City.

the two masters. Frank has full command of this difficult medium and a full grasp of anatomy and design. He knows how to sublimate the detail to the whole.

Realism starts with good drawing. That comes before light and shade, color, or edges. Frank's growth from the early "Buck Rogers" drawings—beautiful in their own right—is phenomenal. His skill in drawing and painting animals, either in repose or action, is the best I've seen.

We are both realists, although very different in style and subject. My paintings are mostly of people in subtle attitudes, done tightly in muted color. Frank has taken an entirely different path, emphasizing action, with a looser painting style an vivid color. His subjects and compositions are dramatic and his use of color is unique. He is, in the truest sense, a colorist and Impressionist.

There is no one in this field close to Frank. His work is as vital, rich, and exciting today as it was 30 years ago. There will never be another like him.

Thank you, Frank Frazetta, for sharing all this magic with us.

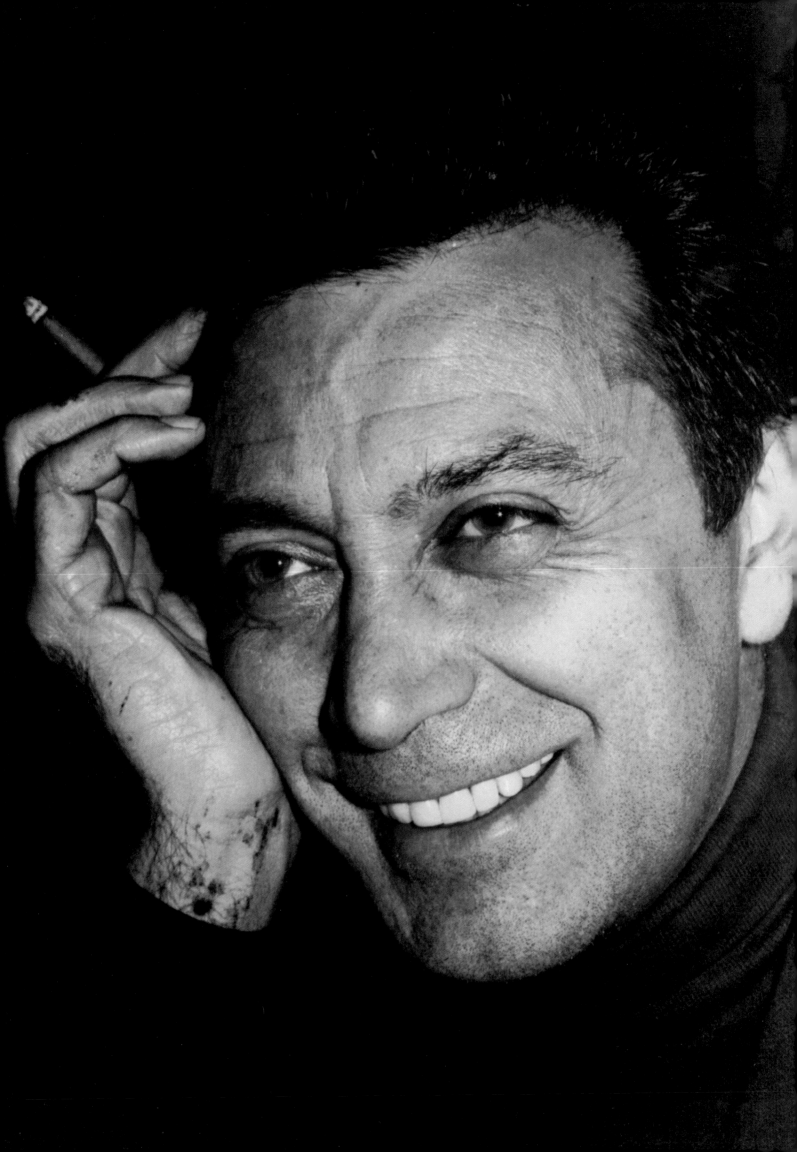

FRANK FRAZETTA
Master of Imagination
by Arnie Fenner

There were giants in those days.

Historians looking back on the field of illustration of the 20th Century will have an eclectic selection of talent to examine. Never mind that there may always be debates about the validity of the illustrator's place in the sacred halls of art galleries and museums. Try to ignore the condescending attitudes of those who have swallowed Andy Warhol's jokes as profound, who have simultaneously dismissed the idiom of comics and embraced the panels of Roy Lichtenstein.

Instead, think of the titans who touched people's lives with a stroke of their pen or a flourish of their brush. Appreciate the creators who unleashed their imaginations and gifted us with wonder. Consider the Brandywine School of Howard Pyle and his famous students, N.C. Wyeth, Harvey Dunn, and Frank Schoonover. Or Maxfield Parrish's neuter figures and translucent glazes, Arthur Rackham's innocent watercolors and Norman Rockwell's sentimental photographic interpretations of American life. J.C. Lyendecker, Dean Cornwell, Saul Tepper, Coles Phillips, Mead Schaeffer, Tom Lovell, James Bama, Leo and Diane Dillon, Bob Peak, Stanley Meltzoff, Robert McGinnis, and onward—the list of 20th Century masters of narrative art is lengthy, their talents prodigious.

The entire 20th Century has been a Golden Age of illustration and there *were* giants in those days. Artists of unparalleled vision, of prodigious imagination and infectious enthusiasm. Artists like Frank Frazetta.

The oldest of four children and the only boy in the family, Frank Frazzetta (he would later drop one of the "z"s) was born February 9th, 1928, in Brooklyn, New York. Precocious, inquisitive, physically gifted, and artisti-

cally talented far beyond his years Frank benefited from a close-knit Sicilian home and a Brooklyn that was far different than today. "Believe it or not," he relates, "there were large spaces of open land and even some woods. I can remember vividly those glorious and imaginative years, so filled with adventure and fantasy. I was a dreamer then and I'm still a dreamer. I can't remember when I drew my first picture, but I wasn't quite three years old when I sold my first crayon drawing to my grandma for the tidy sum of one penny. I'll always be grateful for the interest she showed in my efforts and the encouragement she gave me each and every day."

A fan of the Hal Foster *Tarzan* and the Milton Caniff *Terry and the Pirates* newspaper strips, Frazetta began drawing his own comic books around the age of six. Intricate, labor-intensive colored pencil stories featuring his original characters like "Snowman" and "The Red Devil & Goldy" [sic] still exist and exhibit a level of style and sophistication that is amazing. One of his sisters would often take Frank's home-drawn comics and trade them to other kids for their store-bought issues of *Famous Funnies*.

Frazetta's artistic ability wasn't a secret to his elementary school teachers. "Christmas, Easter, and Thanksgiving were my big days," he remembers. "I guess I drew more Santas, bunnies, and turkeys on blackboards than anyone could count. At the insistence of one of my teachers, my parents enrolled me in the Brooklyn Academy of Fine Arts when I was eight. The Academy was little more than a one floor/three room affair with a total of thirty students ranging in age from eight—me!—to eighty. I still remember the Professor Michele [Michael] Falanga's look of skepticism as I signed in. He was rolling his eyes and

you could almost see the thought balloon over his head, 'Oh no! Not another child prodigy!' He sat me down with a pencil and paper and asked me to copy a postcard featuring a group of realistically rendered ducks. When he returned later to see how far I had progressed, he snatched up my drawing exclaiming, 'Mama mia!' and ran off waving it in the air, calling everyone over to look at it. I thought I was in some kind of trouble."

Falanga, a fine artist of some renown in his native Italy, was impressed with Frazetta's natural ability and believed he had tremendous potential. "He died when I was twelve," Frank explains, "right about the time he was making arrangements to send me off to Italy at his own expense to study fine art. I haven't the vaguest idea of whether it would have really affected my areas of interest. I don't know, but I doubt it. You see, we never had any great conversations. He might look over your shoulder and say, 'Very nice, but perhaps if you did this or that...' He spoke very broken English and he kind of left you on your own. I think I learned more from my friends there, especially Albert Pucci. Falanga would look at some of the comics stuff I was doing and

say, 'What a waste, what a waste! You should be in Italy and paint the street scene and become a very famous fine *artiste*!' And that didn't thrill me! After he died the students tried to keep the school going; we had become such close friends that we couldn't bear to close up shop so we all chipped in and paid the rent and continued to hold classes. I did nude life drawings and still lifes; we'd paint outdoors. It was all totally different than the way I work

now, but it taught me a lot about brush technique and perspective and helped me to develop my own style."

Frazetta's childhood years were an odd mixture of influences. He loved comic strips by Hal Foster, E.C. Segar, and Milton Caniff but was exposed to and appreciative of opera and the fine arts. He was athletic almost to an extreme yet pursued a career that nurtured his sensitivity. Brooklyn in the 1930s and '40s was becoming a rough place to grow up and Frank found he had to toughen up to survive. "Sure, I got picked on," he relates, "but not for long. I was a loner and I knew that if I didn't stand-up for myself I'd have nothing but trouble. So one day I threw a rock at the leader of this gang of punks and he came swaggering over and said, 'Did you hit me with this rock?' I said, 'Yeah, what're you gonna do about it?' And just as he was starting to tell me I was on him! Bam! Like that! He was down and hollering for help and all of his buddies were running for cover. All I had to do was take on the leader and suddenly I had a reputation all over Brooklyn. I went looking for fights after that, hoping that someone would provoke me. It was only for a short period of time, between the ages of 15 and 19. If anybody's going to be tough, that's the period. I was sort of a confused kid, between adolescence and adulthood, and I acted like a jerk. But I felt good, I didn't give a damn. I *wanted* these cowardly bullies to fear me. I thought that was great. And I grew up and realized how incredibly *stupid* that was. What a waste of time."

Throughout his teenage years Frazetta actively pursued his three areas of interest: girls, baseball, and art. He ex-

Above: *A page from* Snowman, *one of Frazetta's many home-made comic books, circa 1937.* Snowman *would be the basis of his first professionally published work. Below: One of the budding artist's first oil paintings, circa 1936-37. Opposite: An early page by Frazetta from Standard's humorous* Barnyard Comics #19, *circa 1948.*

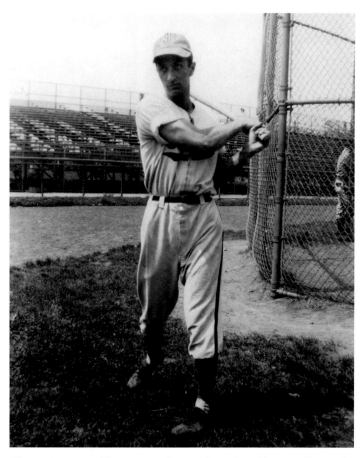

Above: *A 17-year-old Frazetta at the Lincoln High Field in Brooklyn, 1945.* Below: *One of his* Ghost Rider *covers for National.* Opposite: *The splash page to the only comic Frank entirely illustrated,* Thun'da #1 *[M.E., 1952].*

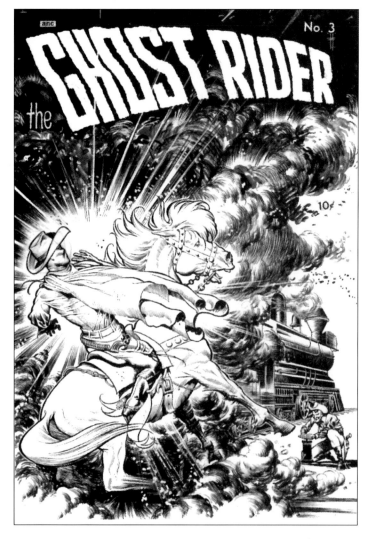

celled at sports, set several high school records, and eventually caught the attention of a scout for the New York Giants professional baseball team. Frank was offered a position on their farm squad with a good prospect of moving up to the major league within a season, but he turned them down. "I was involved with a girl at the time," Frazetta says a little sorrowfully. "And going down to Texas and sweating it out in the minors for a year didn't seem very appealing. You have to remember that at that time athletes weren't making the money they do today. They bussed you back and forth and it was just a big disgusting hassle. I remember that traveling to another state seemed like going to the end of the world, so I told them, maybe next year. Time went by and before I knew it I was too old. It was just my way of letting time make the decision for me. If I have any regrets it's that I didn't turn pro. If I was in my twenties and had it to do over—*today*, at today's salaries—you better bet I'd do it."

But while still in school, between pounding on bullies and hitting home-runs, Frank had already embarked on a professional art career. "When I was about sixteen," he recalls, "someone in my family introduced me to John Giunta. He was a professional artist who was working for Bernard Bailey's comics publishing company and he really wasn't a very personable guy. He was very aloof and self-conscious and hard for me to talk to, but he was really very talented. He had an exceptional ability, but it was coupled with a total lack of self-confidence and an inability to communicate with people. Being around him really opened up my eyes, though, because he was really *that good*. He had an interesting style, a good sense of spotting and his blacks worked well. You can see a lot of his influence even today in some of my ink work."

Giunta liked Frazetta's home-made "Snowman" comic and persuaded Bailey to publish a revised version in *Tally Ho* #1 in 1944. "I did the drawing and Giunta inked it, slicking it up to look like their other comics," Frank says.

He next worked briefly for Fiction House Comics, cleaning up panels and erasing underlying pencil art for Graham Ingels, Bob Lubbers, and George Evans. "They canned me after six months," Frazetta says. "They told me I had potential, but there wasn't a lot for me to do. So I went over to Standard and, lo and behold, there was Graham Ingels, who had just quit Fiction House and was working as their new art director. He had always encouraged me so he went out on a limb and gave me a feature, 'Judy of the Jungle.' I did a *terrible* job. Graham felt that it would be a great shot in the arm and really get my career going, but the owners said, 'The kid's not ready.' Which was probably true."

Frank was a quick study with an obvious, if unrefined, talent and Standard employed him as an apprentice. He drew backgrounds, ruled borders, and cleaned up other

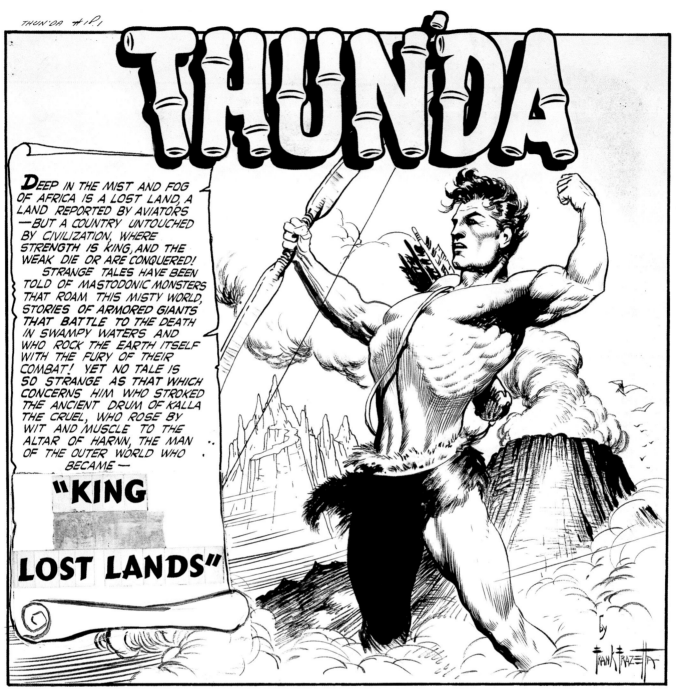

THUN'DA

DEEP IN THE MIST AND FOG OF AFRICA IS A LOST LAND, A LAND REPORTED BY AVIATORS —BUT A COUNTRY UNTOUCHED BY CIVILIZATION, WHERE STRENGTH IS KING, AND THE WEAK DIE OR ARE CONQUERED!

STRANGE TALES HAVE BEEN TOLD OF MASTODONIC MONSTERS THAT ROAM THIS MISTY WORLD, STORIES OF ARMORED GIANTS THAT BATTLE TO THE DEATH IN SWAMPY WATERS AND WHO ROCK THE EARTH ITSELF WITH THE FURY OF THEIR COMBAT! YET NO TALE IS SO STRANGE AS THAT WHICH CONCERNS HIM WHO STROKED THE ANCIENT DRUM OF KALLA THE CRUEL, WHO ROSE BY WIT AND MUSCLE TO THE ALTAR OF HARNN, THE MAN OF THE OUTER WORLD WHO BECAME —

"KING LOST LANDS"

by FRANK FRAZETTA

HIS TALE BEGAN SOME YEARS AGO, WHEN THE SANDS OF THE SAHARA RAN RED WITH THE BLOOD OF ROMMEL'S AFRIKA KORPS, WHEN ALLIED AIRPLANES ROARED OVER THE GORILLA-INFESTED JUNGLES, CARRYING FOOD AND SUPPLIES TO EISENHOWER AND MONTGOMERY.

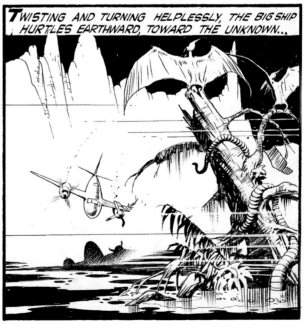

TWISTING AND TURNING HELPLESSLY, THE BIG SHIP HURTLES EARTHWARD, TOWARD THE UNKNOWN...

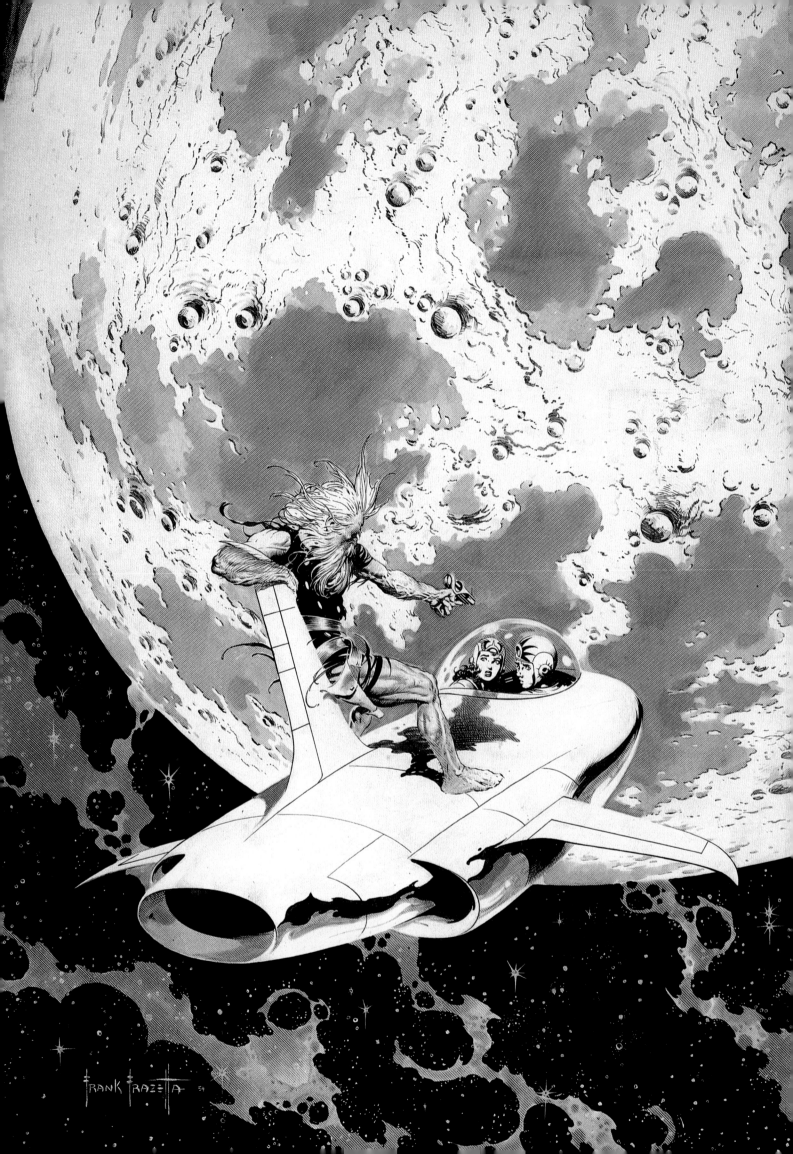

artists' pencils. Graham Ingels would become famous several years later for the horror strips he signed "Ghastly" for EC Comics, but chronic alcoholism cost him his art director position with Standard. He was replaced by Ralph Mayo. "When Ralph took over he pulled me aside and said, 'Frank, your stuff is great, but you need to learn some anatomy.' When I was in school with Falanga the emphasis was on *feeling*, not on the nuts and bolts, so I really didn't understand what he meant by 'anatomy.' So Ralph handed me an anatomy book and when I went home that night I had decided to learn anatomy. I started with page one and copied the entire book—everything, in one night, from the skeleton up. I came back the next day like a dumb kid and said, 'Thank you very much, I just learned my anatomy.' Of course Ralph fell over and roared with laughter. 'Frankie, you silly bastard! I've been studying for ten years and I *still* don't know anatomy, and you went home and learned it *last night*?!' But the thing was, I *had* learned an awful lot. I had the ability to absorb things and he saw an improvement in my work right away. It amazed him and that meant a lot to me. From that point on I developed pretty rapidly: I started to do things with figures that made sense. I worked for Mayo and Standard for a few years, doing things like 'Louie Lazybones' and the funny animal stuff."

The majority of Frazetta's comic work at this time, signed with his nickname, "Fritz," were humorous stories or spot illustrations for short text pieces. These charming and whimsical drawings exhibited a great deal of anima-tion and caught the attention of the Disney Studio. "I still have the letter," Frank says. "They wanted me to come out to California. I was excited and flattered, but I was just a *kid*. There was no way I could have left Brooklyn."

When he started working for Magazine Enterprises and National (now known as DC Comics) he graduated to the adventure titles and drew stories for *Durango Kid*, *Manhunt*, *Adventure Comics*, and *Blackhawk*. His covers for *Ghost Rider* received tremendous recognition and in 1951 M.E. gave Frank the go-ahead to create his own comic, *Thun'da*. "I came up with this Tarzan-like character who gets trapped in a lost world," he explains. "They brought in Gardner Fox to write the script based on my idea and the first story in the book followed my plans pretty closely. Then the editor, Ray Krank, had Fox take everybody out of the prehistoric setting by the end of the third story in the book and ruined the entire concept; they turned it into just another cardboard jungle comic." *Thun'da* #1, published in 1952, was the only complete comic book Frazetta ever drew. He quit working for M.E. after they sold the rights to the character to Columbia Pictures for a serial starring Buster Crabbe. Since he had created *Thun'da* under the comic industry's standard work-for-hire agreement, Frank never received additional payment for the characters and art he had created. Bob Powell took over as artist on the comic with the second issue and stayed with it until the title was canceled with #6.

War was raging in Korea and the prospect of being drafted was a daily worry, yet the early 1950s were an in-

Below: *A panel from* Tiga, *a proposed newspaper strip from 1950.*
Opposite: *Frazetta's exciting "Buck Rogers" cover for* Famous Funnies #214 *[1954].*

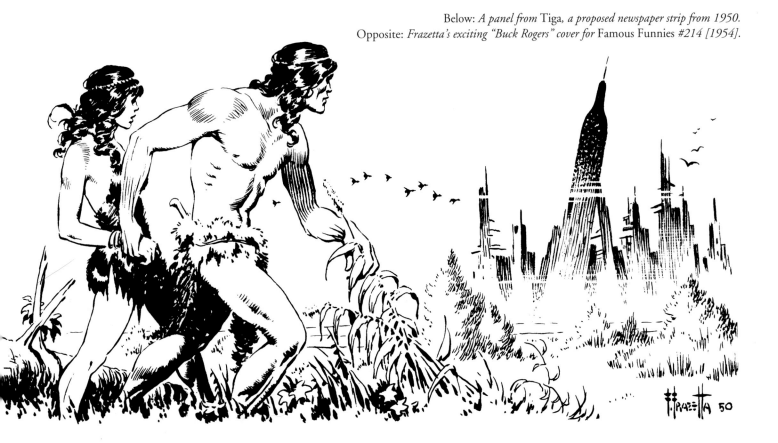

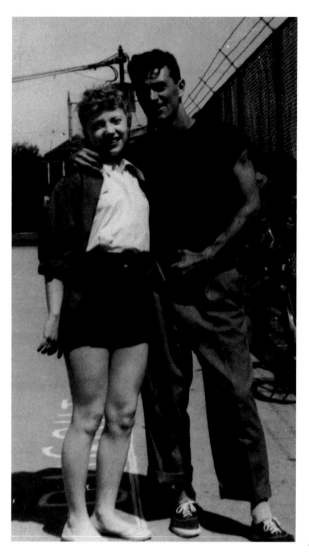

At left: *Ellie and Frank Frazetta when they were dating, 1953.* Above right, top to bottom: *Newspaper comic strips by Frazetta, circa 1952;* Sweet Adeline *(never syndicated),* Ambi Dexter *(likewise never syndicated), and* Johnny Comet. *Opposite:* A drawing for Nina, *an unsold comic strip with a female "Thun'da."* The Nina *drawings eventually saw print as illustrations for Edgar Allan Poe's poem "The City In the Sea" in the amateur magazine* Witzend *#8 [1971].*

vigorating, fun-filled period in Frazetta's life. He worked as much or as little as he pleased, producing a memorable stack of art for EC (publishers of world-class scary and violent comics), Toby Press, and Prize Publications. His Buck Rogers covers for *Famous Funnies* are considered some of the finest comics work ever published and many prominent filmmakers have cited them as a visual influence on their movies. At the same time, Frank was far from a workaholic. He enjoyed life too much to be chained to a drawing board and he made a point of playing baseball everyday. He enjoyed hanging out with friends like Nick Meglin, Angelo Torres, and Roy Krenkel, posing for reference photos, and going to the movies. Handsome, muscular, and charismatic, Frazetta was popular with women and he had a string of intense romances.

In 1952 petite seventeen-year-old Eleanor Kelly caught his eye and his days of jumping from one relationship to the next came to an end. "I sensed that she would be forever loyal and I never ever had that feeling about any other girl I'd been involved with," Frazetta reveals. "Sure, she had most of the physical attributes I looked for in a woman, she was beautiful and athletic. But beyond that she was very sharp and alert and pert and she knew a lot of things I didn't know."

Ellie was the perfect foil for Frank, matching his pow-erful personality with one that was quietly tenacious. "I'd sit for hours watching him play ball," she remembers, "because we couldn't go out until his games were over. I didn't mind. I talked him into buying a motorcycle because my old boyfriend had had one, and Frank and I would go riding when he was finished." After four years of dating they were married on November 17, 1956.

1952 was a pivotal year for Frazetta: *Thun'da* was published, he met his future wife, and he began drawing his own newspaper comic strip, *Johnny Comet*. "McNaught Syndicate had seen advance pages from *Thun'da,*" Frank explains, "and they offered me a strip. I was excited, even though I wasn't thrilled with the subject matter, automobile racing. But it was my own comic strip and I remember thinking, 'Jeez, I'll have a steady job. I'll make a lot of money.'" During the late '40s and early '50s car racing had become a popular pastime and *Johnny Comet* was created to appeal to the sport's growing number of fans. Peter DePaolo, winner of the 1925 Indianapolis 500, was credited as the strip's writer, but his name had only been licensed to add credibility to the racing storyline: Earl Baldwin was the actual scripter.

Johnny Comet (which changed its name to *Ace McCoy* in middle of its run) never really found an audience and was canceled after a little over a year. During its brief run

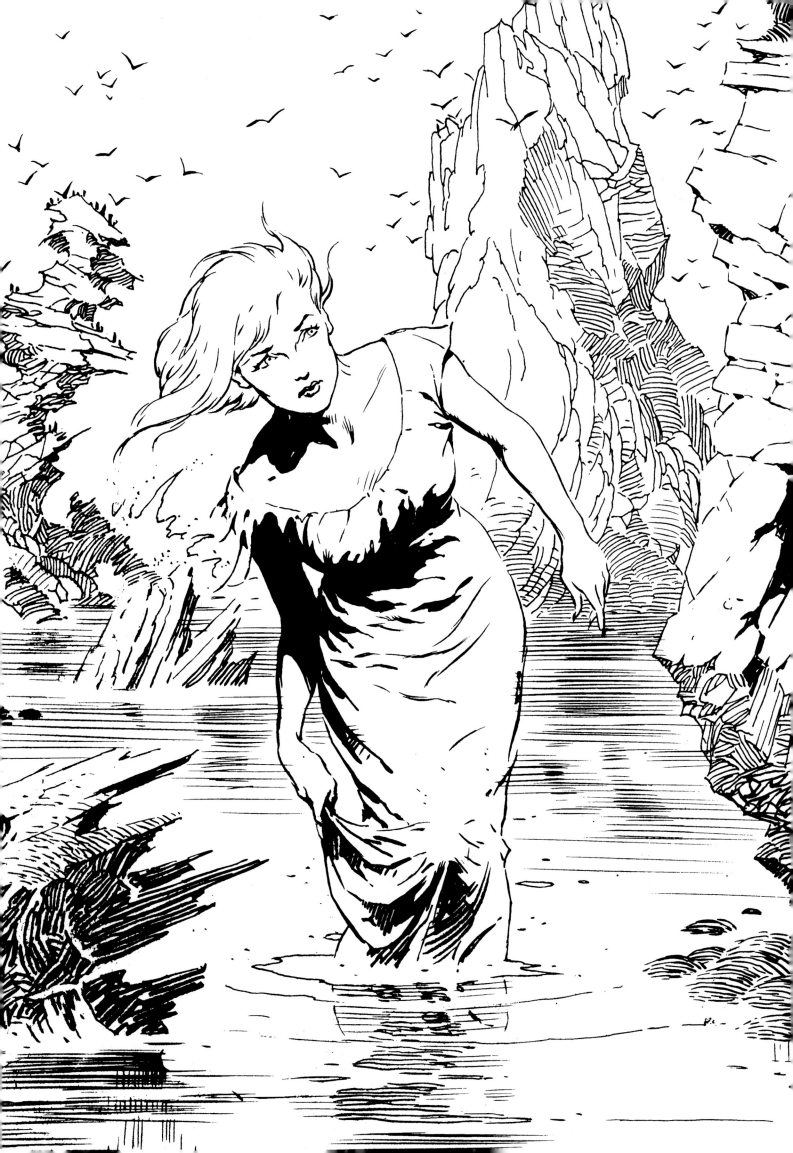

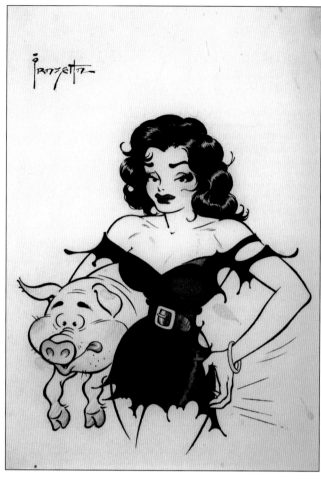

Above: *An ink and watercolor drawing of "Moonbeam McSwine" Frazetta completed for a greeting card during his stint with the Capp studio. Al Capp bitterly tried to hurt Frank's career after Frazetta quit ghosting* Li'l Abner. *Below: "The Giantess" from the men's magazine* Cavalcade *[vol. 4, #18, 1961]. Opposite: A collaborative page from Harvey Kurtzman's* Little Annie Fanny *from* Playboy, *circa 1963.*

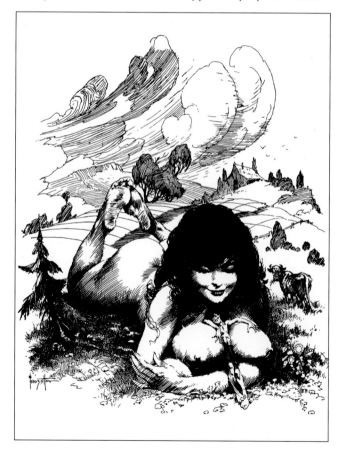

Frazetta occasionally called on the talents of friends and fellow comic artists Al Williamson, Wallace Wood, and Jack Hearne to help beat deadlines. "Once in awhile, I'd ask someone to help me get a week's-worth of strips done in a day," Frank says, "because I liked to take time and live a little. I just couldn't sit there when the sun was shining outside and grind out artwork. I never understood other artists who spent 100% of their waking hours at the drawing board. How could you draw for an audience without getting out in the world and experiencing life?"

Frazetta ghosted a few weeks of *Flash Gordon* for Dan Barry and tried unsuccessfully to sell the syndicates several other ideas for newspaper strips: *Ambi Dexter* featured a baseball pitcher adept with either his right or left hand, *Sweet Adeline* was the humorous story of a young working woman, *Nina* was a female version of *Thun'da*, and *Tiga* (originally conceived in 1950 with a script by Joe Greene) was a post-apocalyptic adventure tale.

Then in 1953 Al Capp hired Frazetta as one of the uncredited ghost artists for the popular *Li'l Abner*.

"I shouldn't have done it," Frank confesses, "but I was lazy. All I could think of was that I loved to tell stories and do comics and Al Capp came along and made me an offer I couldn't refuse. The pay was wonderful and it took me only a day to pencil his Sunday page and I had the rest of the week off! What more could I ask for? On a couple of occasions I went up to his Boston studio and he paid me $100 a day, which was really big money back then." Frazetta worked for Capp for the better part of eight years, burying his own style under that of his employer. Although he did freelance assignments for several comics publishers in the mid-1950s, after the depression in the comic book industry following the notorious senate investigation into juvenile delinquency Frank devoted his full attention to *Li'l Abner*.

"Al Capp was really a miserable s.o.b.," Frank asserts, "but he had a lot of talent. He didn't draw realistically, but he had a touch, he could capture the peak expression. He knew what made something ultra-cute or ultra-nasty or ultra-funny. He was a little screwed up, but really a very brilliant guy. I'll never knock his talent; I think he was quite the artist." When Capp attempted to cut Frazetta's salary in half in 1961, Frank angrily quit, believing that he could take up his comic book career where he had left off.

"I couldn't get work anywhere!" he remembers. "I went back to everybody I'd done stuff for and they just looked at me with a blank expression. 'Styles have changed, Frank. This is what we do now.' I could've done whatever they wanted but they wouldn't give me a chance. George Evans helped me put some food on the table by giving me some stories to ink. I can't begin to say enough nice things about George—and it has nothing to do with the fact that he bailed me out. He's just a wonderful human being, always was and I guess always will be."

Frazetta was eventually able to secure some commissions providing art for the men's magazines, *Calvacade*, *Gent* and *Dude*, and the soft-core paperback publisher, Tower. "Mort Dugger was the art director at Tower," Frank relates, "and he loved my

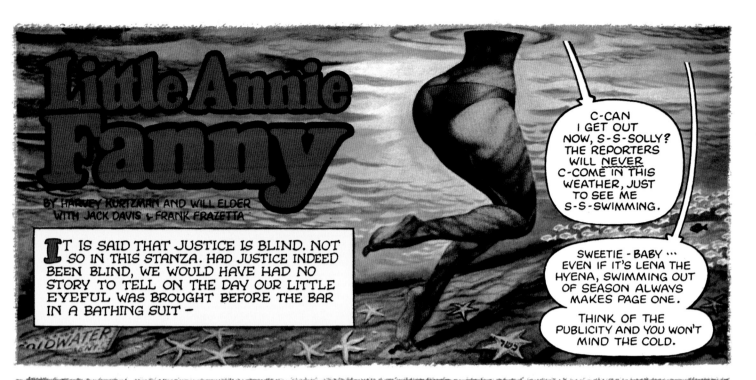

stuff—he was the *only* one who loved my stuff! He gave me jobs that I guess were racy for the time but the art's really pretty innocent. And people started to pay attention. Then Harvey Kurtzman brought me in to paint the women's bodies in his and Bill Elder's *Little Annie Fanny* comic strip for *Playboy*, but that didn't last very long. Hugh Hefner thought I was changing the look, making the women too realistic, so that was that."

Frazetta had never considered a career painting book covers; the majority of his work over the previous decade had been in pen and ink and what little painting he did was in watercolor. In the early 1960s he had illustrated several Edgar Rice Burroughs books for Canaveral Press, a small specialty publisher, with great success and when his close friend Roy Krenkel was approached to paint covers for Ace's ERB paperback reprints, Frank was eager to join in. "[Editor] Donald Wollheim had seen Roy's art in various fanzines," he remembers, "and, you know, Roy was sort of a spinoff of [J. Allen] St. John and Ace loved that. Wollheim wanted to bring back the St. John look for their Burroughs line. But Roy couldn't handle the workload and I was his pal and wanted to be involved. But Wollheim wouldn't give me work; he wanted no part of me! I showed him some samples and he just sneered at me! I looked too much like a guy from Brooklyn and he just didn't like me at first sight. After awhile Roy started falling behind and he kept insisting that they try me out. They reluctantly gave me one cover to do in 1962—and their sales took off. It happened again and again and again. They kept shaking their heads: 'Why are we getting all this fan mail for this guy? Why are the books with his art selling so well? This *has* to be a fluke!' Wollheim never had respect for me."

At the time it was a common practice for publishers to keep the artists' originals; they would later sell the paintings at science fiction conventions, give them away to fans, or even destroy them when they had no further use for the art. Ace's policy infuriated Frazetta. He detected a condescending attitude and it contributed to a bitterness which caused him to dismiss the quality of the work he was doing, despite enthusiastic responses from readers. But, just as they had a decade earlier, things were about to markedly improve for Frank in the mid 1960s.

In 1964 James Warren, publisher of the movie magazine *Famous Monsters of Filmland*, offered Frazetta the opportunity to paint anything he wanted for the covers of his new horror comic, *Creepy*. Matching Ace's fees and allowing him to keep his originals, Warren became the publisher of Frank's final comic art ("Werewolf" in #1,

At right: *Roy G. Krenkel was one of Frazetta's closest friends. A lovable eccentric, RGK advised and encouraged Frank and helped get Frazetta his first book cover assignments. A Hugo Award-winning artist [1963], Krenkel never had much faith in his own abilities. Below: Two of Frazetta's four covers for the controversial Warren comic* Blazing Combat *(issues #3 and #2 respectively). Opposite: Tarzan and the Lost Empire, Frank's first paperback book cover. [Ace Books, 1962.]*

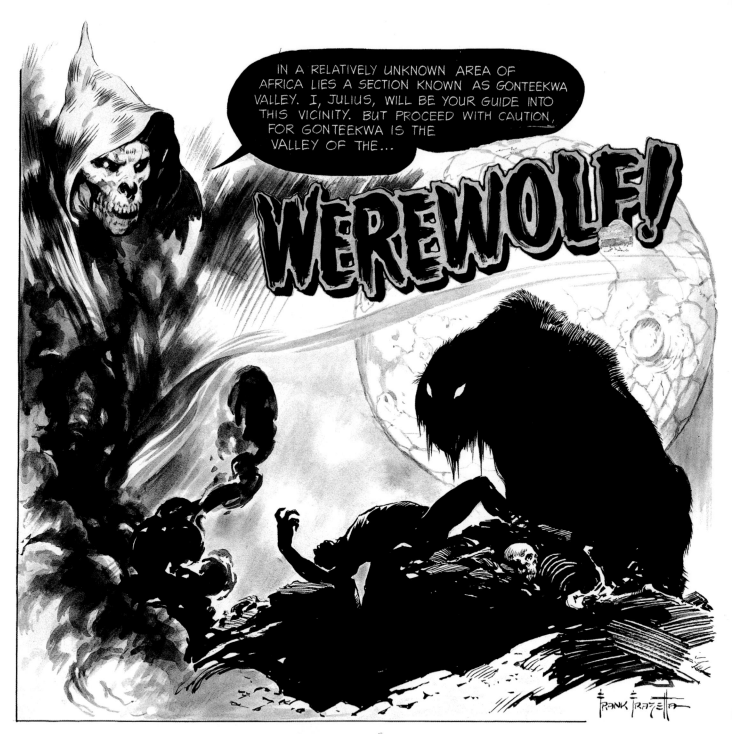

"Loathsome Lore" features in #2 and #7, and a stop-smoking public service strip in various issues) and a brilliant string of masterfully-rendered-in-oil cover paintings. Other Warren magazines (*Eerie*, *Blazing Combat*, and *Vampirella*) would also benefit from his compelling images in the ensuing years.

Lancer Books, a "B" list New York publishing house, had acquired the rights to a series of books by Robert E. Howard featuring the adventures of Conan the Barbarian. A pulp-era powerhouse who had matched H.P. Lovecraft in popularity, Howard had committed suicide in 1936. His work remained modestly popular with several generations of readers through various anthology reprints and an adaptation of of his horror story, "Pigeons From Hell," for Boris Karloff's *Thriller* TV series in 1961. Aware of the phenomenal success Ace was experiencing with the ERB novels featuring Frazetta's paintings, Lancer approached the artist in 1965 with the commission for the Conan covers. They offered him twice the pay rate he was getting from Ace and a provision that the original art would be returned to him. "Conan came to me at exactly the right time," Frank observes. "The timing was perfect. I had something to prove. The pay was in a different ballpark and they treated me with respect. I was ready to do much better work. Howard's stories had been around for a long time and a lot of artists had given it their best shot. But when I read the stories I thought, 'Here's something different, here's something right up my alley and I'm going to show every-

Above: *This caracature of Ringo Starr for* Mad *magazine in 1964 brought Frank Frazetta to the attention of the film industry.* Below: *Frank's heading for a 1965 letter column for* Famous Monsters of Filmland. Opposite: *The splash page to Frazetta's last comic story in* Creepy #1.

one what I can do when I really want to.' I think I did."

Frazetta's Conan covers rocked the publishing world and the illustration community alike and became some of his best known and most acclaimed works. The series of paintings, almost brutal in their intensity, effectively stripped the fantasy genre of its 19th Century naiveté and replaced it with a dark cynicism that appropriately mirrored the turmoil of the '60s. Upon publication of the first cover, *Conan the Adventurer* in 1966, long-time friend and fellow illustrator Wallace Wood clapped Frank on the back and asked, "How's it feel to be the world's greatest cover artist?"

The other momentous commission of the decade also came in 1965. A parody of Breck Shampoo for the October, 1964 issue of *Mad* magazine featuring his painted caricature of Ringo Starr caught the attention of United Artists' advertising agency. Frazetta was hired to create movie poster art for the comedy *What's New Pussycat*? "I made a year's salary off of one painting!" he exclaims. "They paid me *so much* for *one* poster that I suddenly felt financially secure. I knew I'd be able to provide for my family. That was the first time that I felt that I had finally 'made it'." Other poster commissions would follow for such films as *After the Fox*, *Hotel Paradiso*, *The Busy Body*, and Roman Polanski's *The Fearless Vampire Killers*.

Frazetta's career experienced a meteoric rise. From that point on he could pick and choose his assignments and no longer had to scramble for clients. Art directors would

often match preexisting paintings to an appropriate book, story, or project.

Disturbed by the increased crime in their Long Island neighborhood and concerned about the quality of life for their four children, Frank moved his family to a remote house on sixty-seven acres in the Pocono Mountains of eastern Pennsylvania in 1971. "I didn't want to go," Ellie confesses. "My family lived right on the next block, but Frank said this is what he wanted so we went. When we pulled up to this run-down house in the middle of nowhere just as the sun was setting I wanted to cry. But I smiled for the children—I had to be the brave mommy—and made a game of it. 'Oh, isn't this wonderful! Won't this be fun!' The place was just horrible. But we got buckets of bleach and scrubbed everything from top to bottom and slowly we made it into a wonderful home. And, yes, I came to love it out here. We had a lake dug and stocked; we'd fish and sail on it in the summer and go ice skating in the winter." Without telling her husband, Ellie secretly saved money whenever she could and was able to retire their mortgage within three years.

Above: *John Derek, actress Bo Derek, and Frank at the artist's studio, circa 1980. Frazetta accepted a commission to paint Bo for her company letterhead.* Opposite: *One of Frank's drawings that followed the titles in the animated film he co-produced in 1983,* Fire & Ice.

Fans had been inquiring about prints of Frank's art for many years. Lancer had released a poster of his *Conan the Adventurer* painting in 1971 and sold over 100,000 copies while several amateur publishers had released Burroughs prints and portfolios and realized modest profits. In 1972 Ellie decided to establish control over all reproductions of her husband's art and founded Frazetta Prints. "I had saved $6000," she remembers, "and I walked into the local printer with the art for the first 'Worldbeater' posters under my arm. I was so scared my knees were shaking! I didn't know anything about printing or sales or advertising, but I was willing to learn." The business was an immediate success, eventually employing nearly a dozen workers and producing over 100 posters as well as books and portfolios. Frazetta Prints was a ground-breaking company that paved the way for the proliferation of fantasy art publishers that would follow in the decades ahead.

Art books had traditionally been reserved for "fine artists" or deceased turn-of-the-century masters. That changed in August, 1975 with the publication of *The Fantastic Art of Frank Frazetta* from Bantam Books. It was edited by Betty Ballantine who, with her husband Ian (the "father of the American paperback"), founded Peacock Press and published monographs by Kay Nielson, Arthur Rackham, James Bama, and others. It was a stunning and irresistible collection of the Frazetta's most popular paintings and it showcased his seductive oils, which were immediately compared to Rembrandt. Within several short months it went through six printings with a total press-run of over 400,000 copies. Four more popular compilations would follow, the last appearing in 1985.

The May, 1976 issue of the prestigious *American Artist* magazine broke with tradition and gave Frazetta the cover feature: it became the only issue ever to sell out at the newsstand. "I don't think it made me very popular with all the barn painters," Frank laughs. He was presented with the World Fantasy Award for "best artist" on Halloween that year.

Frazetta's reputation took on almost legendary proportions in the 1980s. Hollywood celebrities visited his home and tried to entice him into working on various projects while rock'n'roll-style groupies staked out the school bus stops in hopes of catching a glimpse of him when he picked up his kids. Frank's reclusive nature added to his sense of mystery and magazine articles regaled readers with tales of seemingly holy pilgrimages to visit the artist. Very little new work was apparent in the marketplace and there was speculation that he had retired to pursue his interest in golf. But as always, Frazetta was busy behind the scenes. A 1981-83 collaboration with Ralph Bakshi on the animated film *Fire & Ice* was an enjoyable challenge for Frank despite the movie's dismal showing at the box office. Frazetta licensed his character "Death Dealer" to Tor Books in the late '80s as the basis for a series of novels and provided impressive new cover paintings for the books.

In 1985 the family opened the Frazetta Museum in downtown East Stroudsburg, Pennsylvania. Occupying the top floor of a block-long, three-story brick building the Frazetta's had purchased for their children's businesses, the museum tastefully displayed his most famous works. Accented with African art and wildlife bronzes, it was an unprecedented showcase for *any* living artist, much less for one categorized merely as an "illustrator." "It was

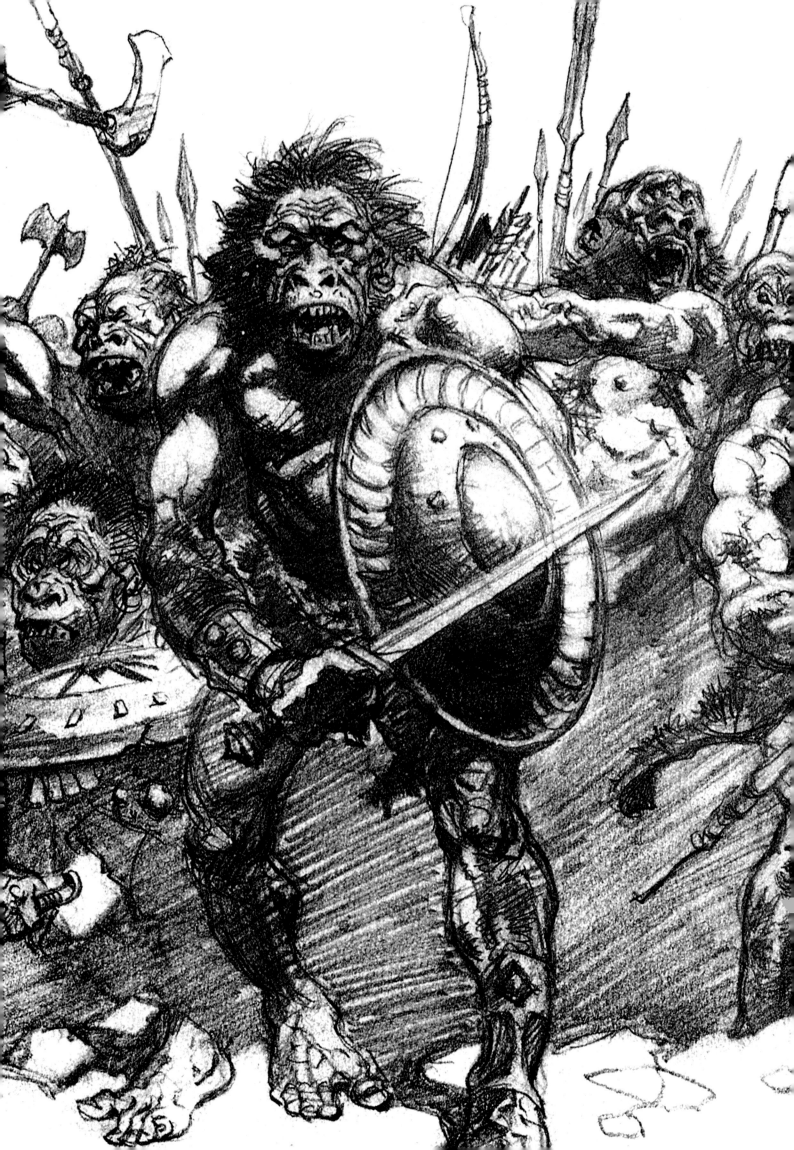

all Ellie's idea," Frank explains. "We were always getting calls from the fans asking if they could come see the originals. The best we had done through the years was to have some exhibits at various conventions, but that got to be a risky hassle. We did the museum for all the people who have had fun with my art over the years. It wasn't for

Above: *The Frazetta children on the grounds of the family estate: Heidi, Holly, Bill, and Frank, Jr.* Opposite: *"The Countess and the Green Man," a previously unpublished painting created for Bridge Publications, circa 1989. Oil on board, 18"x22".*

profit—if I wanted to make money I would've sold the originals. My joy is in showing the work." A fire on the lower floors of the building in 1995 closed the museum; fortunately none of the artwork was damaged. Announced plans to relocate the gallery to Boca Grande, Florida were changed at the last moment and Ellie plans, at this writing, to reopen the museum in East Stroudsburg in 1998.

But along with financial comfort and critical acclaim, the 1980s also brought health problems to the vigorous artist. "The first symptoms appeared about 1986," Frank relates. "I had three jobs going on at the same time and I was burning the midnight oil. Coincidentally I had bought some really inexpensive turpentine, real junk. The

fumes were so terrible that it probably screwed my thyroid up. Nobody's quite sure what makes a thyroid malfunction or quit or go hyperactive, but they certainly know it can be affected by chemicals. I was working for about two weeks with this turpentine that just permeated my studio: my wife and kids wouldn't even come into the room it was so bad. But good ol' Frank just kept plugging away. 'I'm tough, this won't affect me.' Around the time I was finishing the jobs I suddenly got this eerie, insidious taste in my mouth. It was almost as if Death had entered." Painting became more difficult and he began to experience dizziness and debilitating pain. For the next eight years Frazetta saw dozens of doctors and was subjected to every imaginable test, always with inconclusive results. His weight plummeted from 180 to 128 pounds and his anxiety increased. "After I was practically dead," he says, "they decided to check the thyroid again because there was nothing else to test and the problem showed itself. It had gone sky-high and they couldn't quite understand it. I went through the usual treatment after that, got well, and I came back to the normal range. But it happened all over again, and I went through all that trouble of trying to convince them that maybe my thyroid didn't belong in the 'normal' range, but they wouldn't listen. Finally a doctor decided to experiment and dropped the dosage of my medication. And I was normal again! It was the difference between 100 micrograms and 75. Idiotic! I was suicidal; it almost destroyed my family, my life, everything. Just because of a crummy pill! Twenty-five micrograms!"

His recovery sparked a creative renewal and in the early 1990s Frank reemerged in the market with a series of covers for *Mad* and for *Shi* and other comics publishers. He allowed a few of his originals to be sold at auction at Sotheby's and Christie's, where they went for high five-figure sums. Bridge Publications produced several fine art prints from his new works and in 1994 Frazetta had his first New York gallery exhibition.

He was commissioned to paint the poster art for the Quinten Tarantino/Robert Rodriguez vampire film, *From Dusk Till Dawn* and licensed "Death Dealer" and a new character, "Jaguar God," to the comics. Kitchen Sink Press produced books of his funny animal comics [*Small Wonders*, 1991] and his capricious watercolors [*The Frazetta Pillow Book*, 1994], Verotik released a large edition of his pencil drawings [*Frazetta: Illustrations Arcanum*, 1995], and Frazetta Prints published a collection of his recent oils [*Frazetta Book 1*, 1996]. He was presented with the first Spectrum Grand Master of Fantastic Art award in late 1995.

Although his health has somewhat declined in the last

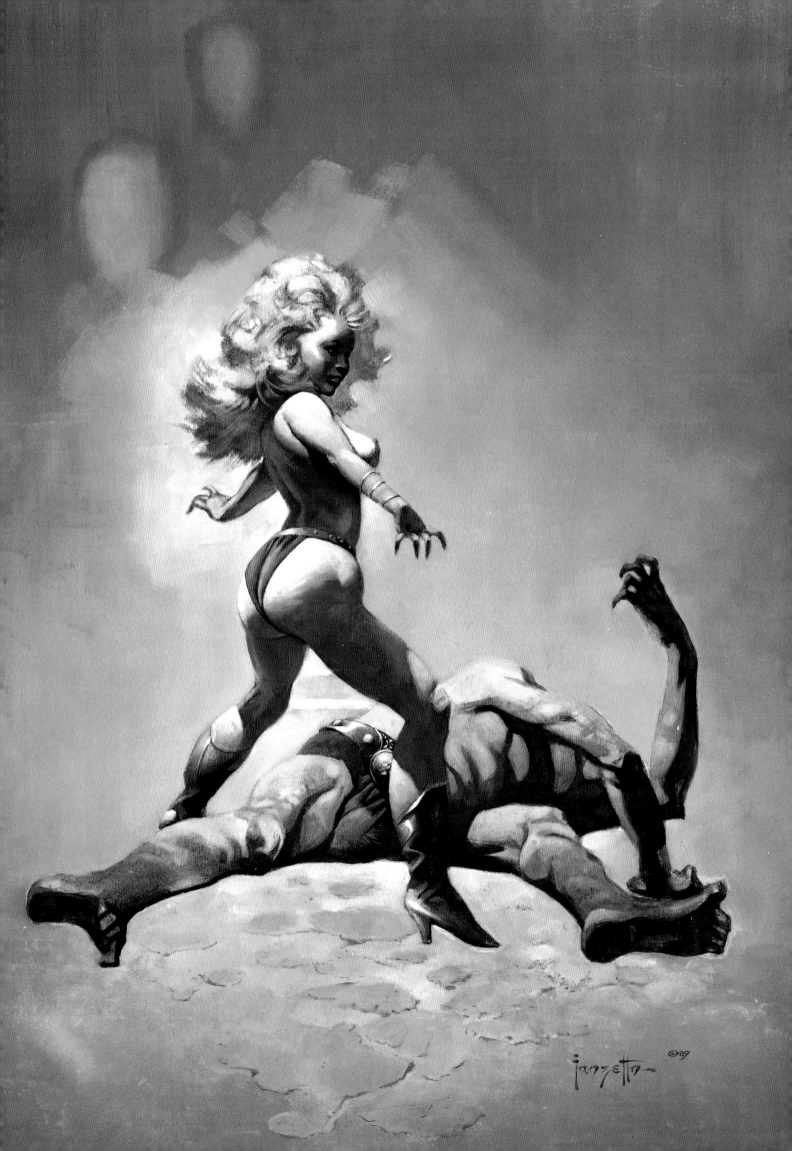

several years, Frank Frazetta is still the friendly, opinionated, wonderfully talented enigma his wife and friends have always known him to be. Devoted to his family and a pack of grandchildren, his enthusiasm for life is unmistakable and infectious. Certainly Frazetta possesses a strong ego and seems cavalier with his self-confidence. But at the same time he's dismissive of many of his accomplishments, hesitant to accept credit when it's due. In trying to insure that he wasn't taken advantage of, Frank and Ellie inadvertently fought the good fight for *all* artists' rights before it became fashionable, setting precedence for the return of originals and acknowledgement of copyrights.

During a recent conversation in his studio I asserted that he had pretty much single-handedly shaken off the constraints of the publishers' expectations in the 1960s and made careers as fantastic artists possible for a whole generation of creators that followed. To which he responded (good naturedly), "Oh, big whoop." (Don't ask about our conversation concerning Pete Rose and baseball.)

That Frazetta became such an influence in contemporary illustration, such a cultural icon, was unexpected and unintentional—which may partially explain his lasting popularity. He never had a "master plan" beyond putting food on the table, supporting his family, and having fun. He was not an art intellectual trying to pontificate through his work: Frazetta always saw himself as an entertainer and storyteller. Yet, never purely illustraton, his best works, on the surface, seem to owe little to the time-periods in which they appeared.

But Frazetta's paintings *are* open to a wide range of interpretations: whether his canvases are cries for excitement in reaction to the blandness of the Eisenhower 1950s, metaphors for the political upheaval of the '60s, celebrations of personal power and individuality in the increas-

ingly depersonalized society of the 1970s, responses to the arms race of the '80s, or, quite simply, timeless and arresting escapist art, it's ultimately up to each viewer to determine for him or herself.

The one thing that everyone *can* agree on is that Frank Frazetta is an original. His cartoon work is charming and funny; his comic art is unmatched in vitality; his fantasy paintings are virile, authoritative, and masterful. His portraiture, figure studies, and religious art (all largely unseen by the public) provide a quiet balance to his more exuberant commercial work.

As the 20th Century ends it is natural to reflect on the preceding decades and those who have enriched our lives with their imaginations and personal visions. In the "golden age" of illustration there *really were* giants: eccentric, monumentally talented geniuses with amazing talent and the uncanny ability to indelibly imprint their dreams on the souls of their audiences. The artists we know, whom we revere and celebrate, didn't create by committee. Didn't follow fads. Didn't imitate their peers. Didn't rely on a singular perception or subject or tool or color palette. Imagination was their only "gimmick."

There were giants in those days.

And Frazetta is one of them.

Will he find a prominent place in the art history books and become the subject of university studies? A question that only time will answer: the list of accomplished artists unknown to the masses is sadly long. But for now we can take pleasure in the visions he shared with us, find joy in his inventiveness, and embrace him as an irascible rebel-without-a-cause of the art world. In the vast international arena of fantastic illustration and contemporary art there are thousands of wonderfully gifted creators...

But only one Frank Frazetta.

Above: *Frank Frazetta playing it cool in Brooklyn, New York, circa 1953.* Opposite: *The artist in front of his Pennsylvania home with his omnipresent camera, 1997. His studio occupies a specially constructed wing at the rear of the house.* Photograph by David Winiewicz.

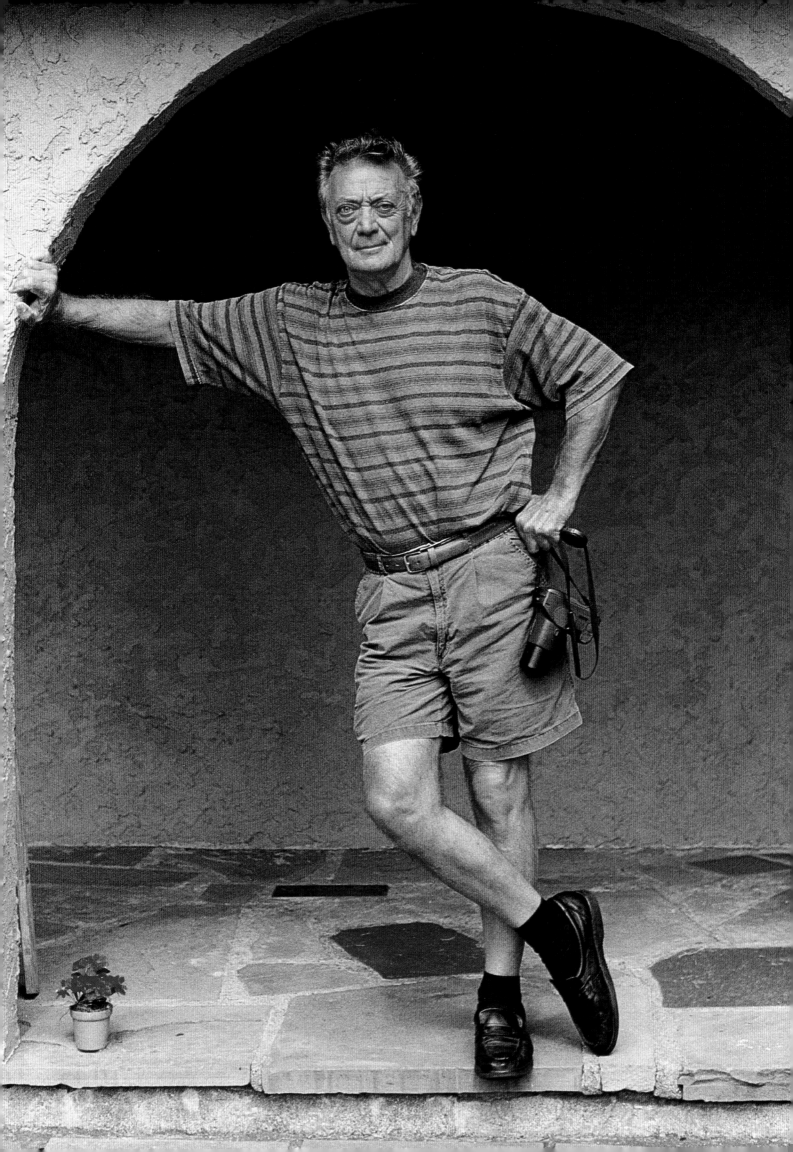

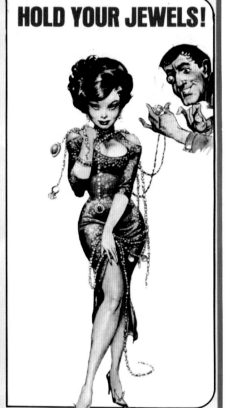
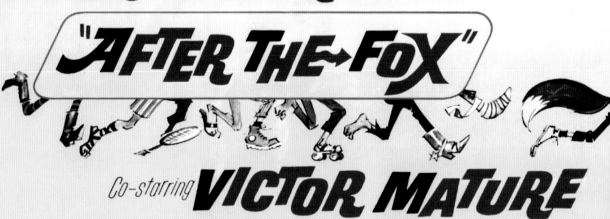

FRANK FRAZETTA
Motion Picture & Television Advertising Artist

by William Stout

Comic book artist, gallery painter, dinosaur illustrator, and film conceptual designer, William Stout has achieved acclaim throughout the creative community. His numerous movie posters (including Wizards, House, *and* More American Graffiti*) and role as storyboard artist (for films including* Conan the Barbarian *and* Invaders From Mars*) more than qualifies him to reexamine and shed new light on the little-known motion picture/Frank Frazetta connection.*

Renowned American illustrator Frank Frazetta is primarily acknowledged for the dramatic fantasy subject matter that has enhanced paperback book and magazine covers, art posters, and calendars. His work has been the subject of at least ten richly illustrated monographs. The material in those books rarely overlapped and served to spread the Frazetta name far beyond the limits of science fiction fandom,

It's not commonly known that Frazetta frequently ventured past these stylistic boundaries and subject matter limitations to produce record album covers, men's magazine illustrations, and comic book art. One genre exposed his work to more of the public than any other graphic medium: motion picture and television advertising. Ironically, this genre has been the least examined aspect of his varied career. Reproduced in nearly every newspaper in the country, Frazetta's film and TV promotions provide a chance to study an interesting variety of visual approaches. Especially interesting is the chance to glimpse the rarely seen humorous side of Frank Frazetta.

Technically, the first time Frazetta's art ever graced a movie poster was in 1952. *King of the Congo*, a Columbia Pictures serial starring Buster Crabbe, was "based on the adventures of the dynamic hero of THUNDA cartoon magazine." The cover to Frank's 1952 comic book, *Thun'da* #1, is reproduced in the lower right hand corner of the movie poster. Unknown to Frazetta, Magazine Enterprises (publishers of *Thun'da*) sold rights to his Tarzanish character to Columbia. Frank was never paid a cent in licensing profits for the character he created, which is why there never was a second *Thun'da* (or any other work) for M.E. by Frazetta.

Frank's first real movie job was for the Peter Sellers film *What's New Pussycat?* in 1965. He got the assignment when an art director saw Frazetta's Ringo Starr caricature on the *Mad* #90 back cover. His art for *Pussycat* is reminiscent of his 1950s *Li'l Abner* work for Al Capp. The familiar Frazetta touch is evidenced in the cracked stone archway and the crumbled rock at the first policeman's feet in the "A" sheet. Frank's enthusiasm for the Wagnerian Brunhilde-type is apparent in his execution of the surface texture and design of her Conan-esque axe and armament in the "B" poster. The "A" sheet image was repeated for the soundtrack LP; the "B" image was reused for the paperback novelization and for the Tom Jones hit single picture sleeve. According to the June, 1977 *Esquire* article "The Incredible Paintings of Frank Frazetta," he was paid $5000 for the art. Frank remarked that that was "a whole year's pay—earned in one afternoon." Frank indeed looked forward to similar work.

Frazetta's next poster, *The Secret of My Success* [1965], allowed him the luxury of painting a ghoulish mad scientist and some particularly spidery spiders. The color in this poster seems unusually low-key when compared to the brightness of his other works in this genre. The pressbook includes an alternate illustration by Frank.

After the Fox [1966], another Peter Sellers film, resulted in two of Frazetta's finest posters. Frank did Sellers fine justice with many excellent caricatures. Victor Mature was right up Frank's alley; he had previously drawn the actor in 1950 on the comic book cover for *Tim Holt* #17. Frank's rendering of the German shepherd is particularly sympathetic and sensitive in its execution. Frazetta delivered some strange and amusing business in the "B" sheet

image, most notably the nude statue and the wide-eyed bird. The "B" art was reused as the soundtrack LP cover; the "A" art was printed on the back of the album jacket.

Hotel Paradso [1966] is a prime example of Frazetta's movie art at its slickest. Careful attention was paid to a variety of textures and details, such as the tropical plants and the swollen vein on the whistle-blowing cop's neck. Also used as the soundtrack cover, this piece is distinguished not only by its textural and visual depth, but by the fact that Frank painted actress Gina Lollabrigida with two left feet!

In 1966 Frazetta painted the key portrait that appears throughout the film *The Group.* Although not used as part of the formal advertising, the painting (which was heavily retouched by a studio hack) appears in the background of some of the publicity stills.

Frank's art for *The Busy Body* [1967] has another all-star cast running in unexplained pursuit (of the box office?), a style pioneered by Jack Davis in his *It's a Mad, Mad, Mad, Mad World* one sheet poster. Stylistically *The Busy Body* is a cross between *What's New Pussycat?* and *Hotel Paradiso.* The graveyard and cadaverous features of the corpses belie his background as an artist for *Creepy* magazine. A cropped version of this painting was used as the cover for the paperback novelization.

The "one-sheet" art for Roman Polanski's 1967 film *The Fearless Vampire Killers or Pardon Me, But Your Teeth Are In My Neck* was a team effort. Frank painted the elaborate cartoon beneath the poster's dominant vampire-attacking-girl image (artist unknown). The subject matter was just right for the Frazetta touch: monsters, bats, an old castle, and the beautiful Sharon Tate. The figures are all a delight, even down to the tiny jumping silhouette far in the back. Frank says he enjoyed the job because "the movie people didn't tamper with the finished art."

Frazetta did two quick and nearly identical paintings for 1967's Fitzwilly. Both were rather uninspired in the drawing and rendering; Frank was turned-off by the studio's insistence that the heads of the four stars not be caricatured. Instead, photographs of the actors' faces were pasted onto the bodies in his painting and Frazetta retouched them to achieve a bit more artistic consistency. Though only one painting was used as a one-sheet, both adorned the Johnny (this was before he became "John") Williams soundtrack LP as front and back cover art.

Also in 1967 Frank did at least three watercolored pencil drawings for *Mad Monster Party,* the animated puppet feature written by Len Korobkin and Frazetta friend (and "Little Annie Fanny" collaborator) Harvey Kurtzman. After Frank completed his sketches he was informed by the art director that he was not to "go to finish." The ad concept that he had worked on had been dropped. Frazetta forgot all about the project until months later when he saw his sketches boldly displayed as the printed one-sheet poster for the movie at his local theater. At least two of the drawings were used: a collection of monsters on a chandelier and the same group of monsters with a car. Collector Robert Barrett also recalled seeing a third design that depicted "a parade of monsters lumbering up a cliff path toward a weird castle." Frank immediately billed the producers and received the extra money that was owed to him. Sketch or finish, Frazetta's *Mad Monster Party* drawings have tremendous charm.

The Night They Raided Minsky's [1968] is perhaps Frank's most complex (Girls! Girls! Girls!) piece of one sheet art. The initial version gave flight to Frazetta's sexy wit—a little *too* much flight for United Artists. Many changes were made, the subtler ones being the removal of the panties dangling from the legs of one of the marquee girls and a disappointing substitution for the nippled balloons. In addition, just prior to the film's release one of the principle actors, Bert Lahr, died. Frank was asked to switch Lahr's head with that of Norman Wisdom, thus giving the surviving player more prominence. This was

Below: *Frazetta's "A" poster art for* What's New Pussycat. Opposite: *The poster for the comic* Hotel Paradiso *starring Alec Guinness.*

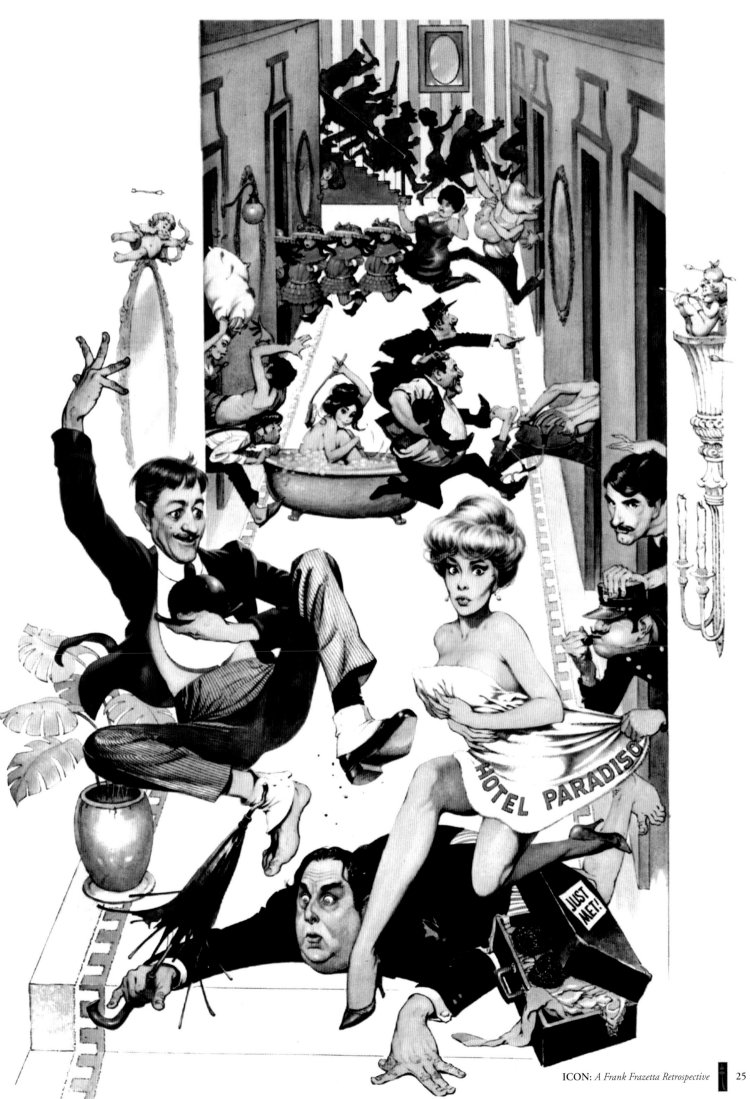

Frazetta's second portrayal of pop singer Rod Stewart's femme fatale, Britt Ekland (the first was for *After the Fox*). A cropped version of the poster art was used as the soundtrack LP jacket and an extra drawing, not shown on any other versions of the poster, was included in the pressbook.

Yours, Mine and Ours, also from 1968, was a light mom-pop-kids subject matter piece. Its distinction is that the one sheet art consists of three separate ink and dye paintings. The movie soundtrack album also featured the poster art.

Hidden in the oval at the bottom of the poster for *The Fastest Guitar Alive* [1968] was part of a loose, quick Frazetta oil painting. The delightful entirety of the art was represented on the soundtrack LP cover. Strangely, its cowboy figure bore no resemblance to the film's star, singer Roy Orbison. Apparently this was intentional. As with *The Fearless Vampire Killers, Fastest Guitar* was another combination of two different artists on the same one sheet; the Orbison portrait illustrator remains unknown.

In 1969 an agency hired Frank to do drawings for a speculative (and to this day, unpublished) poster for *Paint Your Wagon*. The line and watercolor piece consisted of large portraits of Clint Eastwood, Lee Marvin, and Jean Seberg surrounded by loads ("hundreds," according to Frazetta) of funny little vignettes of Western figures, goofy gold miners, treasure maps, and other visual tidbits of the genre. But after awhile Frank's heart wasn't in the work. "I got tired of doing all of those little vignettes and didn't go any further," he explained.

1971's *Mrs. Pollifax—Spy* is among Frazetta's most ambitious movie paintings. Instead of Frank's line and wash build-up coloring technique, *Pollifax* is a full, rich, and fairly opaque oil painting. Frazetta touches include a

solid castle-style fortress, delightful goats, and his trademark mushrooms. This art also graced the cover of the paperback adaptation. The only full, uncropped version of the art (featuring the full crowd and the entire tree) published at the time was National Screen Service's promotional "art still" for the film.

For the 1972 documentary feature, *The African Elephant,* Frazetta painted a one sheet that was never used. The three-quarter view of a massive bull elephant against a setting jungle sun eventually saw print in the Peacock Press/Bantam edition of *Frank Frazetta: Book Five* [1985].

The bulk of Frazetta's fame is supported by a style and content rarely seen in his film advertising. His 1973 work for *Luana* was a rare exception. The "A" poster got additional public exposure as the cover for the comic magazine *Vampirella* #31 and as the cover for the *Luana* paperback novelization. At one point during the job the film's release was canceled. Frank had already been paid for the two finished paintings, yet he hated to see them go unused. This, coupled with a tight deadline for his second series of Edgar Rice Burroughs covers for Ace Books prompted Frazetta to change the black panther of the *Luana* "B" art into a sabertooth cat. The altered painting was sold to Ace as the cover to their 1973 edition of *Savage Pellucidar*. A short time later, much to Frank's surprise, both the *Luana* movie and its Frazetta posters were released. Unfortunately, extra loincloth material was crudely added to the shapely thighs of the "B" image of the girl by one of the movie distribution company's staff artists. An uncropped version of the "B" painting appeared as the back cover to *The Burroughs Bulletin* #30. Frank also painted a pre-

Above: *Frazetta's poster art for Sid Ceasar's comedy,* The Busy Body. *Opposite: Frank's cartoon contribution to the Roman Polanski-directed horror farce,* The Fearless Vampire Killers, Or Pardon Me, But Your Teeth Are In My Neck, *one of the artist's favorite film jobs. The concept of a film's cast chasing Keystone Cops-style across the movie poster was common throughout the 1960s and '70s and was first popularized by EC alumni Jack Davis with his art for Stanley Kramer's all-star comedy hit* It's a Mad, Mad, Mad, Mad World. *Most of Frazetta's poster work followed this brief trend in advertising.*

release 8¹/₂"x11" teaser card just prior to his final *Luana* one sheets. The teaser is basically a painted sketch, very quick and loose in its execution. Frazetta recalls the *Luana* art with fondness as the only movie advertising paintings that fully satisfied him.

Mixed Company [1974] was another three-panel domestic comedy scene along the order of *Yours, Mine and Ours.*

Orsatti Productions commissioned Frank to do character designs for a proposed feature-length animated *Dracula* in 1975. The production was postponed and eventually abandoned and Frazetta's work on the project never saw print.

Brief mention should be made here of an opportunity lost. When Dino DeLaurentiis was remaking *King Kong* in 1976 he flew Frazetta to Hollywood as part of an impressive gesture to convince Frank do do the poster art. But whenever he made suggestions about the feeling the art should project DeLaurentiis would suddenly turn a deaf ear. Finally, Frank pressed for a free hand on the job and was refused. Despite DeLaurentiis' financial temptations and other subsequent attempts at persuasion, Frazetta held out against doing the film's ad art. Ironically, Frank painted the 1977 Ace Books paperback cover to the novelization of the original 1933 *King Kong* (a repainting for his cover for *Creepy* #11; this repainted Kong was also *re*-repainted [see page 113]). Even more ironically, Frank created one of his very best paintings for the 1977 Ace film-novelization of the DeLaurentiis Kong movie!

In 1977 DeLaurentiis tried again and this time he was successful. Frank agreed to do eight promotional paintings for Dino's next film, *Orca.* That was until Frazetta read the script. Frank hated it and renegotiated the deal, producing only one painting for the movie. Though Frank was pleased by his *Orca* job ("a nice little painting"), DeLaurentiis rejected it. A blurry copy eventually saw print in *Frank Frazetta: Book Five.*

Around this same period the *New York Times* and the *Chicago Tribune* ran a masterful ink line and wash advertisement by Frazetta for the TV movie *Give Us Barabbas.*

By 1977 Frank Frazetta had no financial incentive to continue his work in film advertising. His fantasy painting career had taken off like a rocket, as had the prices for his original paintings. So it came as a welcome surprise to many fans when the advertising for the Clint Eastwood film *The Gauntlet* appeared in the form of a very dramatic Frazetta painting. Eastwood, back home in Carmel, California, had seen articles on Frank in *Esquire* and *Newsweek*. Clint called Frazetta to express admiration for his art and to voice hopes that Frank would be available to do the poster art for the next Eastwood film. Frank's wife and business manager, Ellie, answered the phone. She didn't believe the man on the other end of the line was Clint Eastwood, but went out to the yard and called Frank anyway. Frank was busy working and didn't feel like answering. He told Ellie that "if it really *is* Clint Eastwood, he'll call back!" He *did* call back, throwing the Frazetta household of Clint Eastwood fans into an uproar. After filming *The Gauntlet* Clint called again about doing the art and Frank agreed. Eastwood and costar Sondra Locke then flew out to the Frazettas' to pose for the painting. Frank asked for and received $20,000 (a phenomenal fee for that time) for his *Gauntlet* poster. To top it off, Ellie hit Eastwood up for an additional sum for the original art.

At the end of 1977 Richard Williams and Rebecca Mills animated a 30 second commercial for Jovan Sex Appeal (a men's cologne) based upon Frazetta's painting for the cover of *Thongor Against the Gods*. [See page 148.] Although he was reportedly pleased with the result, Frank had no involvement with the making of the 1978 spot other than providing his painting as primary source material for the commercial.

On behalf of his 1978 film *Paradise Alley* Sylvester Stallone personally contacted Frazetta. Frank didn't want to do the job, so to gracefully discourage Stallone he doubled his Eastwood price. "I figured if I doubled my price I'd be safe," Frazetta revealed. "They'd have to be crazy to pay that much. But, hell, Stallone called his people who called their people and before I knew it Stallone had called back and said, 'Yes!'" Frank did six rough sketches for approval. As an afterthought, he knocked off a quick seventh sketch, one he didn't like. He figured there was no chance they would ever pick it. "I did the extra rough to make it look like I'd been working," Frank explained. "Of course, it never fails—*that* was the one they went crazy over." The maverick rough was completed as a finished design. To this date, however, the painting hasn't been printed or used to promote the film.

Also in '78 popular director George Lucas asked Frazetta to paint the dustjacket for a lavish *Star Wars* book. Some fans are of the opinion that Frank's early 1950s Buck Rogers *Famous Funnies* covers had been an influence on the look and feel of *Star Wars*. But Frank turned down the job, preferring instead to concentrate on painting projects of a more personal nature.

Yet, to launch 1978's TV series, *Battlestar Galactica*, and to promote its release as a film in Europe, Frazetta was commissioned to do four paintings. A new painting was revealed in black and white each week for the first four weeks of the show in U.S. TV guide schedules everywhere. The execs who hired Frank wisely gave him freedom of interpretation in his execution of the illustrations. Although the *Galactica* ships are a direct antithesis to Frazetta's organic Buck Rogers-style spaceships, they're handled with facility and are consistent with Frank's own style. The girl-and-two-guys painting is similar in feeling to Frank's paperback cover for Brett Sterling's *Danger Planet*. The "five girls" Galactica painting is notable for its unusually (for Frazetta) monochromatic qualities. The

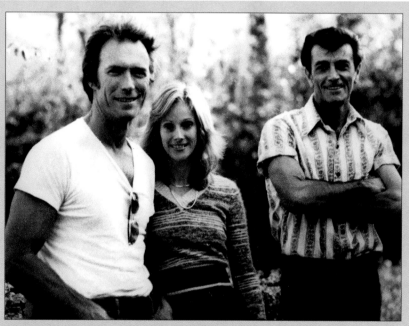

Above: *Clint Eastwood, Sondra Locke, and Frank at the Frazettas' Pennsylvania estate in 1977.*

"This guy calls up," Frazetta relates, "and tells my wife on the phone that it's Clint Eastwood. I said, 'Yeah, Clint Eastwood. Big joke.' So she hung up on him. He calls back and sure enough it *was* Clint Eastwood. So I apologized and he laughed. He told me about the movie he was doing, how he saw my work, and wanted to come out and see me. When he came out we talked about *The Gauntlet* and he had some very specific ideas about what he should look like on this poster and he made comparisons with a specific painting. He picked out one that he called his favorite and said, 'I want to look like *that*.' It was 'Dark Kingdom.' [See page 133.] So I laughed and said, 'You've *got* to be kidding!' 'Not that I want to look like that, but I want that *look*. I want your look.' I mean, I've been handed some challenges in my time, but jeez—this movie was a contemporary action film." Frank provided Eastwood with a variety of watercolor roughs to choose from and the final poster [see opposite] *is* similar in tone and composition to the Kane painting.

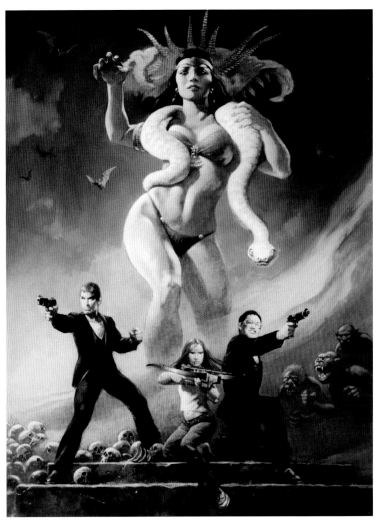

Above left: *Frazetta's painting for the "A" sheet poster for the low-budget film,* Luana. *Above right:* The unused poster art for the 1996 Robert Rodriguez vampire thriller *From Dusk Till Dawn. The studio opted for a computer-manipulated photographic poster that placed more emphasis on the movie's star, George Clooney. Opposite:* Frank's fourth promotional painting for the *Star Wars-"inspired"* Battlestar Galactica *TV series.*

Galactica cave scene (a vertical painting; the first two were planned and printed as double-page spreads) treads lightly into Conan territory. The fourth *Galactica* painting (another vertical) features a mysterious bald wizard-type and the boldest color of the series.

Dino DeLaurentiis used the image from Frazetta's painting for *Conan the Adventurer* as pre-production promotion for his 1982 *Conan the Barbarian* movie.

Filmmakers and long-time Frazetta admirers John and Bo Derek commissioned Frank to draw and paint the stationery for their Svengali production company in 1980. This gorgeous piece features Bo Derek as sexy puppeteer with John as her bewildered puppet.

In 1982 what seemed tantalizingly inevitable to the Frazetta fan audience finally happened: Frank was offered a chance to make a Frazetta movie. Long-time admirer, acquaintance, and fellow Brooklynite Ralph Bakshi was the conduit and *Fire and Ice* became the film. Frazetta designed the full-length animated feature, created the characters, and co-wrote the basic story. He even sculpted head models of his key leads as guides for the characters' animators. Frank supervised the background paintings of future Dinotopian James Gurney and Painter of Light™ Thomas Kinkade so that they would mimic the Frazetta style as closely as possible. It was only natural that Frank would produce the one-sheet image for his own film. He

painted an American poster based upon input from the studio, which Frazetta considered to be meddling and completely clueless in regards to understanding the film and the power and appeal of his art. Left to his own devices for the German poster, Frank pulled all the stops [see page 115]. Upon seeing this new art the studio scrapped the U.S. image and replaced the posters with Frazetta's German design, a classic work that stands with some of the best of his personal pieces.

After a disappearance of over ten years Frazetta surprised everyone when he resurfaced in the world of movie advertising with his one-sheet art for film director (and Frazetta fan) Robert Rodriguez's 1996 over-the-top horror thriller *From Dusk Till Dawn*. Although the alternate non-Frazetta photo-collage became the studio's ad art of choice, Frank turned in a juicy piece of work, ripe with Frazetta demons, a sexy woman, and a huge snake.

The movie art of Frank Frazetta provides students and fans of his work a chance to enjoy a rich variety of styles and content from the same artist. Although some may feel it unfortunate that Frazetta's off-and-on thirty-one year association with the film business is perhaps over, his subsequent efforts to create grand masterpieces that are "pure Frazetta" have provided the art-hungry public with an impressive body of work matched in its power and influence by no other living artist.

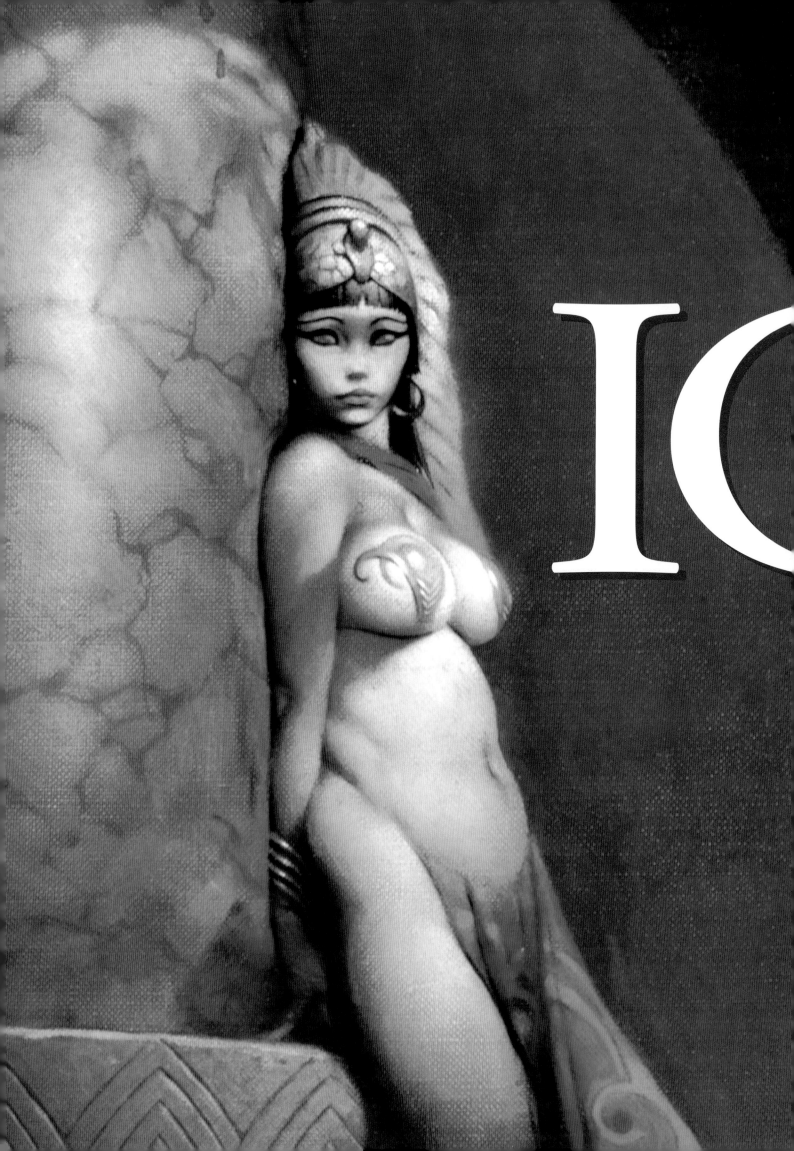

IO

ICON

Frank Frazetta

Gallery of Works

BOTH CHINA AND JAPAN ABOUND WITH LEGENDS OF *FOX-WOMEN*... BEAUTIFUL GIRLS SAID TO ENTICE MALE VICTIMS, THEN CHANGE INTO A SNARLING ATTACKING FOX!

THROUGHOUT THE MALAY PENINSULA ARE TOLD TALES OF *WERETIGERS*, MEN WHO STALK THE JUNGLE FOR PREY AS GREAT CATS! BUT EVEN WHEN IN HUMAN FORM THEY CAN BE RECOGNIZED, FOR THEIR REFLECTION IN WATER IS ALWAYS THAT OF A TIGER!

ARAWAK INDIANS DEEP IN THE AMAZON TELL OF A YOUTH WHO WOULD VISIT A MYSTERIOUS POOL IN THE JUNGLE AND BATHING IN ITS MOONLIT WATER BECOMES TRANSFORMED INTO A DEADLY JAGUAR.

TANGANYIKA WAS HELD IN A GRIP OF TERROR IN 1947 BY A FANATICAL CULT OF KILLERS KNOWN AS THE *LION-MEN*... THEY CLAIMED MORE THAN 40 VICTIMS BEFORE THE AUTHORITIES BROUGHT THEM UNDER CONTROL!

Winged Terror

Cover to Creepy *magazine, Warren Publishing Co. [issue #9, New York, 1966]. Oil on board, 16"x20". At left: One of two "Loathsome Lore" pages Frank Frazetta completed for* Creepy, *this from issue #7 [1965]. This page was never returned to the artist and is considered stolen.*

James Warren established his place in American pop-culture history as the publisher of the pun-filled *Famous Monsters of Film-land* (edited by Forrest J. Ackerman). The mixture of movie stills, interviews, news, and humor made *FM* a must-have item for budding 12-year-old film makers in the late 1950s and early '60s: directors Stephen Speilberg, Joe Dante, and John Landis were among its loyal adolescent readers.

During the Joseph McCarthy-induced paranoia of the mid-'50s the comics industry was the subject of a senate investigation which linked, without justification, juvenile delinquency with horror and crime comic books. The negative publicity and the indignation of alarmed parents forced many publishers out of business, including EC, producers of the popular and influential *Tales From the Crypt, Weird Science,* and *Front Line Combat*: the only EC title to survive the purge was *Mad*, which ultimately switched to a magazine format. In an attempt to battle the bad publicity and a backlash from distributors and retailers, the publishers formed a self-regulating Comics Code Authority that effectively eliminated all traces of crime, horror, sex, and violence from the comics. Without the Code approval it was almost impossible for a traditional-size comic book to be circulated in the marketplace.

In 1964 Warren entered the comics business with *Creepy*, a black and white full-size horror magazine that avoided the restrictions of the Comics Code Authority with its format and adult newsstand distribution. Edited by Archie Goodwin and featuring art by many EC alumni (such as Al Williamson, Joe Orlando, Wallace Wood, Reed Crandall, and John Severin), the magazine was a beautiful forum for many of comics' legendary talents.

And none took greater advantage of the opportunity to work in the larger "adult" format than Frank Frazetta.

Creepy #1 published the last complete comic story Frazetta would draw ("Werewolf," scripted by Larry Ivie), issues #2 and 7 would feature his "Loathsome Lore" pages (one page "factual" strips about monsters), and he would provide astonishing cover art for twelve of the first seventeen issues. Not including reprints, Frank painted fourteen covers for *Creepy*. "I got a call from this guy named Russ Jones, who was this fair-haired boy, the guy who kind of puts stuff together. He was aware of my past comics work and knew I was doing some Burroughs covers for Ace. He wanted to put me together with Jim Warren. I didn't fall for that agent bullshit at all, but I liked the idea that I could pretty much work for Warren and do whatever I pleased."

Frank's covers for the early issues of *Creepy* were eye-catching and evocative and were unlike anything that had ever been done before. But this painting markedly differs from the others in the series in its mood and subject matter. Whereas the others portray the humans as doomed victims of the various creatures, "Winged Terror" is very much a painting of a heroic struggle and determination. It is not a foregone conclusion that the monsters are going to win. This was a precursor to his Conan covers and was the cause of some excitement among readers.

The Frazettas had sold the original of "Winged Terror" to a fan in the late 1960s; realizing they had let a seminal work out of their possession, Ellie was able to persuade the owner to trade it back to them in exchange for a Tarzan painting in the 1970s.

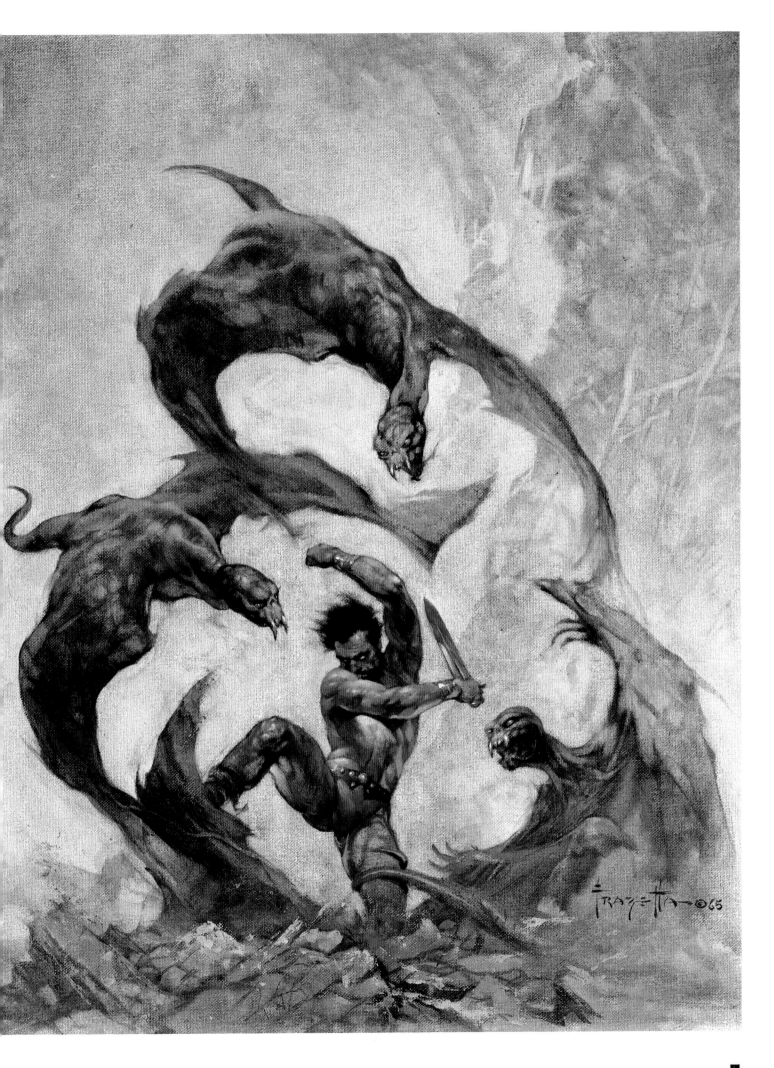

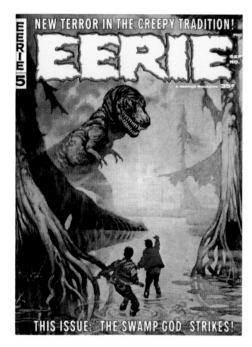

Swamp God

Cover to Eerie, *Warren Publishing Co. [issue #5, New York, 1966; revised 1972]. Oil on board, 12"x16".*
At left: The cover as it originally appeared on Eerie.

The run-away success of *Creepy* perhaps made a companion magazine inevitable. In order to protect the title of *Eerie* from his competitors, Warren cobbled together a first issue—comic book-sized with a black and white cover—and rushed it into limited circulation. With the title identity secured, a full-sized second issue of *Eerie* was released to the mass-market in 1965.

As with *Creepy*, Frazetta could paint whatever he pleased without the intrusion of an editor or art director. Always interested in dinosaurs, he took advantage of the freedom Warren afforded him to create this misty encounter with a T-Rex. Many times editor Archie Goodwin would write a story based on the magazine's cover, and this painting for *Eerie* #5 was no exception: "The Swamp God" was illustrated by one of Frazetta's long-time friends, Angelo Torres.

Torres, Al Williamson, George Woodbridge, Nick Meglin, Roy Krenkel, and Frazetta were affectionately known by the close-knit New York comics community of the '50s as "The Fleagle Gang," a name given to them by *Mad*'s creator Harvey Kurtzman. The friends took every opportunity to, as each would put it, "goof off, play baseball, and chase girls."

"Many afternoons were spent chasing Frazetta's long blasts [fly balls]," Meglin recalled in an article for the fanzine *Squa Tront* #3 [1969], "whether in the meadows of Central Park or in the schoolyard near Fritz's studio in Sheepshead Bay (Brooklyn, for the out-of-towners). The latter was preferred, for the schoolyard was in walking distance of Frank's parents' home and Mrs. Frazetta would never bat an eye when her son walked in with three or four of us, *without notice*, at dinner time. Frank was like that!"

[overleaf] **Sea Witch** *Cover to* Eerie, *Warren Publishing Co. [issue #7, New York, 1966]. Oil on masonite, 36"x20".*

"I told Jim Warren, 'Look, be prepared, because I'm going to shock you from time to time'—and I did," Frazetta remembers. "But he didn't care *what* I did—'Just do it, just bring it in!' But then I did that horizontal painting, 'Sea Witch,' and Jim almost *died*: 'Frank! What did you *do*?! How are we going to print this? We'll have to crop it and go close in on it.' I said, 'Don't you touch it.' He printed it horizontal, all on the front cover, and the response was *enormous*, in spite of the fact she was very tiny."

The "Sea Witch" is considered by many to be one of the truly classic paintings of contemporary fantastic art, a benchmark against which others are judged. The version printed on the cover of *Eerie* (and as a poster from Frazetta Prints) is the one most people are familiar with, however it no longer exists in that form. Frank extensively revised the figure, essentially creating a new painting that matches the allure of his earlier seminal work. This reworked version [pp 38-39] is published here for the first time.

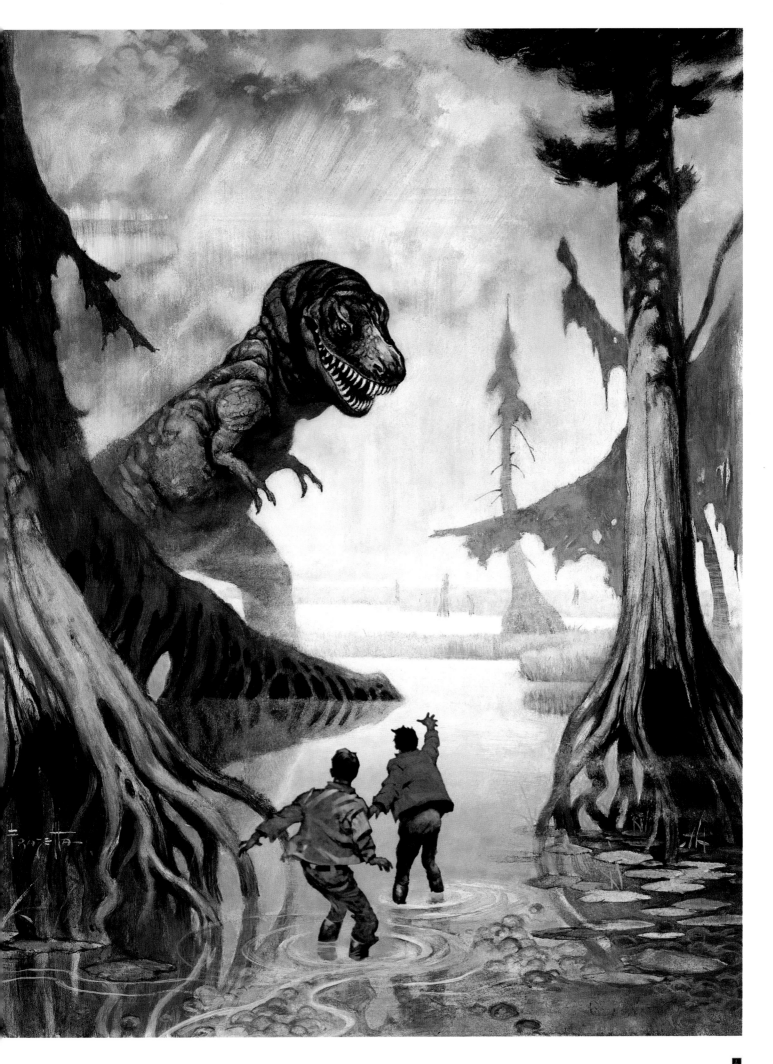

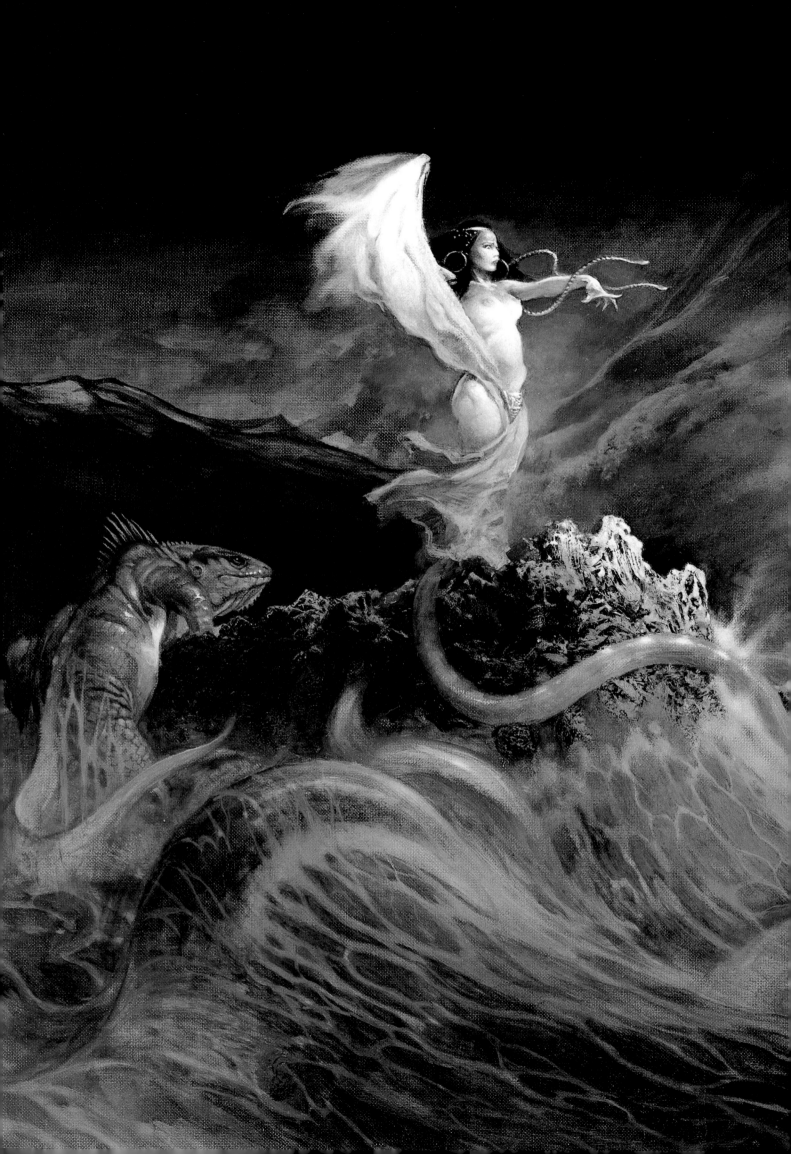

Dracula Meets the Wolfman

Cover to Creepy, *Warren Publishing Co. [issue #7, New York, 1965]. Oil on academy board, 16"x20". At left:* Pencil rough for Creepy #7 cover by Roy Krenkel.

"I liked Warren," Frazetta remembers. "He was very amiable, a lot of fun. He was a cocky little guy and he'd bullshit you a lot, but if you knew that about him you could handle him. He was funny. He had this routine, 'We're a team, Frank, blah blah blah.' That might have worked for other artists—it didn't work for me. I painted for him because I loved working for a larger format—and he stayed off my back. I guess I always had a pretty good time and I think it shows in the art."

A long time movie-fan, the Warren magazines gave Frazetta the opportunity to paint his versions of old favorites like Dracula, Frankenstein's monster, and the Wolfman. Roy Krenkel [1918-1983], a peripheral contributor to *Creepy* and *Eerie*, worked up a series of pencil roughs which he passed on to Frazetta as possible cover ideas. "My happiest thought was getting away from doing it myself," Krenkel said shortly before his death, "and enjoying all the goodies Frank would produce. I loved to see what he could come up with, but I would have hated like hell trying to beat him at his own game. There was no way I could have come even close to matching him."

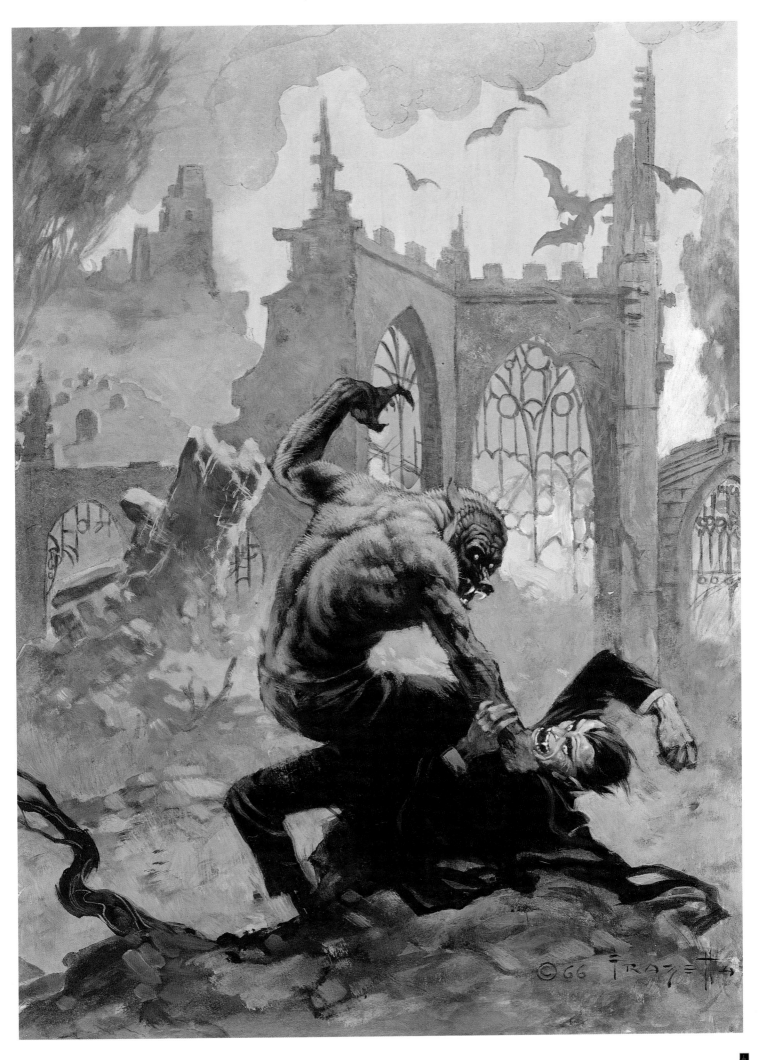

Neanderthal

Cover to Creepy, *Warren Publishing Co. [issue #15, New York, 1967]. Oil on academy board, 16"x20". At left: A portrait of "Uncle Creepy," circa 1964, that was one of the premiums of Warren's Creepy Fan Club.*

While the perspective of his covers for Warren remained fairly uniform, Frazetta was able to experiment with content and color: his painting for *Creepy* #15 is a prime example of how he was able to convey a sense of horror with a limited, non-traditional palette and an unusual subject matter. The strong, central composition of "Neanderthal" with its figures emerging from the mist would be echoed in 1969 with an even more commanding painting for the cover of *Bran Mak Morn* [see page 75], another example of Frazetta's mastery of mood.

It is interesting to note that while the style and tone of this illustration had an enormous influence on other artists, the detail of the popped veins on the cavemen's arms and their gnarled, tree-limb clubs were the first stylistic peculiarities young draftsmen picked up on and began to incorporate into their paintings, often with unintentionally humorous results.

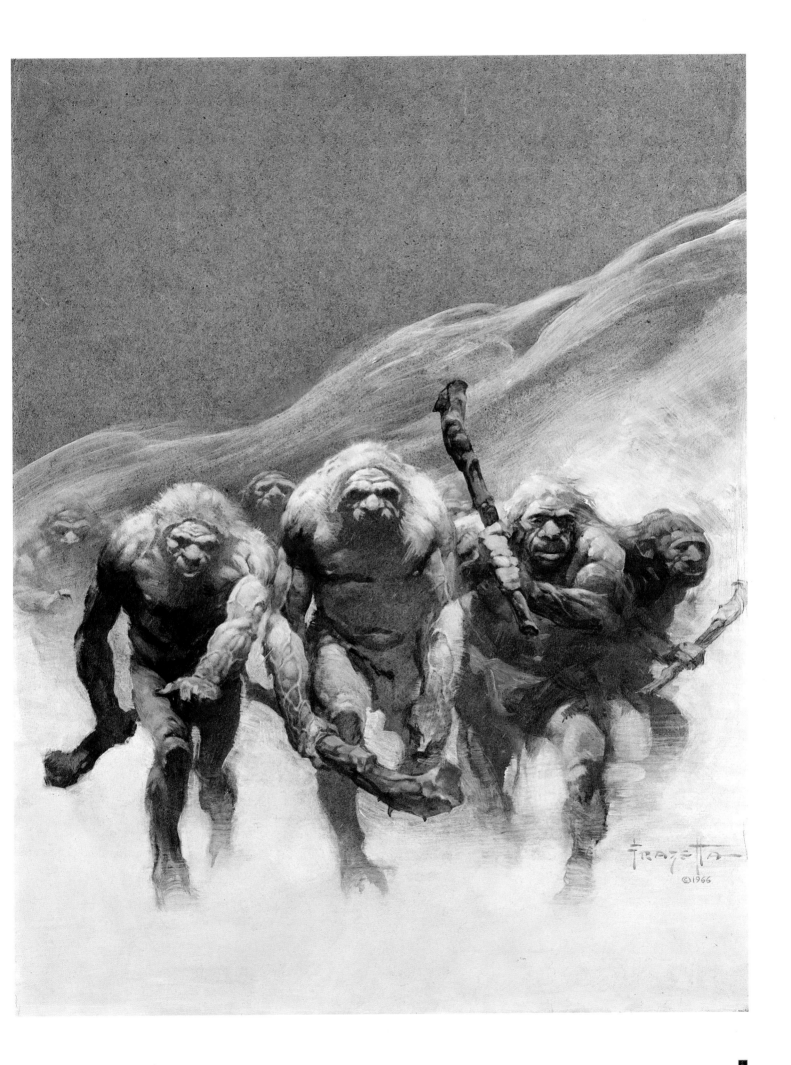

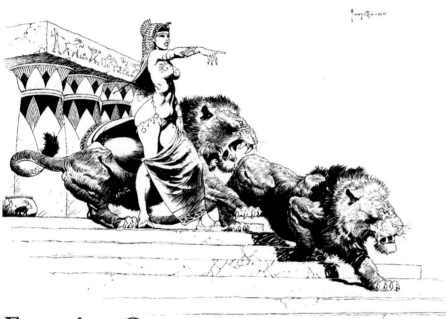

Egyptian Queen

Cover to Eerie, *Warren Publishing Co. [issue #23, New York, 1968]. Oil on canvas 18"x24". Above:* Illustration for a limited edition art portfolio, *Women of the Ages, for the Denver, CO, publisher Middle Earth [1975]. Brush and ink on paper.*

Although an illustration might have been mulled over for several weeks and been the subject of stacks of doodles and thumbnail roughs, once Frazetta started painting he worked with an obsessive intensity and rarely spent more than a day on any his best known works. His speed was legendary—he once completed three covers for Ace's first Burroughs series in two days. "I worked fast, but that was too much. I doubt if each piece had more than a few hours devoted to it; all three are bad, but what the hell, you just don't *do* three paintings on a weekend!"

The list of his memorable art completed in only a few hours time is long and impressive, but occasionally things didn't go as smoothly—or as quickly—as he was accustomed.

"Sometimes it's the silliest little thing. It might be a head, a little face. I'll never forget working on the 'Egyptian Queen.' I got that whole thing done in about a day and a half, and I looked at it. It was done as far as I was concerned. Then I looked at her face and I didn't like it. So I started to repaint the face, and I painted the face, and I painted it again, and I painted it again. Well, I was like three days trying to get the right face. And I suddenly got sort of blinded to it. I just looked at it and didn't know where I was anymore. It was weird. Finally I just settled for any face and took it to Warren and they printed it that way and then I forgot about it. So a couple of months later I got it back—I was fresh again. And I just looked at it and, Pow! I whacked in that face everybody is familiar with. When I got it back, looked at it fresh, her face was painted in five minutes."

The "Egyptian Queen" is an exceptional representation of Frazetta's use of chiaroscuro (extreme light and dark). The dramatic single overhead illumination brings the outlines forward, giving the painting an illusion of three-dimensionality and accentuating the figures' musculature. The influence of the Dutch masters was perhaps lost on the monster magazine audience of the late '60s: they just loved Frazetta's cover and bought *Eerie* by the stack. The increased sales helped to pull Warren out of a two-year slump and inadvertently paved the way for a third addition to their horror comics line.

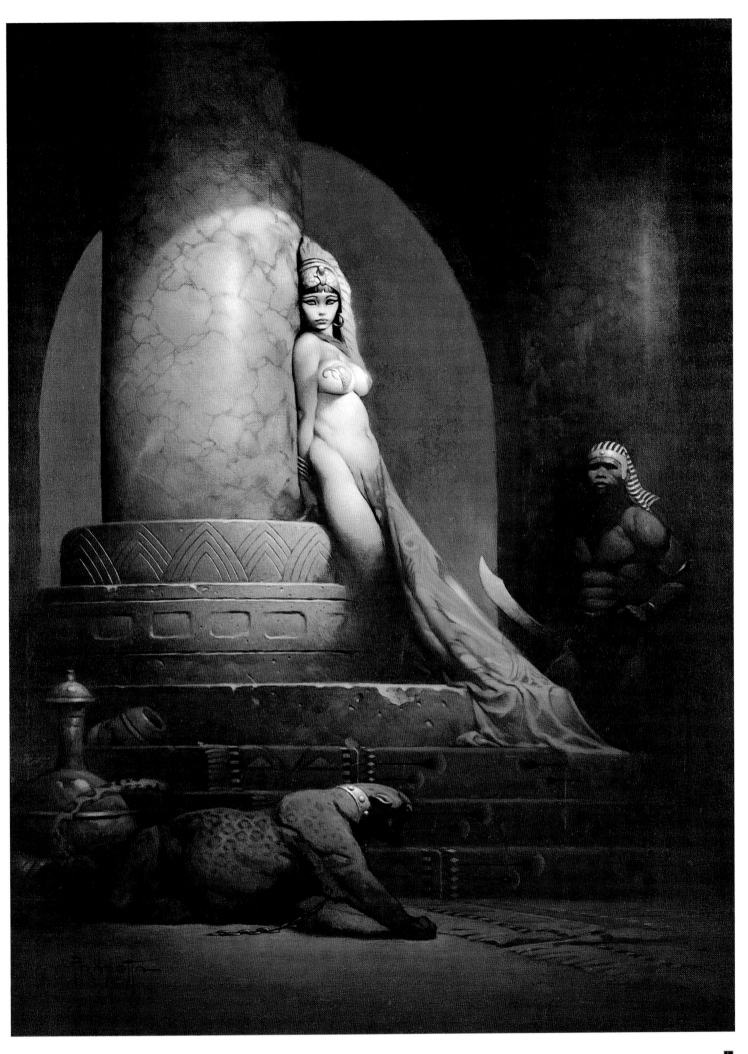

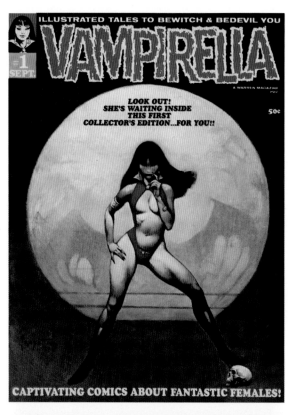

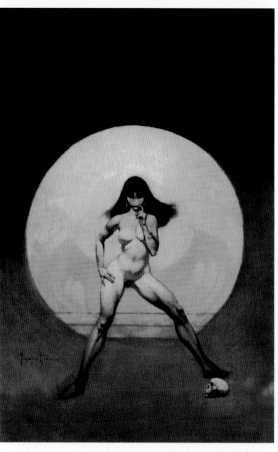

Cornered

Cover to Vampirella, *Warren Publishing Co. [issue #5, New York, 1970]. Oil on academy board, 16"x24". At left top: The published cover to* Vampirella #1, 1969. *At left bottom: Frank's revised painting, circa 1991.*

After weathering a comics-market slump for several years, Warren felt sufficiently confident to add a third horror title to his magazine line. Since *Creepy* and *Eerie* had intentionally been patterned after EC's "hosts," the Crypt Keeper and the Vault Keeper, it was only natural that a "hostess" be added to the mix: enter *Vampirella* in 1969. According to Warren's press releases this was a horror title with a feminist viewpoint, but of course the reality was that it was a comic carefully designed to pander to the teenage male market. Which it did quite successfully. The emphasis in *Vampirella* was clearly female anatomy rather than tales of terror.

Forrest J. Ackerman wrote a rather embarrassingly unfunny "humorous" origin story of Vampirella for the first issue (illustrated by Tom Sutton), underground cartoonist Trina Robbins was hired to design a peek-a-boo swimsuit costume, and the French pin-up artist Aslan (who had made a minor splash in the U.S. with a series of nudes for *Playboy*-owned *Oui* magazine) was commissioned to paint the cover. Ackerman has written that, "the great artist Frank Frazetta broke down and cried like a baby with a busted balloon and begged on bended knee to be able to portray her."

"Anyone who knows me knows that story isn't true," Frazetta responds. Aslan's painting turned out to lack a sense of drama and he gave the character an elongated face that seemed ordinary. Warren, realizing the need to grab an audience immediately, turned to his most popular cover artist for help—without telling him that he had promised the original to Ackerman in return for writing the origin. "We discussed the character," Frank remembers, "and I did a few drawings. He told me about this funny costume: Vampirella was a kind of vampire-type girl and it was really pretty silly. But people just went nuts when the magazine came out. When I sold the original at auction I undressed her, I thought that costume was so corny, I painted it out, made her brazenly nude—and everybody loved it more. We *never* talked about them keeping my original; at a couple of hundred bucks a cover, Jim knew better than to even suggest it." The original sold for $77,000 (plus a 10% buyer's premium) at Sotheby's of New York in 1991. Aslan's painting was eventually published as the cover of the first *Vampirella* annual in 1972.

Frazetta cheerfully ignored scientific conventions and mixed primeval men and women with dinosaurs in countless doodles, paintings, and drawings and this cover for *Vampirella #5* is a prime example. "I really have a thing for prehistoric worlds. I love dinosaurs and really primitive peoples...and sabertooth cats. It gives an artist more room to dream, I think."

Four of the five covers Frank provided for *Vampirella* embraced that favorite antediluvian theme, unlike the settings of his paintings for *Eerie* and *Creepy* which ranged from prehistoric to gothic to contemporary and back again.

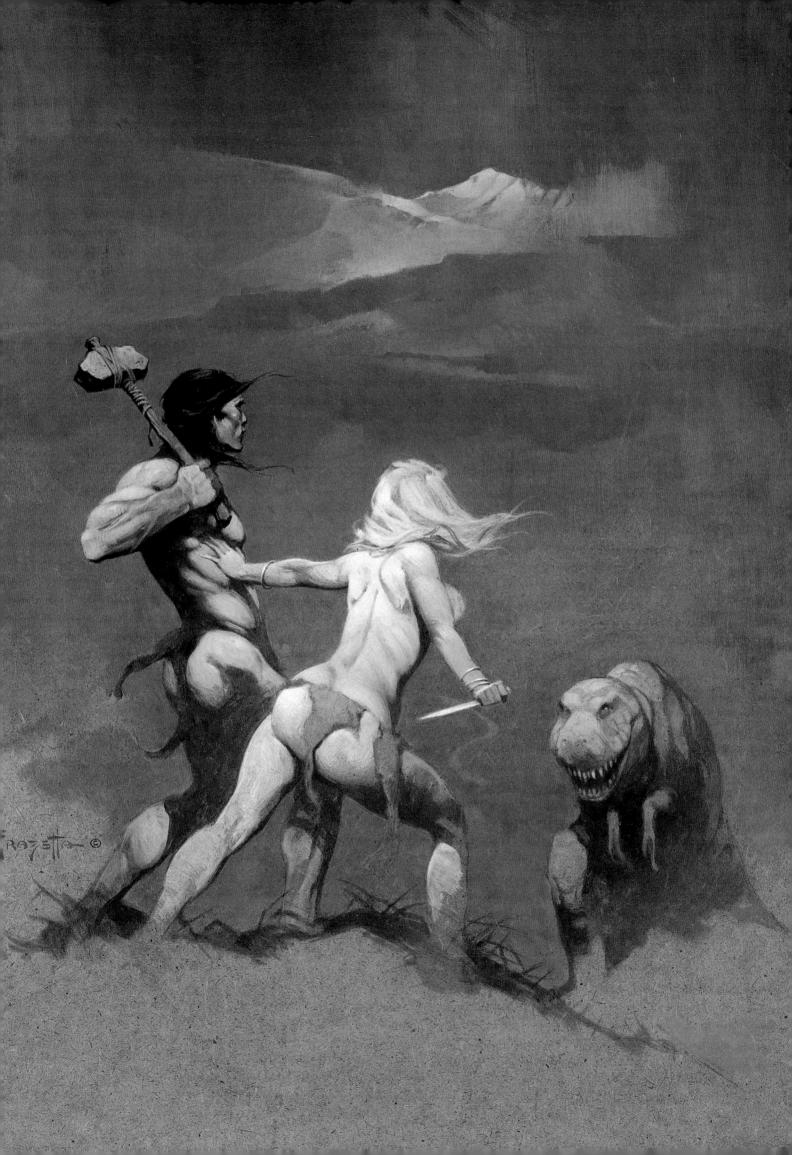

Sun Goddess

Cover to Vampirella, *Warren Publishing Co. [issue #7, New York, 1970]. Oil on academy board, 16"x20". At left: Sketchbook ink drawing, circa 1973*

Frazetta's critics have made much of an apparent sameness in appearance of his characters, failing to realize both that the artist was working within an established style that was much in demand in the marketplace and that he regularly used himself and his wife, Ellie, as models. As his advertising and movie work attests, Frank was more than capable of painting any variety of dissimilar characters: that he chose to create his own archetypical women and warriors and villains for repeated use shouldn't come as a surprise to anyone familiar with art history. "All artists have personal likes and dislikes, and I love a certain body type in women and men and in creatures and lizards and dinosaurs. I'd like to think that I break it down to the perfect machine, whatever it may be. There's a certain physical type, a certain look, in a heroic figure that I think works perfectly. I have a very personalized woman: they all kind of look alike. I've tried to escape from that and I was never happy. I'd make a perfectly nice rendering of a female and it just didn't work for me. 'I don't love her.' She's got to have a certain look, those eyes that I love."

"Sun Goddess," however, is something of a deviation. This deceptively simple painting of pagan invocation is an emotionally charged *chef d'œuvre*. The primordial priestess, with her small breasts, wide hips, and dimpled flesh, is easily one of Frazetta's most realistic figures. The stunning execution and that non-exploitative realism is probably what allowed Warren to get away with placing a primarily nude woman on the cover of what was ostensibly a children's comics magazine.

Some have described "Sun Goddess" as a celebration of the women's movement of the 1960s and '70s while others consider it a harbinger of the '90s new age "goddess" worship. Frazetta just shrugs at the suggestions. "If you try to intellectualize when you paint, the message inevitably gets in the way of the art," he says. "I don't try to be profound when I create, I just try to entertain. If people can find something beyond that in a picture, great, but I deal pretty much with emotions, not symbols."

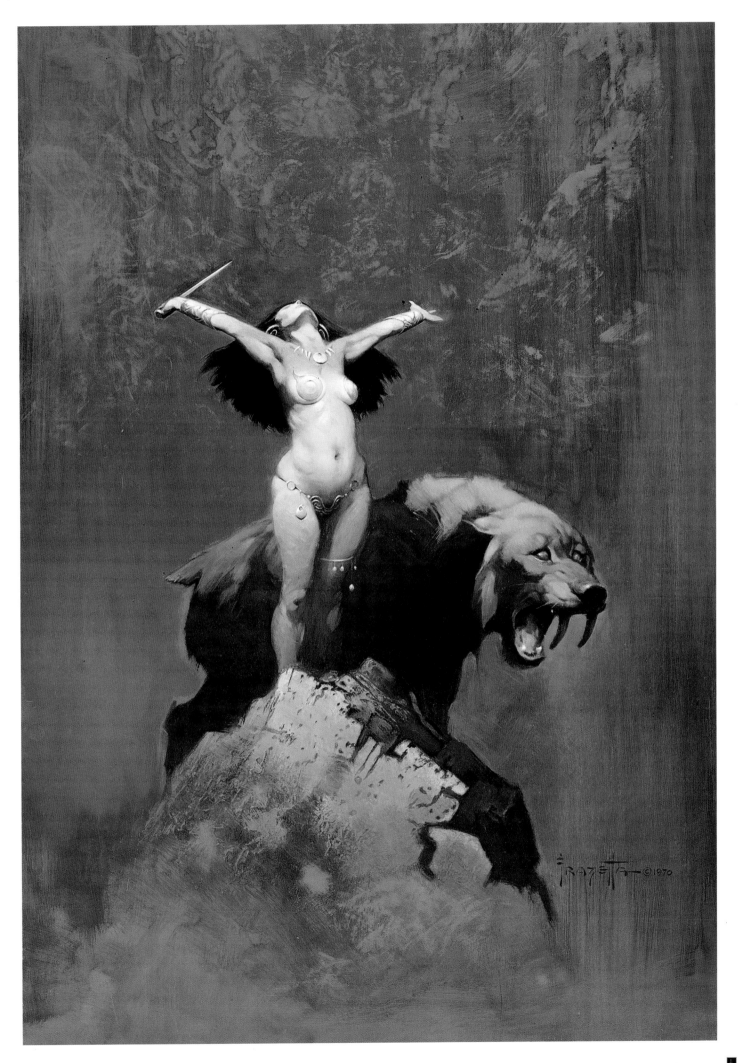

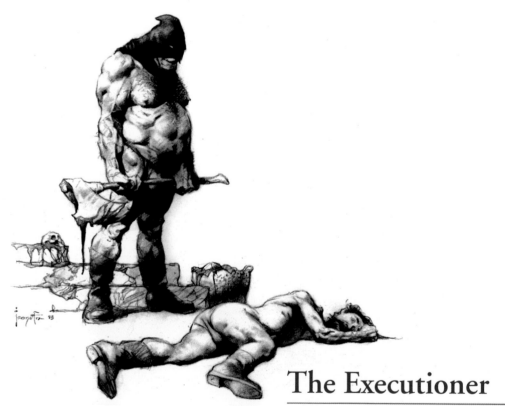

The Executioner

Cover to Creepy, *Warren Publishing Co. [issue #17, New York, 1967]. Oil on masonite, 16"x20". Above left: Personal work, originally commissioned by Glenn Danzig and eventually published in* Frazetta: Illustrations Arcanum *[Verotik, 1995], a collection of previously unpublished pencil drawings.*

The grim visage of the medieval headsman in 1967 was the last painting Frank would do for Warren for several years. A flourishing career in the book and advertising industries kept Frazetta's schedule full at the same time that economic difficulties forced Warren to lower his standards and rely on reprint comics. As mentioned earlier, Frank's occasional return to the magazines' covers eventually helped the publisher to return to profitability.

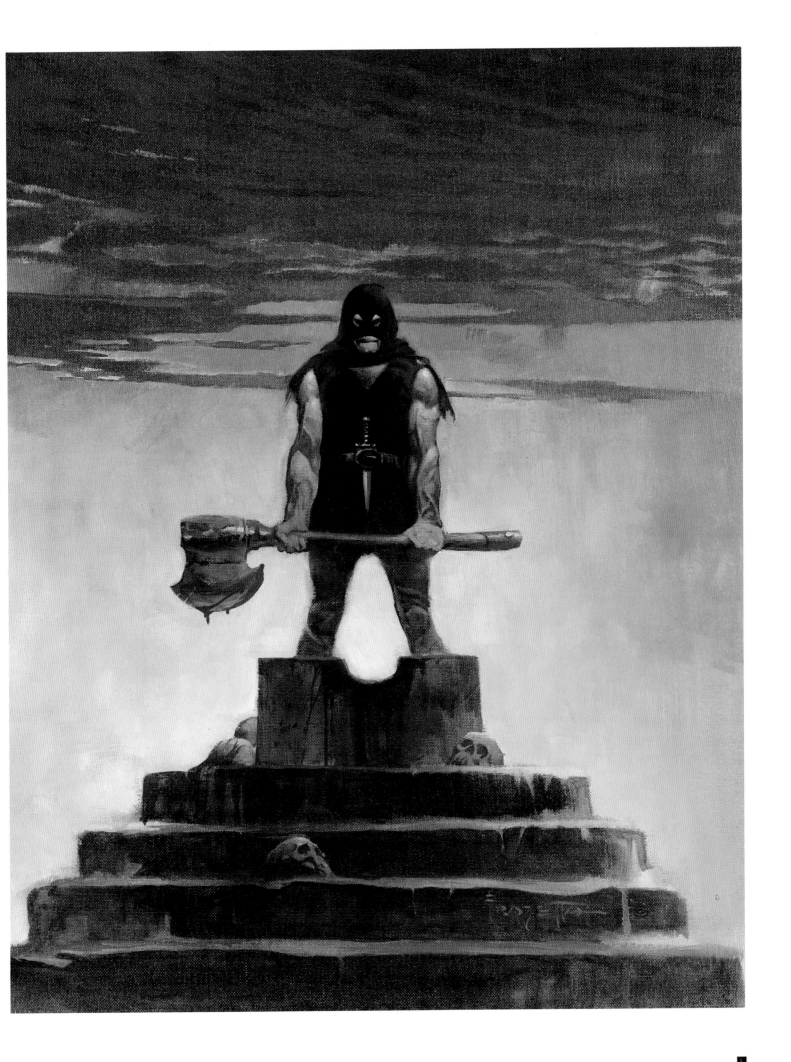

Queen Kong

Cover to Eerie, *Warren Publishing Co. [issue #81, New York, 1976]. Oil on masonite, 16"x20."*
At left: The original movie poster for King Kong, *RKO Radio Pictures [1933]. Artist unknown.*

This parody of Frazetta's favorite movie, *King Kong*, was the last art he would do for Warren Publishing. Over the course of their twelve year relationship he produced some of his most exciting work and influenced several generations of young talent. At the same time, James Warren's comics achieved their highest sales when they featured Frazetta covers and he unhesitatingly reprinted many of them on new issues (without additional compensation to the artist) whenever he needed to reverse dipping circulations. "I don't actually remember why I stopped doing paintings for him," Frank admits. "I didn't have a falling out with the guy or anything. I guess it was partly due to the fact we were moving to Pennsylvania and I wouldn't be able to get into the city anymore. Also, by that point I was doing movie posters and getting paid pretty big money. Even though I enjoyed doing that material, meaning anything I wanted to, he was only paying about $250. I was having fun and producing some nice paintings, but the others were paying me anywhere from $1000 to over $10,000 for commissioned work. I had a family to support and bills to pay so I guess I couldn't justify continuing to work for Warren." This painting was never returned to Frazetta and its true ownership became a source of controversy and acrimony when Jim Warren sold it at auction in the early 1990s.

The Warren Publishing Company went bankrupt and closed shop in 1983. That it lasted for almost twenty years is attributable more to the artists than to the editorial skills of the publisher—and considering the directions the magazines had taken toward the end of their runs, one would have had a difficult time discerning *any* real editorial presence whatsoever. But the list of contributing illustrators to *Creepy, Eerie, Blazing Combat,* and *Vampirella* is a veritable Who's-Who of the greats of the comics industry, from Neal Adams to Steve Ditko to George Evans to Gray Morrow to Angelo Torres to Alex Toth to Wallace Wood and beyond. While there were a number of competing magazines on the newsstands whose higher production values and financially viable parent companies ultimately hastened the demise of Warren's line, none would ever be able to boast the same historically impressive list of contributors.

Or a string of wondrous, throat-grabbing Frank Frazetta covers.

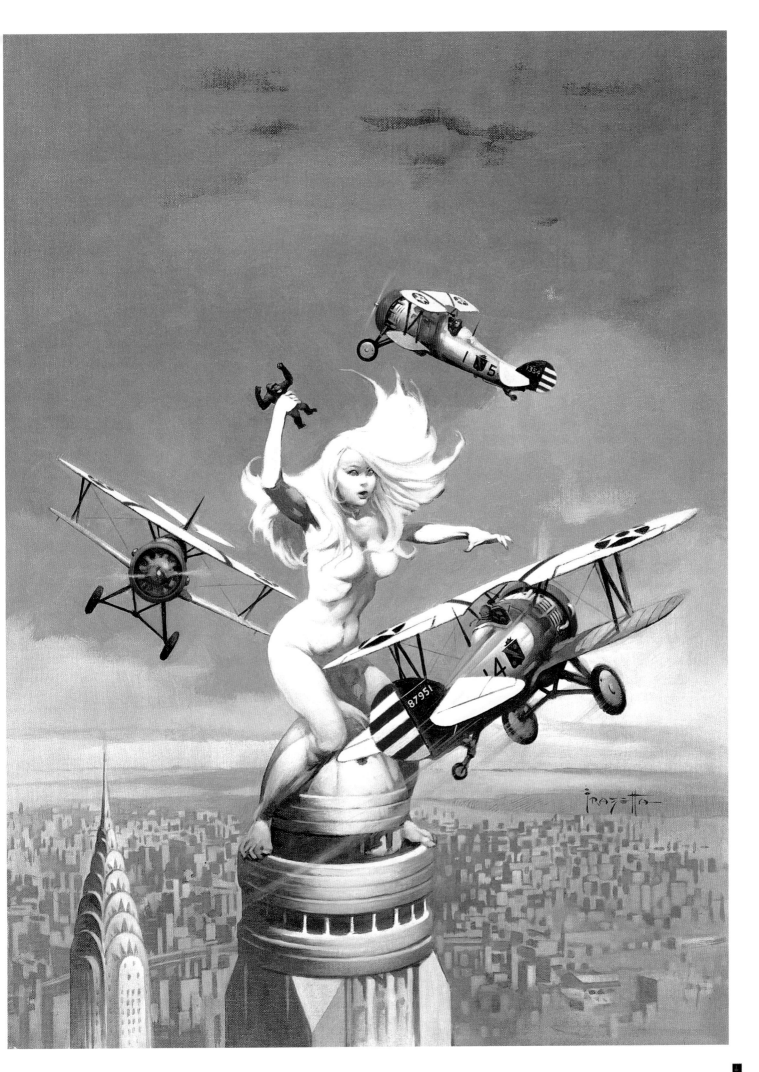

Vampirella 1996

Cover to Vampirella 25th Anniversary Special, *Harris Publications, Inc. [New York, 1996]. Oil on academy board, 18"x24".*
At left: One of several promotional drawings of Vampirella Frazetta created for Jim Warren, circa 1969. Brush and ink on paper.

Harris Publications, Inc. purchased the assets of Warren Publishing during bankruptcy liquidation and tried unsuccessfully to relaunch the magazine line, but there was no longer a market for full-sized black and white horror anthologies. However, there *was* a residual fondness among fans for Vampirella. Harris reworked the concept and produced a continuing series of new and reprint comics featuring the character. Juvenile, exploitative, and more than a little tawdry, their interpretation of Vampirella fit in with the trend of "bad girl" comics and was remarkably successful throughout the 1990s. Harris also profitably licensed the character for various figurines, trading cards, posters, and even a 1997 direct-to-video movie.

Frazetta was commissioned to paint the cover for their "25th Anniversary" special in 1996 (inexplicably two years past the character's true 25th birthday). His triumphant "return" to comics—with this painting and various covers for Verotik and Crusade Comics—after so many years surprised and pleased his fans who had held out hopes for a new story or book. "Come on, I'm not going to sit down and do a continuity strip at this point in my career. It's silly. In the time it would take to do a new story I could do *ten* paintings. Fans have been bugging me for years, 'Why don't you do your own comic book?' Easy for them to say! It's a lot of work! And in case anyone hasn't noticed, I'm not a kid anymore."

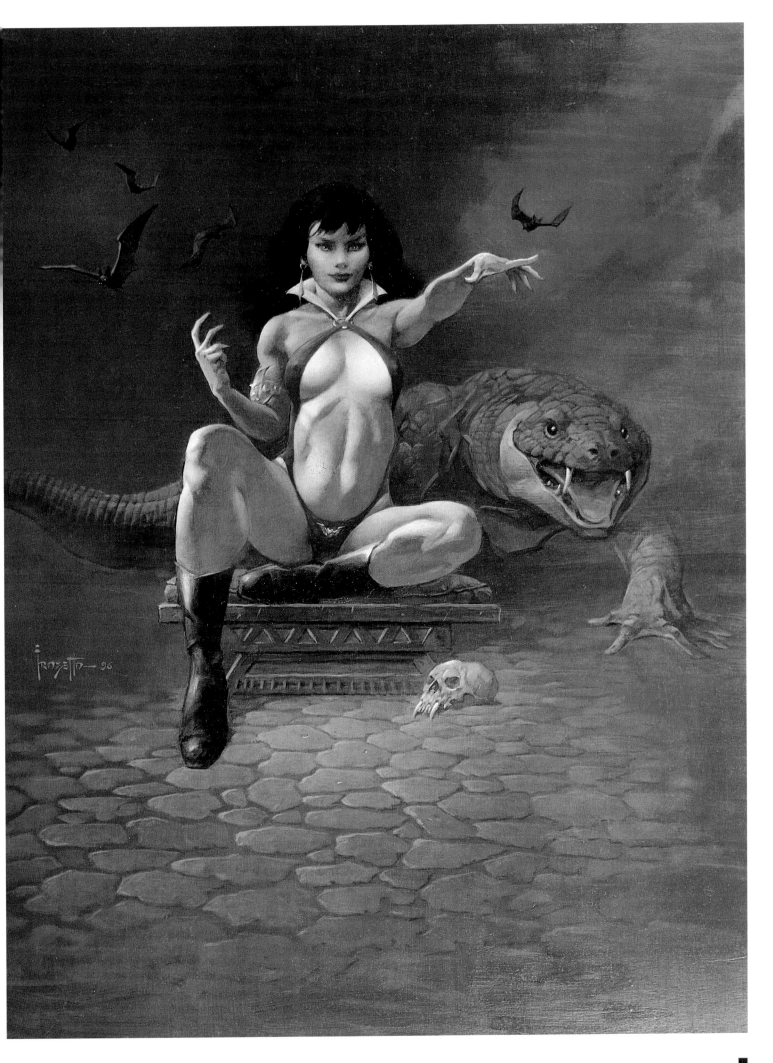

The Barbarian

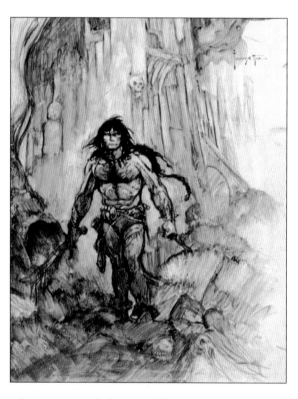

Cover to Conan the Adventurer *by Robert E. Howard, Lancer Books [New York, 1966]. Oil on canvas, 20"x30.* At left: *Frank Frazetta's first preliminary rough for* Conan the Adventurer.

Robert E. Howard's Conan had originally appeared in a series of stories that ran in the pulp magazine *Weird Tales* during the 1930s. Easily the most popular of REH's sundry list of brawny, brawling creations, Conan's adventures came to an abrupt end with the writer's suicide in 1936.

Attempts to revive the character's success in the '50s with a paperback reprint of Howard's only Conan novel from Ace Books and a series of hardcover collections from a small sf publisher, Gnome Press, had no success. When Lancer Books agreed to take another chance with the character in 1965 (this time with a series compiled by science fiction writer L. Sprague deCamp) Lancer's editor Larry Shaw decided to insure their bet by hiring Frank Frazetta to paint the covers.

Frazetta, along with his friend Roy Krenkel, had been providing the art for a series of Edgar Rice Burroughs paperback reprints for Ace Books. Sales had sky-rocketed and fans were thrilled, but Frank wasn't especially happy about the circumstances. "They paid me peanuts and kept the art. I wasn't about to paint little masterpieces for $200 and let them keep the art. And what compounded it was I found out they were selling my originals to interested fans for two or three times what they paid me in the first place! Their books made money because of my covers, then they turned around and made more money off of the actual art—and acted like they were doing *me* a big favor! Lancer called me out of the blue and said, 'We'll pay twice the amount of Ace, and yes, the art belongs to you.' I got pretty excited about Conan; I figured it was right up my alley. I could really pull out all the stops. I was fresh in the business so I didn't dare go too far. But there was something... Oh boy! The minute they mentioned it images popped right into my head."

Conan the Adventurer was the first book published in the series in 1966 (although based on the "history" established by the editors it was chronologically out of sequence) and it was an immediate success. Frazetta's portrait of Howard's character was menacingly unique, a composition that snarled its animal magnetism at an audience accustomed to sterile Steve Reeves-flavored interpretations of sword and sorcery characters. With a single painting Frazetta defined the look for an entire genre.

Lancer's future, for awhile at least, was assured by the bestseller-status achieved by the Conan books. And while the series' editors (de Camp and Lin Carter) were dismissive when discussing the correlation between the covers and the revived popularity of Howard's work—complaining that Conan needed a haircut or that he wasn't very handsome—Frank's importance was not lost on the publishers or their competitors. He was commissioned to paint other covers for REH's collections, including *Wolfshead* (also for Lancer) and *Bran Mak Morn* (Dell).

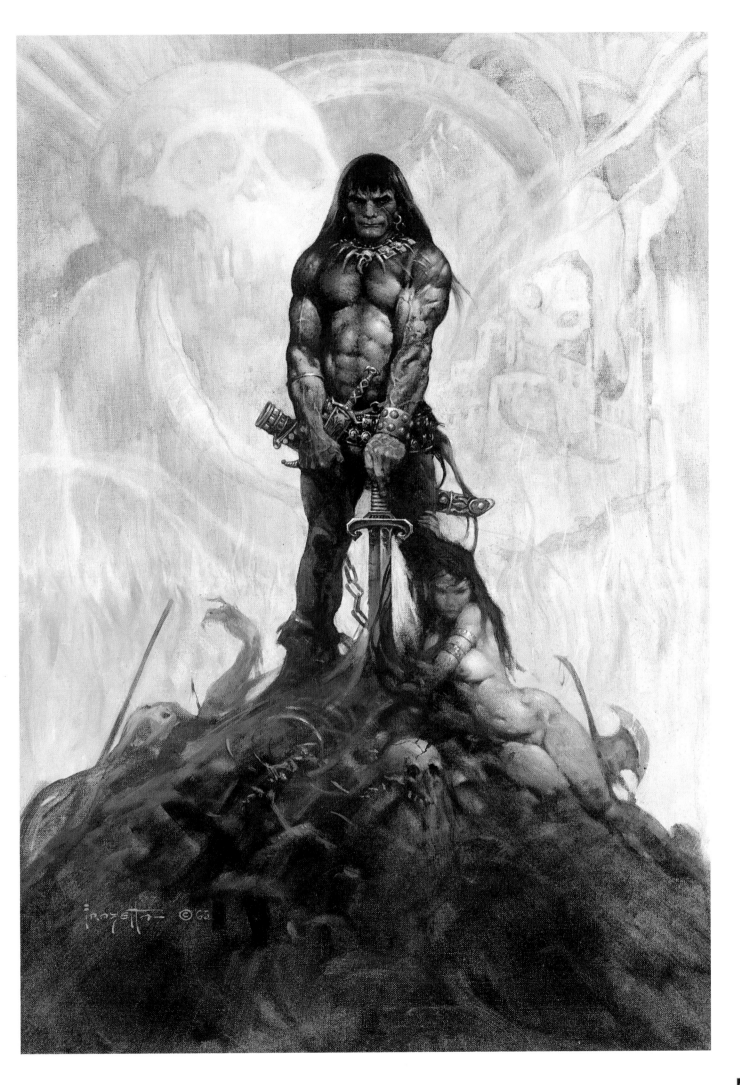

Man-Ape

Cover to Conan *by Robert E. Howard, Lancer Books [New York, 1967]. Oil on academy board, 14"x18".*
At left: A macho pose by Conan's creator, Robert E. Howard. Photograph courtesy of Glenn Lord.

Robert Ervin Howard [1906-1936] was not, by current standards, a great writer. Pounding out stories for the cheap pulp magazines during the Depression at a half-cent a word (when the publishers chose to pay him at all), he had few illusions that his work would make a lasting impression. Born and raised in a small Texas town, he was the son of a doctor and was known by the locals for his eccentricities. His fiction is rife with formulaic plots, shallow characters, and awkward dialogue; much of his work showcases REH's insecurities, paranoia, and emotional immaturity.

And yet, Howard's passion for his archetypical material and his natural story-telling skill makes his fiction compulsive reading over sixty years later. His best adventures are still unsurpassed for vivid, colorful, non-stop action. "Robert E. Howard was interesting and nobody else can imitate him," observed noted writer Harlan Ellison in a 1980 interview. "Because Howard was crazy as a bedbug. This was a huge bear of a man who had these great dream fantasies of barbarians and mighty-thewed warriors and Celts and Vikings...and he never traveled more than twenty or thirty miles from home." When his invalid mother slipped into a coma with little hope of recovery, Howard climbed into his car and shot himself to death. A sympathetic and touching film about the last years of his life, *The Whole Wide World* starring Vincent D'Onofrio, received positive critical attention in 1997.

Frazetta's cover for *Conan* (chronologically the first book in the series) accurately depicted the climactic battle from the story "Rogues in the House." The animated facial expressions, film noir lighting, and dynamic crimson sweep of the man-ape's cape are fine examples of the artist's dramatic flair and his enviable ability to manipulate an audience. By capturing a moment before the inevitable violence takes place Frank left the viewer dreading and anticipating the next movement. No small accomplishment.

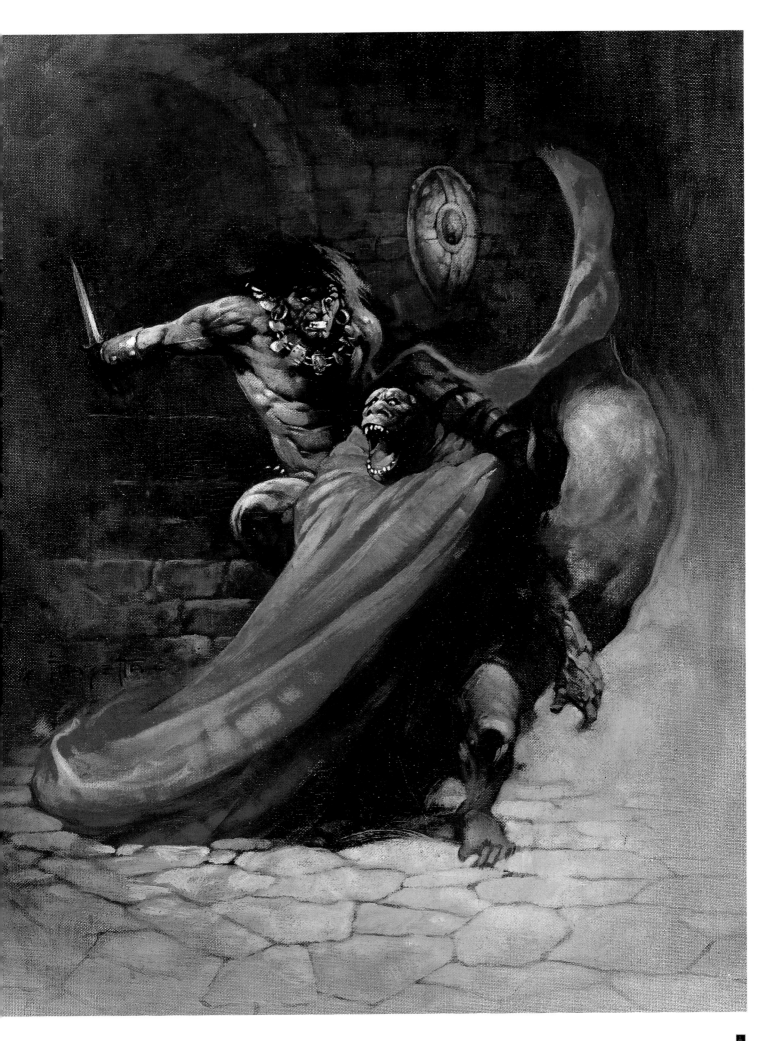

The Snow Giants

Cover to Conan of Cimmeria *by Robert E. Howard, Lancer Books [New York, 1969]. Oil on academy board, 16"x20". At left: Ink sketch of Conan from the late 1960s that was published in miscellaneous fanzines.*

Frazetta obviously took a tremendous amount of pride in his paintings for the Conan books and the appreciation he received from Lancer spurred him to new levels of excellence. There was a kinship with the material that he explained in an article, "The Frazetta Collector," in the fourth issue of the amateur EC magazine *Squa Tront* [1970]: "Although I have enjoyed illustrating the works of Edgar Rice Burroughs, I find them a bit slow and Victorian and the fans are too prone to condemn the artist if he hasn't been faithful to the text. I much prefer illustrating the tales of Robert E. Howard. They are much stronger in mood and narration than those of Burroughs and allow a wider range of illustrative interpretations. As St. John is remembered for ERB and Tarzan, I would like to be remembered for REH and Conan. I feel a certain sense of loss that Howard isn't alive to appreciate what I've done with Conan." Unwarranted sniping from jealous editors would eventually sour Frank's feelings about Howard's work, but there's little doubt of the enormous impact these images had on the readers, the publishers, and the artistic community alike.

Frazetta's cover for *Conan of Cimmeria*, with its vivid blues and stark whites, is a startling contrast to the dominant earth-tones of most of the other paintings in the series. Despite the violence of the situation the color gives it almost a pastoral quality that appealed to viewers otherwise unfamiliar with Howard's stories. It quickly became one of Frank's most popular works and was reprinted as a poster, as a calendar image, and as the album cover for the one-shot rock band, Dust, in the late 1970s.

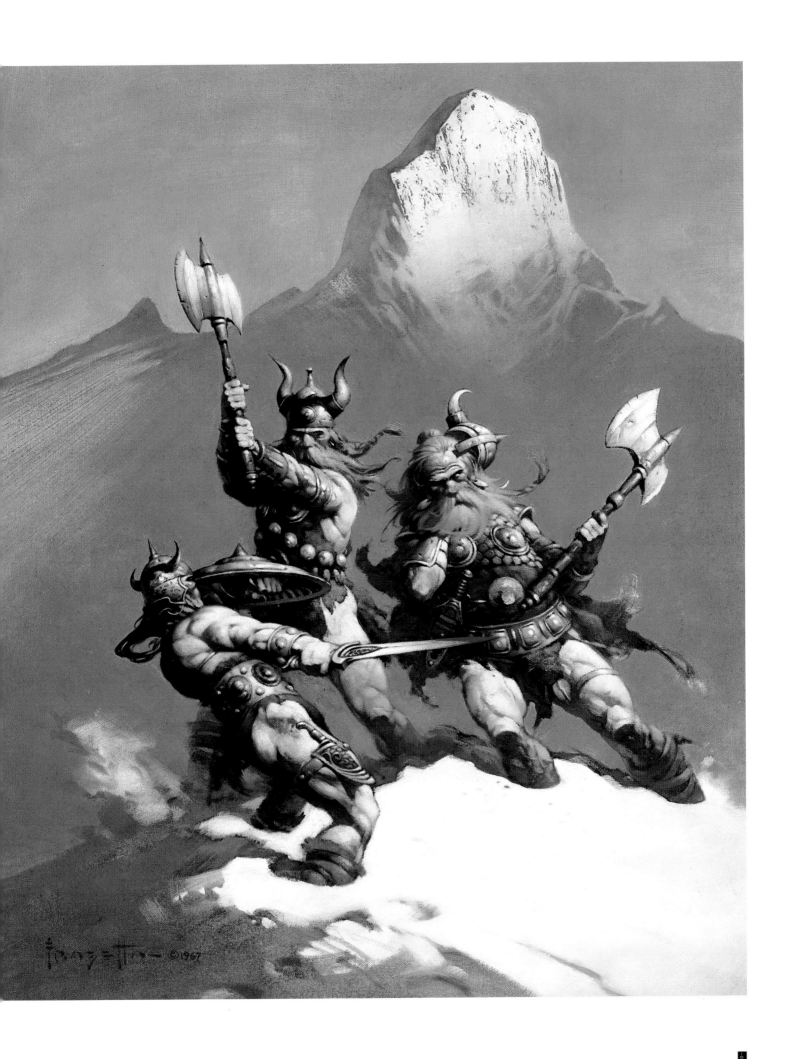

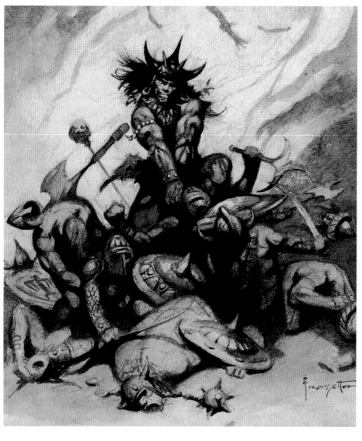

The Destroyer

Revised cover to Conan the Buccaneer *by L. Sprague de Camp & Lin Carter, Lancer Books [New York, 1971]. Oil on academy board, 18"x24". At left: The original gouache concept rough for the* Conan the Buccaneer *cover.*

Hoping that an infusion of new stories would keep the interest in REH growing, L. Sprague de Camp and Lin Carter wrote a number of Conan pastiches, some based on Howard's stories or outlines and others concocted out of their imaginations. *Conan the Buccaneer* was one of these "posthumous collaborations."

It is a *remarkably* bad novel, matched in mediocrity by de Camp's and Carter's *Conan of the Isles* and *Conan* (and son) *of Aquilonia.* Deadly slow and lifeless, unforgivably dull and lacking the bravado and enthusiasm of a true Robert Howard story, *Conan the Buccaneer* could have killed the burgeoning REH franchise in its tracks. Except...

Frazetta painted another masterful cover. Realizing that he had very little illustratable material to work with, Frank ignored the novel entirely and created a scene of carnage which summed up his feelings for the character. Dissatisfied with Conan's face and helmet in the version published on the paperback cover, he subsequently tinkered with the painting in his spare time over several months, polishing and improving it.

Still sensing that something wasn't quite right, he decided to repaint the entire figure.

Despite the dominant, dramatic pose, Frazetta felt that Conan was somehow separated from the surrounding action. His re-worked version is more intimate and more personal, a much more deadly depiction of combat. Horrifying in its viciousness yet fascinating in its intensity, this work clearly transcended its subject matter.

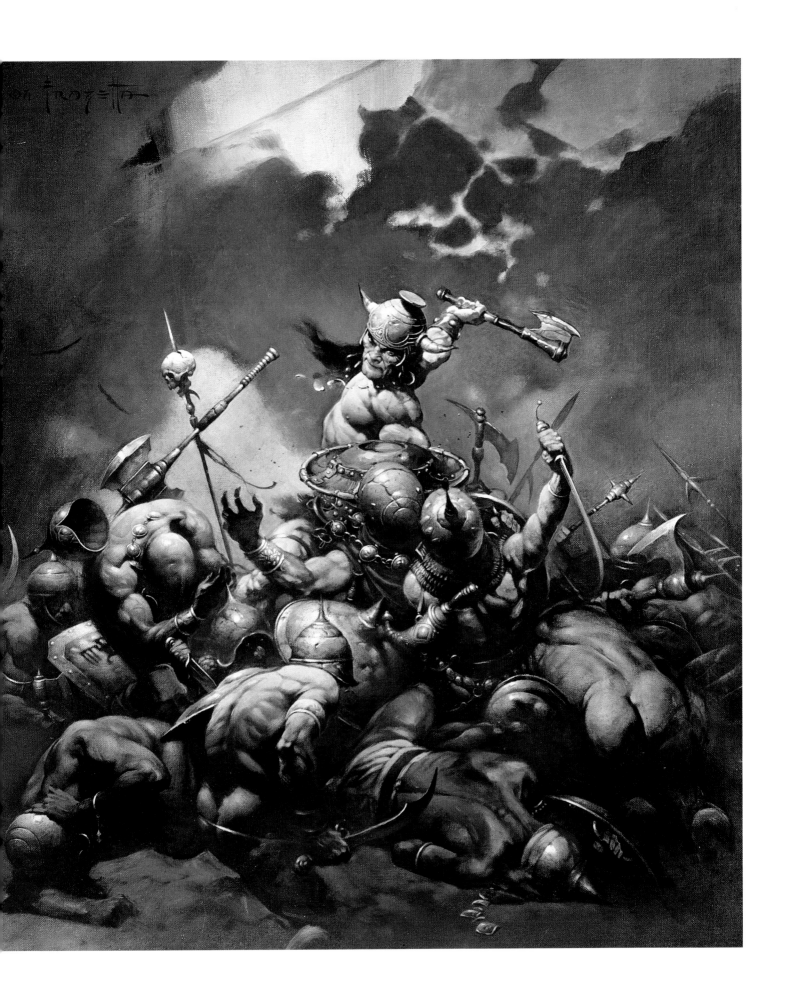

Indomitable

Cover to Conan the Warrior *by Robert E. Howard, Lancer Books [New York, 1967]. Oil on academy board, 16"x20". At left: A sketch that appeared with a Frazetta interview in the fanzine* Infinity #2 *[1970].*

Thanks in no small part to Frazetta's compelling covers, the world-wide success of the books (over 10 million copies of the Lancer editions were sold in the U.S. alone) made Conan into a hot property. Marvel Comics licensed the character in 1970, producing various magazines, comics, and spin-off products for over twenty years. (Despite attempts by Marvel's editors to get a cover from him for their more "mature" *Savage Sword of Conan* magazine, Frazetta refused to work for them, citing as reasons their work-for-hire contracts and their unwillingness to acknowledge an artist's intellectual property rights.) Inevitably, Hollywood took notice and the first Conan film starring Arnold Schwarzenegger was released by Universal Studios in 1982.

"Frank Frazetta is the high priest of Conan," said the movie's director, John Milius in an interview with *Cinefantastique* [vol 12, issues #2 & 3, 1982]. "We were aware of this all the time we were shooting the film. He certainly was an influence on me. Frazetta's Conan illustrations were more important to me than the books were." Early in the movie's lengthy pre-production period the producers had approached Frazetta to act as the visual consultant, but they failed to come to terms. However, he did license his cover painting for *Conan the Adventurer* to be used as the poster for the European release. A second film in 1985, a short-lived animated TV series for children in 1993, and a syndicated live-action Conan series in 1997 followed.

The unusual perspective, motion-burred shapes, and the "king of the mountain" pose of the central figure made Frazetta's cover to *Conan the Warrior* a subject for mild debate among readers. The line seemed to be split between those who believed this painting was the most powerful in the series and those who felt the artist had missed the mark. "Well, these covers tend to be many things to many people," Frank observes. "Most artists and art directors favor *Conan the Warrior*. The design makes it one of my personal favorites, but I know it's not as popular with the fans as my painting for the *Adventurer*. Interestingly, most book editors favor the cover for the *Conqueror* cover. Perhaps it's more commercial, I don't know."

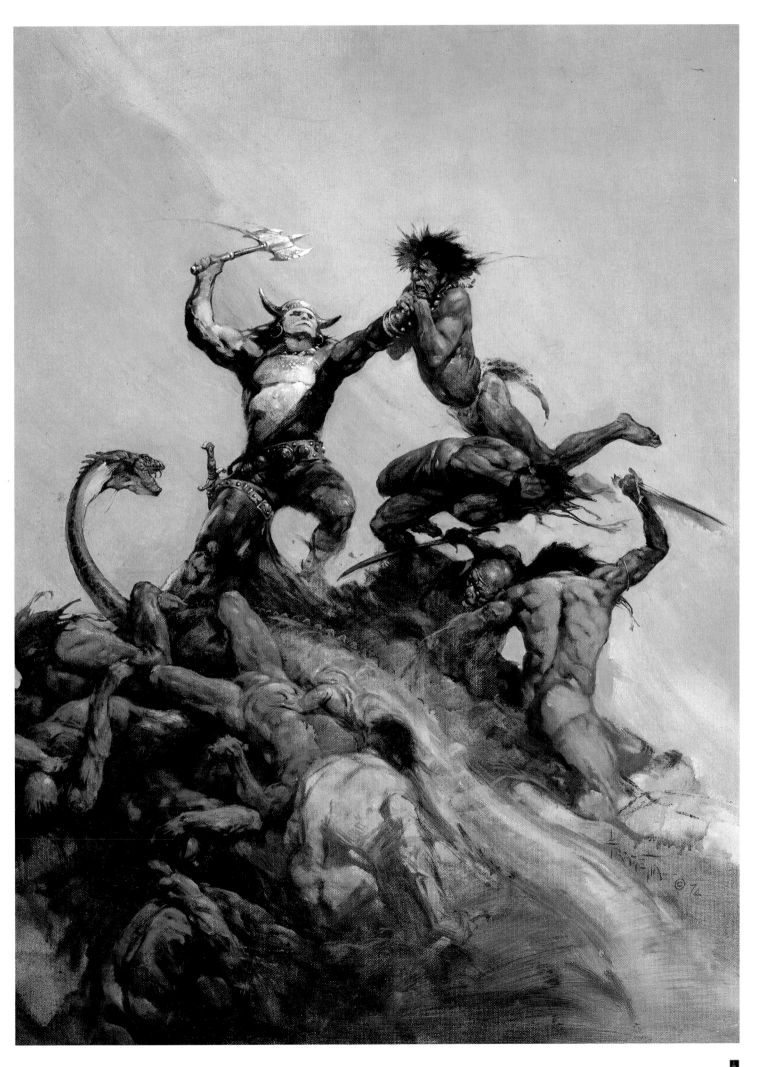

Chained

Cover to Conan the Usurper *by Robert E. Howard, Lancer Books [New York, 1967]. Oil on masonite, 18"x20". At left: The artist, circa 1967.*

Frazetta's painting for *Conan the Usurper* (illustrating a scene from Howard's story "The Scarlet Citadel") is an audacious example of the artist's self-confidence. In a rebellious break from all of the accepted "rules" of book cover art of the time Frazetta elected to turn Conan's back on the readers, effectively making them a witness to the same horror the barbarian is facing. This is a flawlessly designed, superbly executed, nightmarish interpretation of the REH tale.

And, at the same wonderful time, it is an intentionally hilarious work.

The primary audience for the Conan books—teenage boys and adult men still locked in teenage perceptions—reveled in the male power fantasies of the series: kill every bad guy that moves, burn everything that doesn't, ravish the unwilling heroine until she becomes your adoring slave. Beginning to weary of criticisms from de Camp and Carter, and a bit disappointed that he wasn't receiving much credit for the success of the books in the marketplace, Frazetta poked a little fun at the character, the editors, and the fans without compromising the needs of the publisher. His "is that a giant serpent in your loin cloth or are you just happy to see me?" painting is not only a fine example of Frazetta's sly sense of humor, but is, conversely, a ground-breaking classic of contemporary illustration, one that has been imitated by artists around the world over the past thirty years.

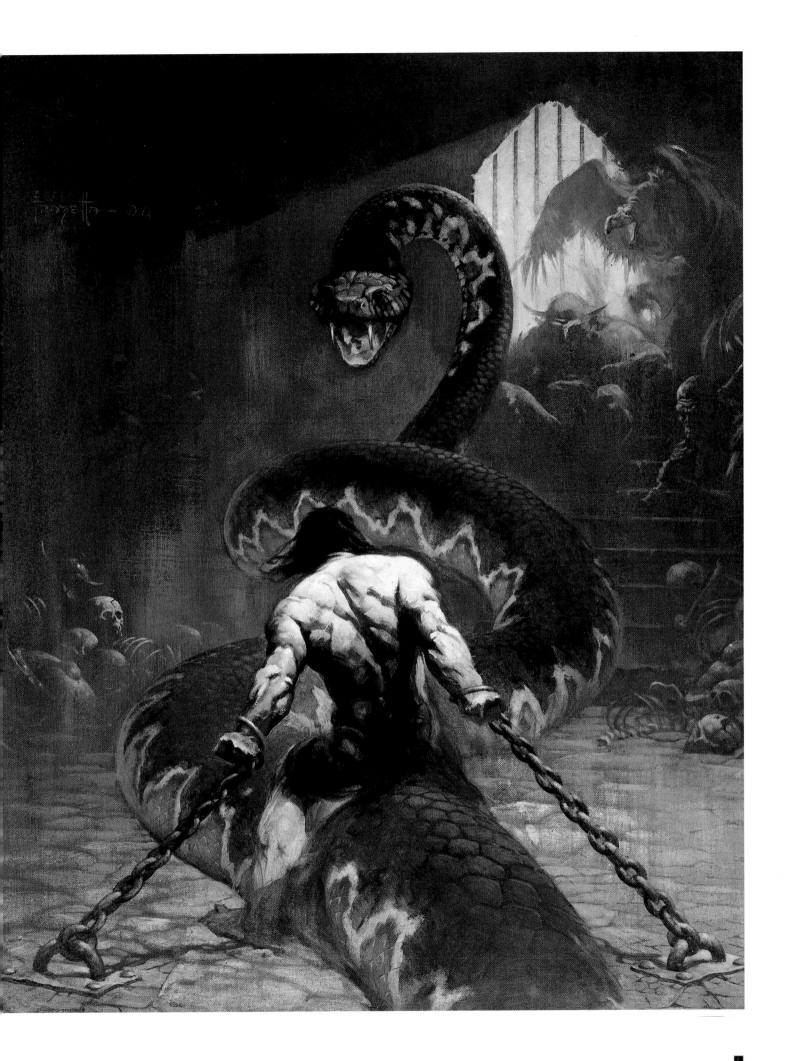

Berserker

Cover to Conan the Conqueror *by Robert E. Howard, Lancer Books [New York, 1967]. Oil on academy board, 18" x24". At left: Margaret Brundage's pastel Conan cover for the pulp,* Weird Tales *[August, 1934].*

Howard wrote his only full-length novel about Conan on speculation for a British book publisher, Pawling & Ness, Ltd., in the futile hope of expanding his markets overseas. Titled *The Hour of the Dragon*, it was eventually serialized in *Weird Tales* over five issues in 1935—36. Donald Wollheim at Ace Books unsuccessfully attempted to restore REH's popularity with a paperback of the novel under the new title of *Conan the Conqueror* in 1950, with a cover by Norman Saunders. (Saunders, a pulp-cover veteran, would gain a certain amount of notoriety and pop-culture fame for his *Mars Attacks* gum card paintings for Topps in the 1960s.) It seemed that none of the artists who had illustrated Conan, including Margaret Brundage, Ed Emshwiller, and Wally Wood were able to get a firm handle on the mythical "Hyborian Age" Howard had created, giving the character either a Roman Empire or Arabian Nights look.

Frazetta, on the other hand, created an all-new visual dictionary for fantasy art. Inspired partly by the eclectic costuming and gritty look of the 1958 Kirk Douglas film, *The Vikings*, he subconsciously blended cultures and designed plausible weapons, armor, decorations, and apparel that had never been seen before.

His cover for the Lancer edition of *Conan the Conqueror* is stunning in its scope: Frank wasn't intimidated by scale. Whereas other artists might tend to freeze-up at the idea of painting battling armies, Frazetta merely rolled up his sleeves and produced a breathtakingly forceful tableau. "Here I've painted a most apparently violent scene and it's not offensive, really. Somehow there's a rhythm to it and a fascinating beauty, in spite of what's going on. Of course if you were there, I'm sure it wouldn't be quite like that; it would be pretty brutal and terrible, but I kind of left that out. It works in the movies, but I don't think it works in art. It works in comics perhaps, but...I don't want people to be repelled by my paintings. If you look at *any* of my Conans, my God, he's beating heads all over the place. You feel the strength and the power, but you don't say, 'Yuck! Boy, look at all those heads flying through the air!'"

Sacrifice

Revised cover to Conan the Avenger *by Björn Nyberg, Lancer Books [New York, 1968]. Oil on board, 16"x22". At left: The original version of the painting as it was first published.*

Conan the Avenger was another odd addition to the already confusing Conan saga. Originally written in the 1950s by Björn Nyberg, a Swedish Air Force officer, it is surprisingly a much more effective pastiche than any of those produced by the books' American editors.

Throughout his stint as the primary cover artist for the series Frazetta utilized his friend Roy Krenkel as a technical advisor. The pair would kick ideas back and forth, scribbling thumbnails, exchanging opinions on how the character should be presented. Krenkel, an idiosyncratic artist who found more value in the work of others than in his own, was a fan of Howard's stories and was very generous with his advice to Frazetta (who insisted on acknowledging Krenkel's contribution in the front of each book).

Between 1968 and 1980 Frazetta totally reworked his painting for *Conan the Avenger*. "I thought it was pretty good at first, but when I got it back I realized, 'Well...' Conan looked a little distorted here and there, his proportions were a bit off. If you compare the original version with the revised one, you'll see he's far better. Everything's improved."

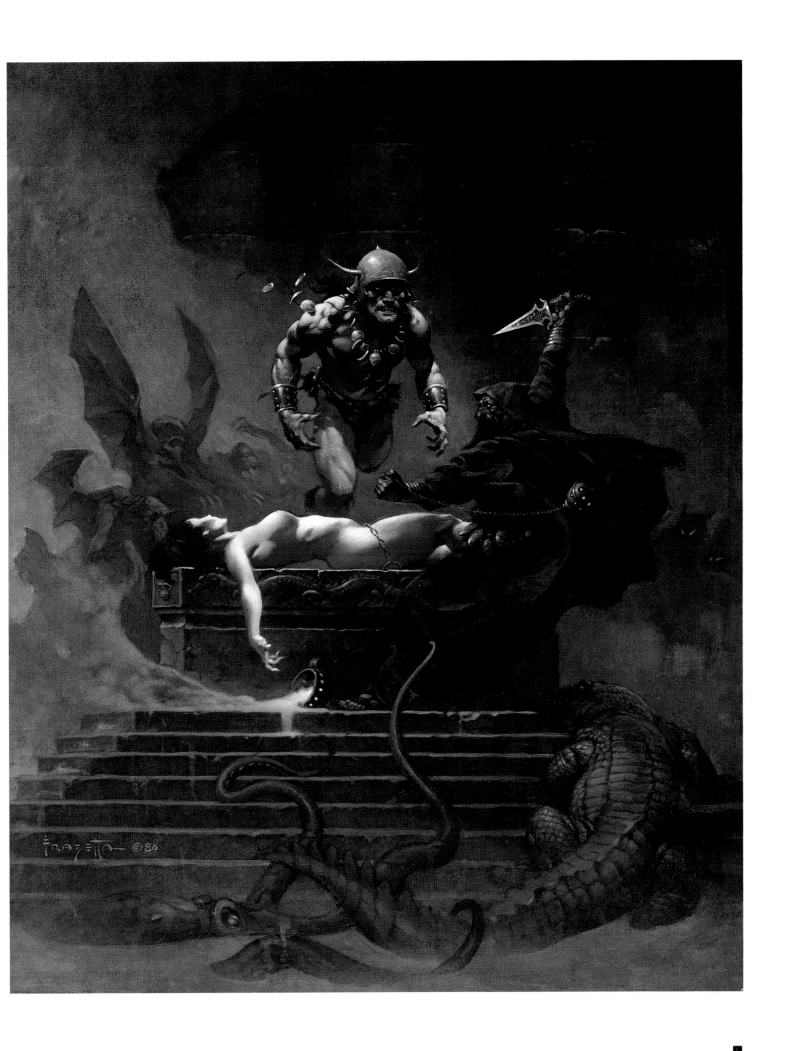

Warrior

Conceptual painting of Conan, circa 1965. Oil on academy board, 12"x 16". At left: Frazetta's final cover for the series, Conan of Aquilonia, *completed but unpublished at the time of Lancer's bankruptcy. 1973. Oil on masonite, 16"x20".*

The oil painting on the facing page is essentially a character sketch that helped formulate Frazetta's version of Conan. Quickly tossed off and not meant to be anything more than a private reference piece, it nevertheless captures the personality of REH's fictional creation.

The painting above is Frank's infamous cover for the pastiche novel *Conan of Aquilonia*, ostensibly the next-to-the-last book in the series (although numerous other titles would follow from other publishers and writers in the years to come) and a bitter closure to Frazetta's relationship with Lancer in 1973. Shortly after he delivered the completed art the publisher closed its New York offices and filed for bankruptcy: Frank's original was stolen during the ensuing confusion.

"I received an anonymous call," Ellie Frazetta relates, "and this guy was trying to arrange to trade Conan back to us in return for several of Frank's other works! I was so angry I didn't think about playing him along and getting enough information so the police could track him down. I just told him, 'Burn it, because you're never going to be able to make a cent off of it!'" The art has never surfaced in legitimate circles, but it is registered with the FBI as a stolen work of fine art and there is a reward for its return.

To add a final insult to injury, the painting was published (from an advance Lancer proof) as the cover to a bootlegged magazine, *The Frazetta Treasury*, in 1975.

Frank provided the covers for nine of the twelve Lancer Conan books, including the unreleased *Conan of Aquilonia*, and they are unquestionably some of his most widely-known and respected works. For unexplained reasons Lancer Books commissioned John Duillo to produce covers for *Conan the Freebooter*, *Conan the Wanderer*, and *Conan of the Isles* in 1968: the sales of these titles never matched those featuring Frank's art. Thanks in no small part to Frazetta's unprecedented vision and unbridled energy, Conan became a money machine in the 1970s that made the editors and various publishers fairly wealthy.

They showed Frazetta their gratitude by refusing him permission to sell prints of his cover paintings under the Conan name.

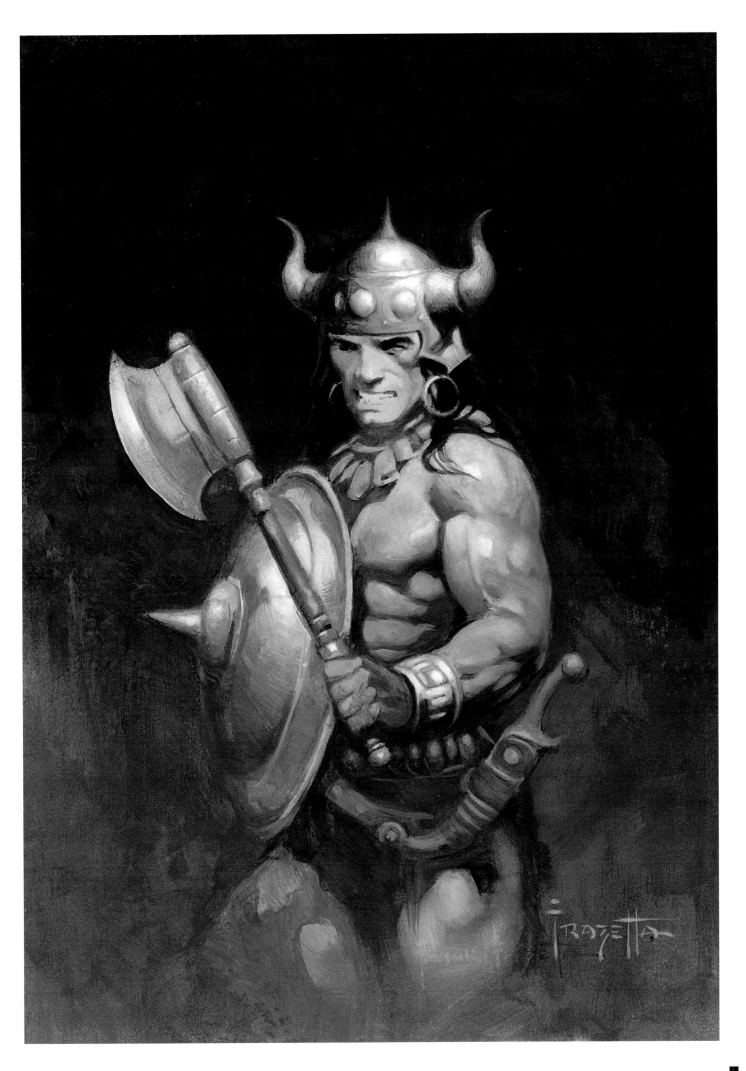

Bran Mak Morn

Cover to Bran Mak Morn *by Robert E. Howard, Dell Books [New York, 1969]. Oil on academy board, 12"x18". At left: Sketchbook drawing, circa 1970.*

The unexpected popularity of Conan left other publishers scrambling for anything else by Howard that could be rushed into print to cash in on the phenomenal success of the series. Dell's collection of stories about Bran Mak Morn, a Roman-era king of the Picts, featured Frazetta's monochromatic, melancholy painting which perfectly captured the tone of REH's tales and their setting of ancient Britain.

"*Bran Mak Morn* is a cover overlooked by most people. I just didn't see it as being a very decorative, colorful piece. It *had* to be dark and grim. The feeling one gets from the painting is so terrible that even the technique must suffer. You look at it and you hurt. You are *hurt* by it. You're frightened by it: 'Ye Gods, it's coming out of there!' I mean, if you were standing there you wouldn't see color but just this heavy mass of horror coming toward you. You're not aware of color or design or anything. It's just this solid mass rolling toward you. That's why the total lack of color and technique seemed appropriate to me. This is the way I feel about art: art is not painting and it's not drawing—it's *total effect*, it's hitting people right between the eyes."

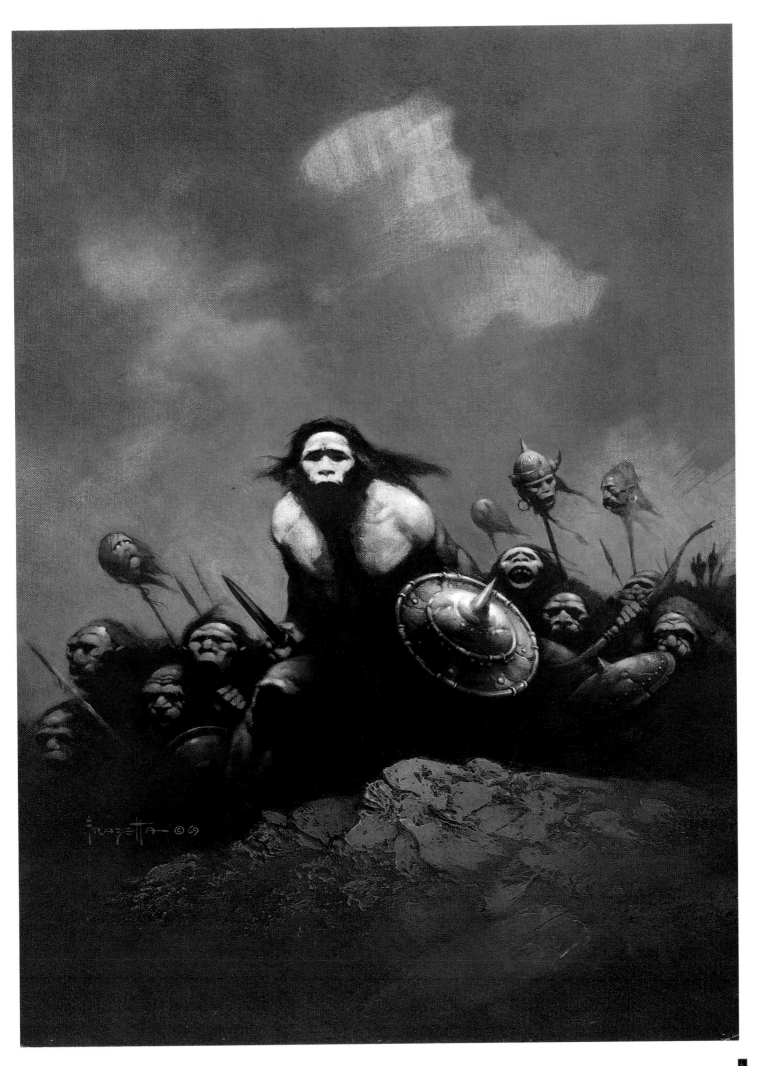

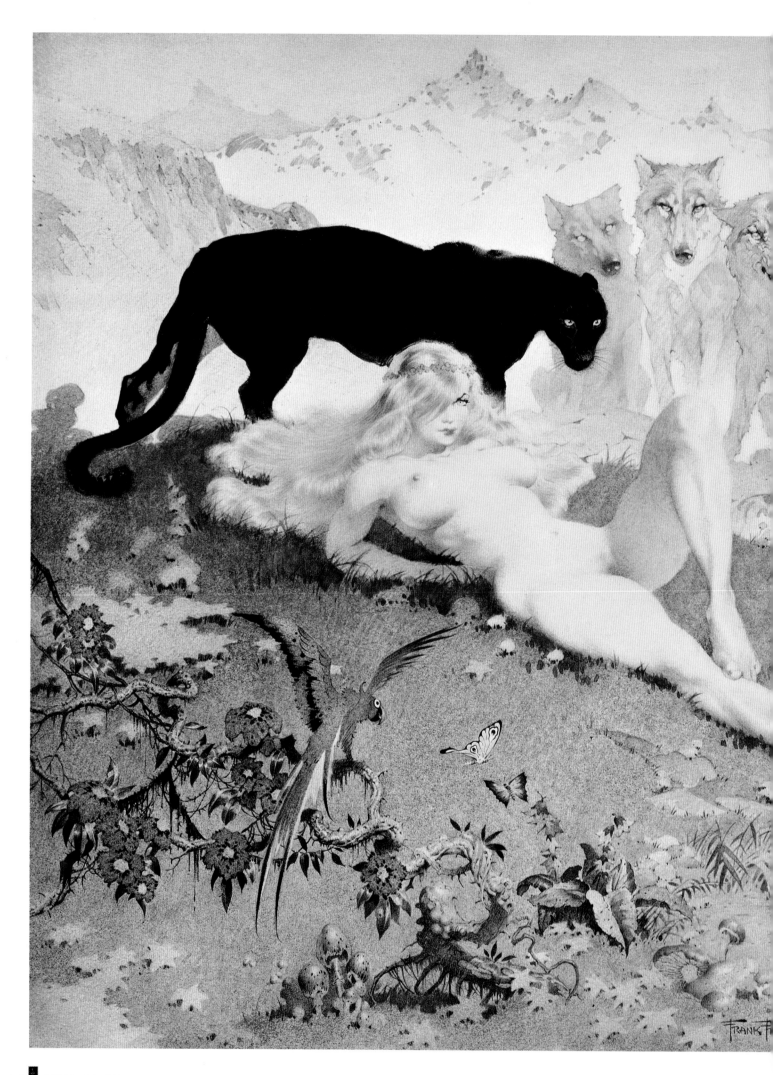

Golden Girl

Personal work, circa 1952. Pencil and watercolor on paper, 15"x11". Above: *Personal drawing, circa 1950. Brush and ink on paper, 8"x10".*

One of the jewels of his early painting career, "Golden Girl" perhaps exemplifies an attitude Frazetta admires in women. Unashamed of her body, confident of her situation, defiant with her arched-brow expression, Frank's character is aggressively in control of her sensuous world. Unquestionably a reflection of the artist's sexual fantasies, "Golden Girl" is nevertheless more than a painted centerfold. While he has depicted numerous females in distress or as secondary decorations, he has drawn an equal number as the center of command, as warriors and saviors with the male in a servile role. Occasional accusations of sexual exploitation (usually misguided and largely based on his use of nude figures) ring false when the whole of Frazetta's art is examined. In his fantasy works *everyone* can be the victim of some horror, just as everyone, men and women, can be heroes or objects of desire. *Print #59*

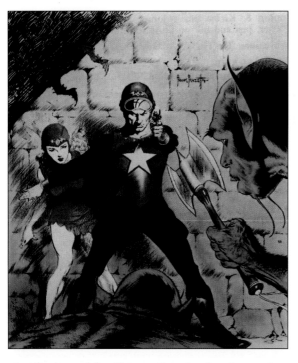

Battle

The unretouched, newly colored cover to Weird Science-Fantasy, *EC [issue #29, New York, 1954]. Ink and gouache on board, 12"x18". At left:* Another of Frazetta's "Buck Rogers" covers *[Famous Funnies #211, May 1954] that was recolored by Frank in 1973.*

Although Frazetta worked for a wide variety of comic publishers his contribution to the legendary EC line was relatively small. The majority of his work consisted of a number of collaborations with Al Williamson (some credited, others not), but he produced only one complete story ["Squeeze Play" in *Shock SuspenStories* #13] and this cover for *Weird Science-Fantasy* #29 by himself—and even it wasn't originally intended for EC.

While Frazetta was working as Al Capp's ghost artist on *Li'l Abner* he also freelanced for *Famous Funnies*, drawing an impressive series of "Buck Rogers" covers. Completed in one night while staying at Capp's Boston studio, this illustration was intended for issue #217. But the McCarthy-era crusade against violence in comics was already causing repercussions and *Famous Funnies* editor Stephen Douglas rejected Frank's cover as being too intense for their juvenile audience.

EC's publisher, William Gaines, wanted to publish the art, but Frazetta would only sell reproduction rights and not the original. "That's the only piece of art I used in my life that I didn't buy outright," Gaines told Rich Hauser in an interview in the fanzine *Spa Fon* #5 [1969]. "As I recall I was paying sixty bucks for a cover in those days. I think I offered him forty bucks for the rights or sixty bucks for the cover outright, and Frank, well, he was never one for the buck. He'd rather have the art. He kept it and I think I paid him $40 or $50. Beautiful work." Interestingly, *Famous Funnies* is acknowledged as being the world's second modern comic book title and was created in 1933 by Max Charles Gaines, the founder of E[ntertaining]C[omics] and father of William, who assumed the role of publisher after Max's death in 1947 in a boating accident.

Gaine's requested two minor changes, the deletion of Buck's helmet and the addition of hair on the foreground figure, which were done by Frazetta on small paste-overs. Although Frank provided color overlays, Marie Severin was the actual colorist for the published cover. In 1972 Adel, Iowa publisher Russ Cochran sold a limited edition of prints hand-colored and personalized with an ink sketch by Frazetta for the then-hefty price of $50. Currently valued in the marketplace in the $2000 range, the version shown opposite is taken from one of those prints. Frank's decision to retain the original art to this cover turned out to be a wise one: he has received and rejected offers in excess of $200,000 for this illustration.

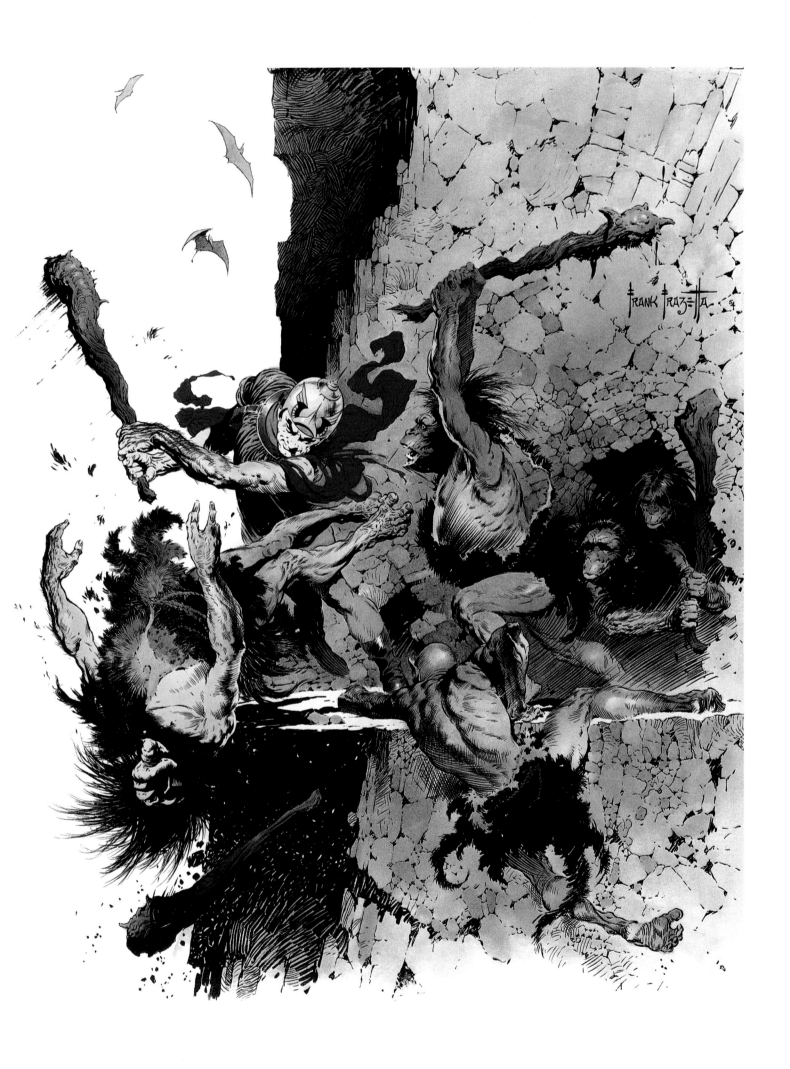

Lord of the Jungle

Interior illustration for Tarzan and the Castaways, *Canaveral Press [New York, circa 1964]. Brush and ink on paper, approximately 10"x12.* At left: *The cover to the Canaveral Press edition of* Tarzan and the Castaways.

Canaveral Press was a small publishing company started in 1962 by Jack Biblo and Jack Tannen. Wrongly believing that the works of Edgar Rice Burroughs were in the public domain, they began producing a series of hardcover reprints edited by Richard Lupoff. A complaint against Canaveral and Ace Books (who was also producing unauthorized editions) lodged by ERB, Inc. was quickly resolved and both publishers became legitimate licensors of Burroughs' material.

The Canaveral Press editions were illustrated by an eclectic selection or artists including Mahlon Blaine, Reed Crandall, Roy Krenkel, and Frazetta. Never especially successful, they ceased publishing in 1965, still owing their illustrators sizeable sums for completed work. Someone, however, had possession of the books' negatives and reprints continued to find their way onto the specialty book market as late as 1975.

Frank's illustrations for Canaveral Press are considered by many to be among his finest works, fully matching the vitality of his oil paintings. Dr. David Winiewicz, a long-time Frazetta friend and owner of the original to "Lord of the Jungle," is especially enthusiastic about the artist's black and white Burroughs art from this period and has been able to obtain quite a few for his private collection. This particular drawing struck a chord with a number of ERB readers and Frazetta himself was so taken with the strong central composition that he would use it as the basis of his original cover for *Conan the Buccaneer* seven years later.

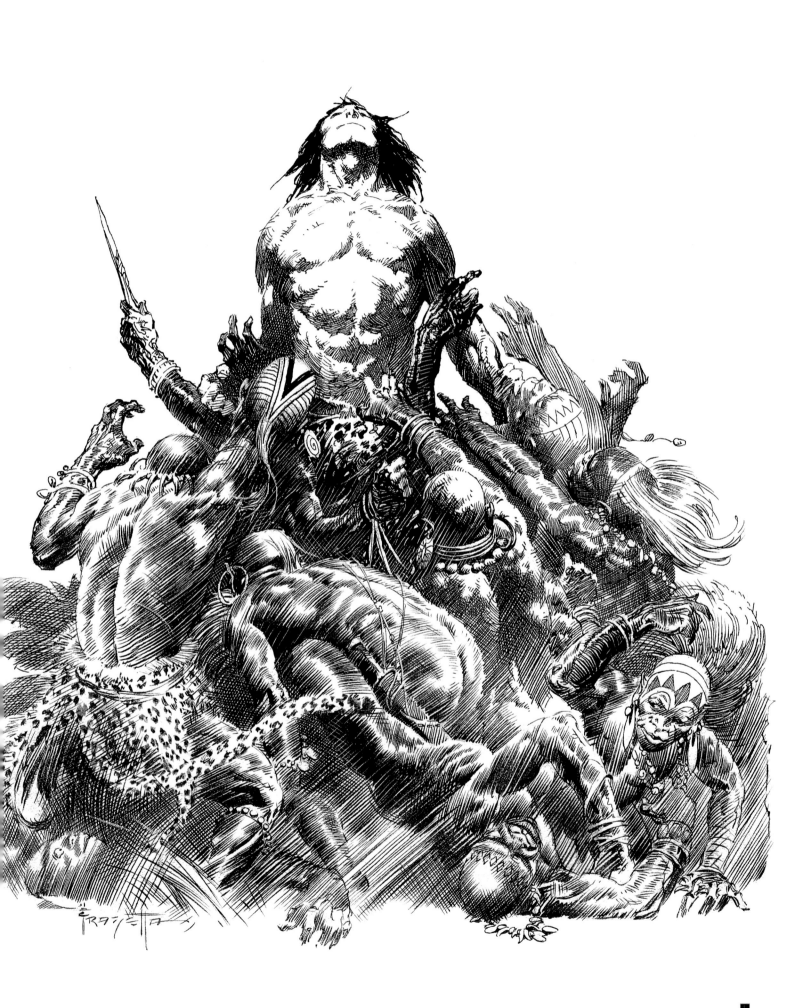

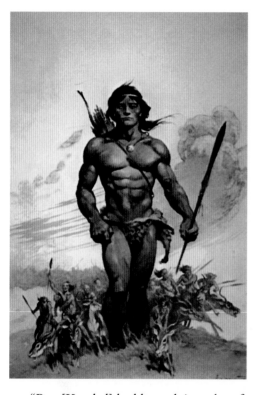

The Son of Tarzan

Cover to The Son of Tarzan *by Edgar Rice Burroughs, Ace Books [New York, 1962]. Watercolor on board, 18"x24". At left:* Frazetta's "try-out" painting for Tarzan and the Ant Men *that helped him secure the Ace ERB commission in 1962. Revised by the artist around 1972. Watercolor on board.*

"Roy [Krenkel] had been doing a lot of pen and ink work, but he had never really done any painting. Ace was giving him a lot of covers to do and he didn't have confidence that he could handle it all, so he wanted to split them with me. He brought me into Don Wollheim and said, 'He's the guy that can do it.' And they were *more* than reluctant to give me a shot. I showed them originals of some of my early paintings, including 'Golden Girl' and my big lion-hunt painting I had hanging in my living room. They said, 'Interesting...but can you do Tarzan?' So I went home and painted *Tarzan and the Ant Men* as a sample. When I showed them that they said, 'Well, okay...maybe.' They finally gave me a cover to do; it was the first paperback cover I ever did and it wasn't very good [see page 12]. I was running scared, not sure of myself anymore, and they didn't help give me any confidence. Plus, they were telling me to do it ala J. Allen St. John. After awhile, because of their attitude, I stopped putting my heart into the jobs and just used them as an opportunity to build my confidence as a painter. It was a time of relearning all of the things I had forgotten while I was working on *L'il Abner* for Al Capp.

"Wollheim didn't seem to like me and he didn't take me seriously. His reaction to a painting was more like a snicker than an approval. That hurt! I'm a proud guy and in the beginning I was trying to give him good work, but he'd just look down his nose at me. Ace paid very little, they kept my originals, and Wollheim acted like he'd rather die than encourage me. It made me bitter, and eventually I just refused to go out on a limb for them. Ten years later the situation was totally different: Ace couldn't have been nicer to me."

While he may have reacted coolly to Frank's art, Wollheim recognized the illustrator's growing popularity and, ironically, commissioned him to paint the cover to his own anthology, *Swordsmen in the Sky*, in 1964.

Regardless of his early relationship with Frazetta, Donald A. Wollheim [1914-1990] became one of the science fiction field's most successful editors, despite controversies in the early 1960s surrounding Ace's unauthorized publication of works by J.R.R. Tolkien and Burroughs. He went on to establish Daw Books, a respected and prolific publisher of sf and fantasy.

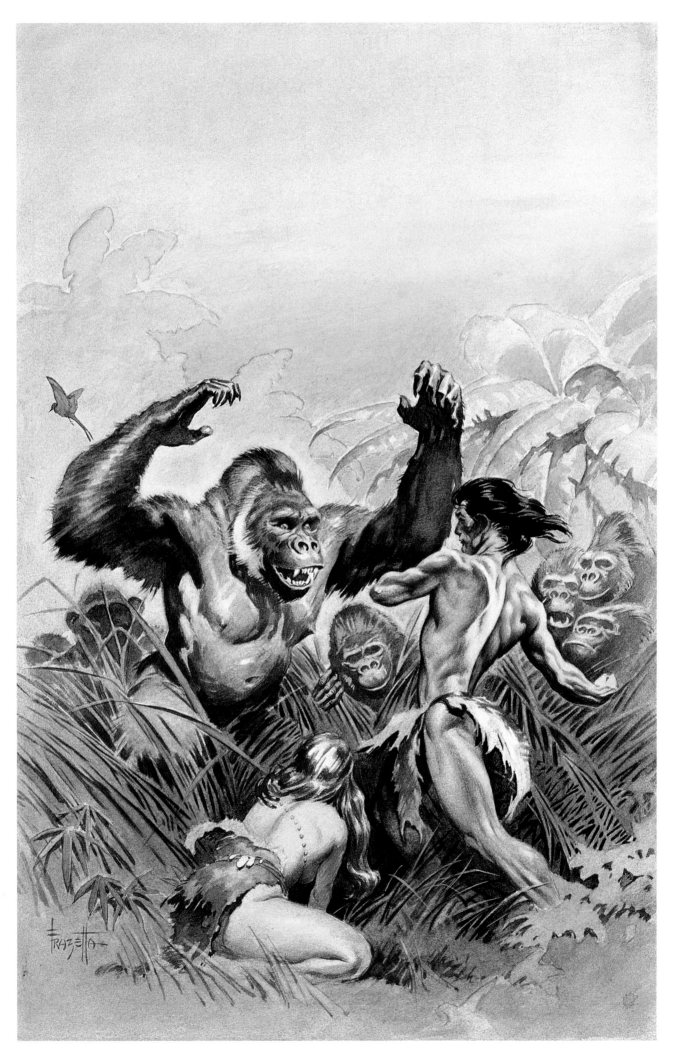

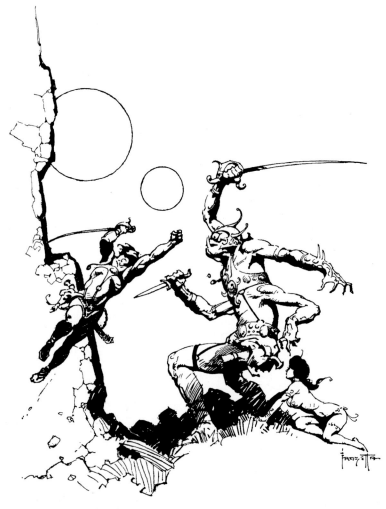

A Princess of Mars

Cover to A Princess of Mars *by Edgar Rice Burroughs, Science Fiction Book Club [New York, 1970]. Oil on academy board, 16"x20". At left: Interior illustration for* A Princess of Mars. *Ink on paper, 9"x11".*

In 1970 Doubleday's Science Fiction Book Club embarked on an aggressive program of reprinting Edgar Rice Burroughs' interplanetary adventures. Naturally, Frazetta's phenomenally popular covers for Ace and Lancer made him the only logical choice to illustrate the series.

His painting for *A Princess of Mars*, the first in the series, was so perfectly "Frazetta" with its central upright figure, exotically beautiful, barely-clad woman, and defeated enemy, that it became almost an immediate cliche. For those generally unfamiliar with either it is an abrupt summation of ERB's fantasy fiction and Frazetta's art.

This isn't a subtle piece.

By accident or design Frazetta essentially strips layers off the readers' romantic perceptions. If there were a generic Cliff Notes for the pulp fantasy genre this would probably be the cover. The up-raised sword and framing planets were concepts immediately swiped by other illustrators for a variety of imitative works.

[overleaf] Thuvia, Maid of Mars

Cover to Thuvia, Maid of Mars & The Chessmen of Mars *by Edgar Rice Burroughs, Science Fiction Book Club [New York, 1972]. Oil on board, 36"x20".*

The painting for this compilation volume was one of Frank's rare wrap-around jackets. Perhaps the most intriguing aspect of this cover is that its strong composition and immaculate craftsmanship compensates for the piece's seemingly incongruous posing. The approaching Martian lion (or "banth") on the left doesn't seem to particularly worry the ice princess on the right. But, taking into account that only the right half of the painting would be initially seen by the viewer, Frazetta engaged in a little audience manipulation. Thuvia's apparent coolness set the reader up for a surprise when they turned the actual book over and discovered the fanged monster about to do battle with the hero, John Carter.

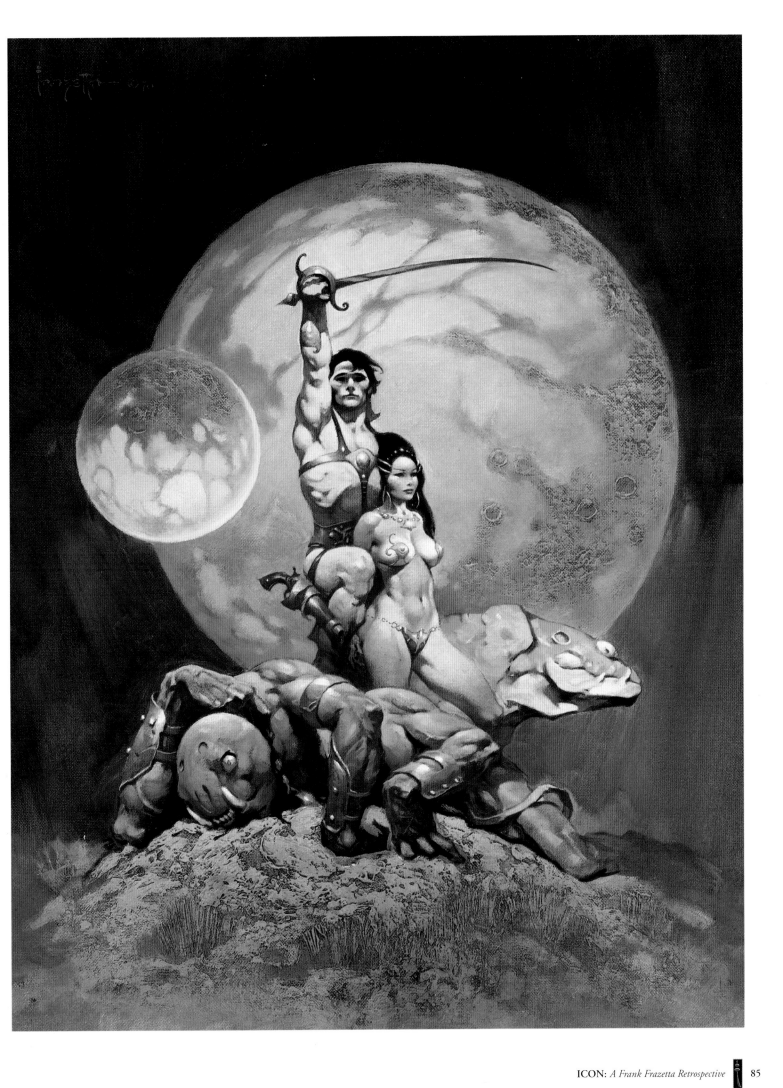

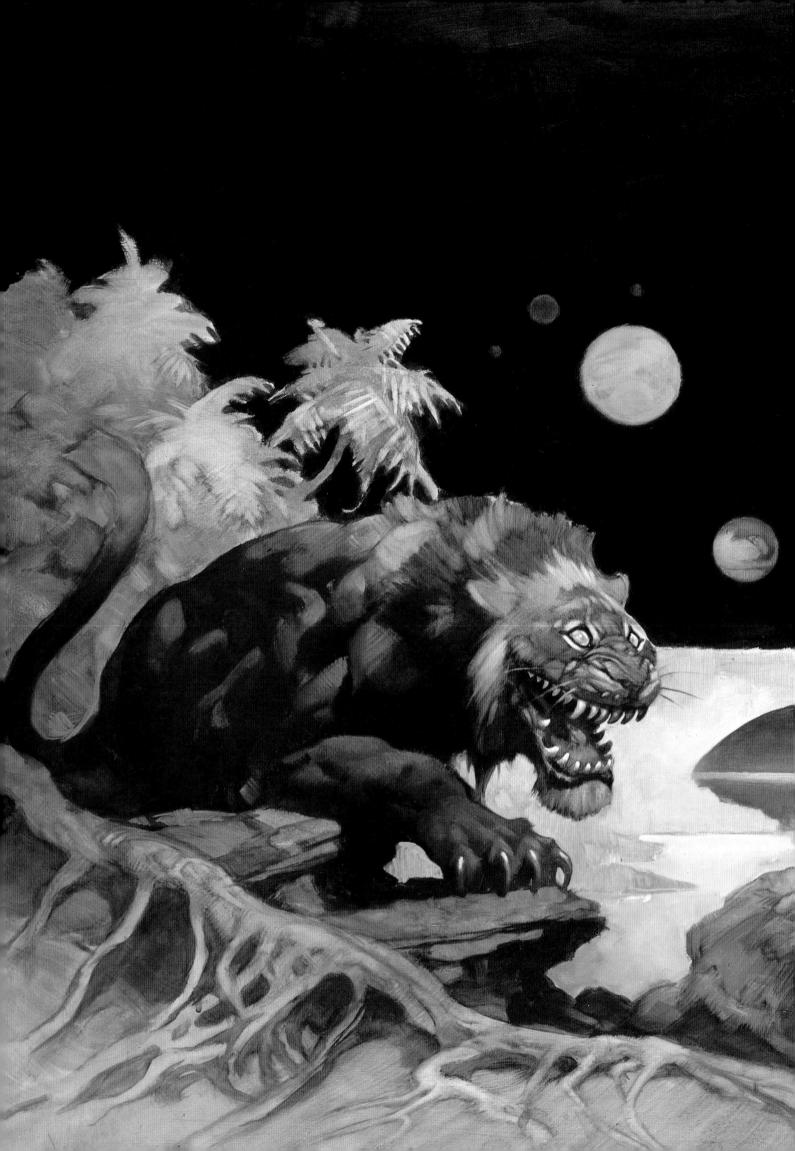

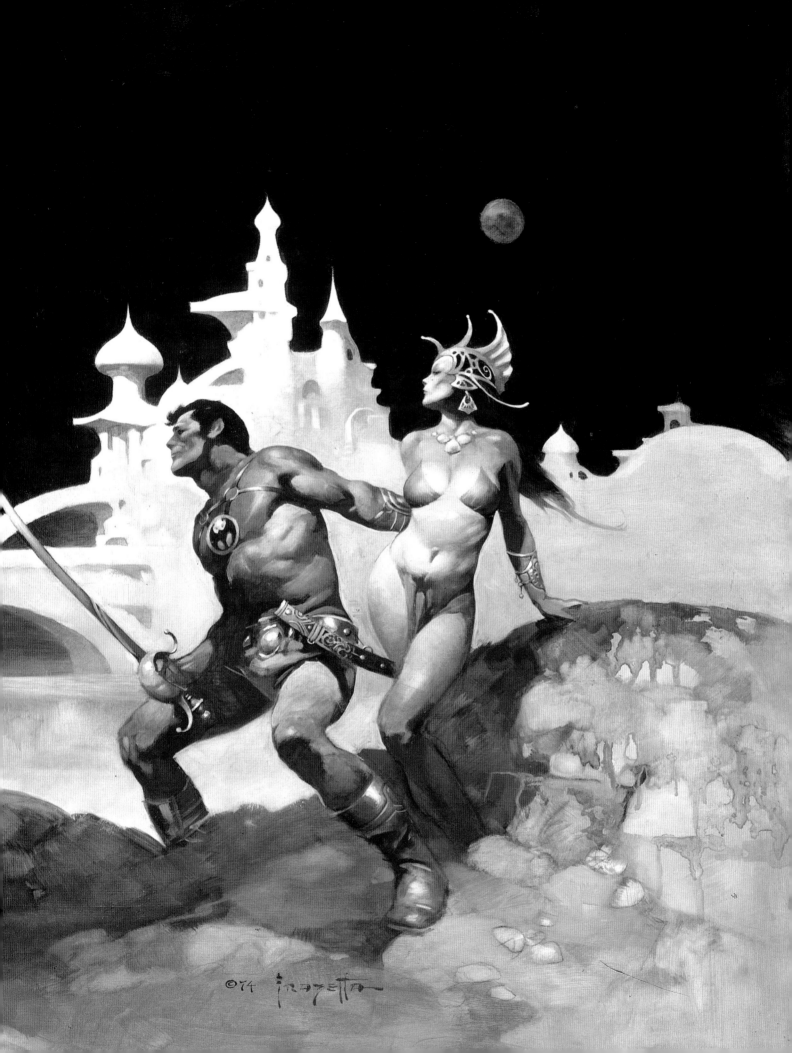

Carson of Venus

Cover to Carson of Venus *by Edgar Rice Burroughs, Ace Books [New York, 1973]. Oil on academy board, 16"x20". At left:* Frazetta's first watercolor cover for Carson of Venus *[Ace Books], circa 1963.*

The working conditions had changed markedly for Frazetta between his first line of Burroughs covers for Ace in the 1960s and the second series nearly ten years later. Acknowledging his popularity and his uncanny ability to sell books, Frank received a lucrative contract and a "hands-off" policy from Ace's art director—and, more importantly, he retained ownership of his originals.

The second Burroughs series demonstrates Frazetta's artistic maturity and focus. Certainly much more painterly in technique than many of his other covers, he often relied on splashes of color rather than minute detail to capture the reader's attention. These are moody, often frightening works and harshly contrast with Frazetta's more innocent "sense of wonder" watercolors for the Burroughs covers of the previous decade.

However, after their first series of Burroughs reprints in the '60s, Ace had lost the rights to publish the Tarzan stories to their competitor, Ballantine Books. Neal Adams and Boris Vallejo were the artists tapped to provide covers to the Ballantine editions in the 1970s and early '80s. "I would have liked to have done some more Tarzan paintings," Frazetta says. "Jeez, when I was a kid my friends and I all thought *we* were Tarzan. We were always competing for Tarzan-of-the-month, climbing billboards and racing along the top of them, leaping from high places—all that stuff. And I guess I imagined that I did it better. So I had this love for the character and I don't feel I ever really succeeded, never did Tarzan with the quality that I gave to Conan."

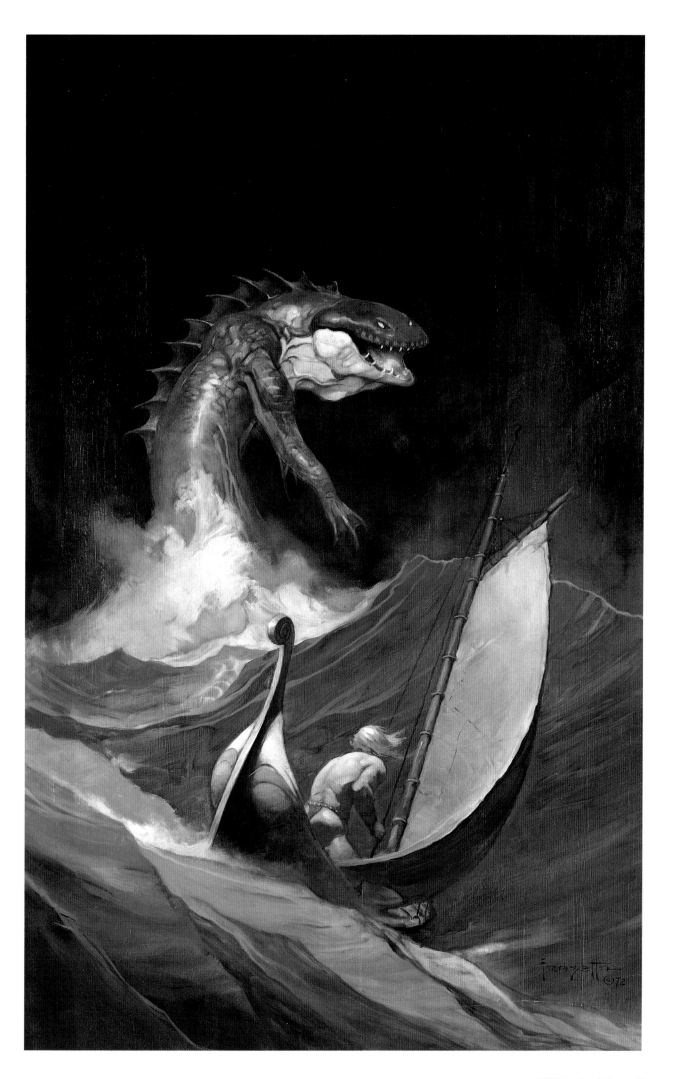

The Mammoth

Cover to Back to the Stone Age *by Edgar Rice Burroughs, Ace Books [New York, 1972]. Oil on board, 16"x24". At left:* Ink sketch, circa 1965.

Frazetta's forceful painting for Burroughs' *Back to the Stone Age* excited more than the average paperback buyer: the Society of Illustrators singled it out for an Award of Excellence in their 1974 annual. His cover for *Downward to the Earth* by Robert Silverberg had received the same honor in 1972. "I was grateful for the awards, but I think it would have been more of a thrill if they had come earlier: you don't like being suddenly 'discovered' after working for 25 years! I guess my style is very old-fashioned and the Society was tuned into a new attitude and their juries simply weren't interested in looking at anything that resembled N.C. Wyeth or other 'prehistoric' illustrators. At the time they called it out-of-date and unsophisticated. I always had the attitude that art was art and nobody has the right to tell an artist to work in a specific style. If his pictures tell a story, do it well, and people have fun with it, that should be what counts."

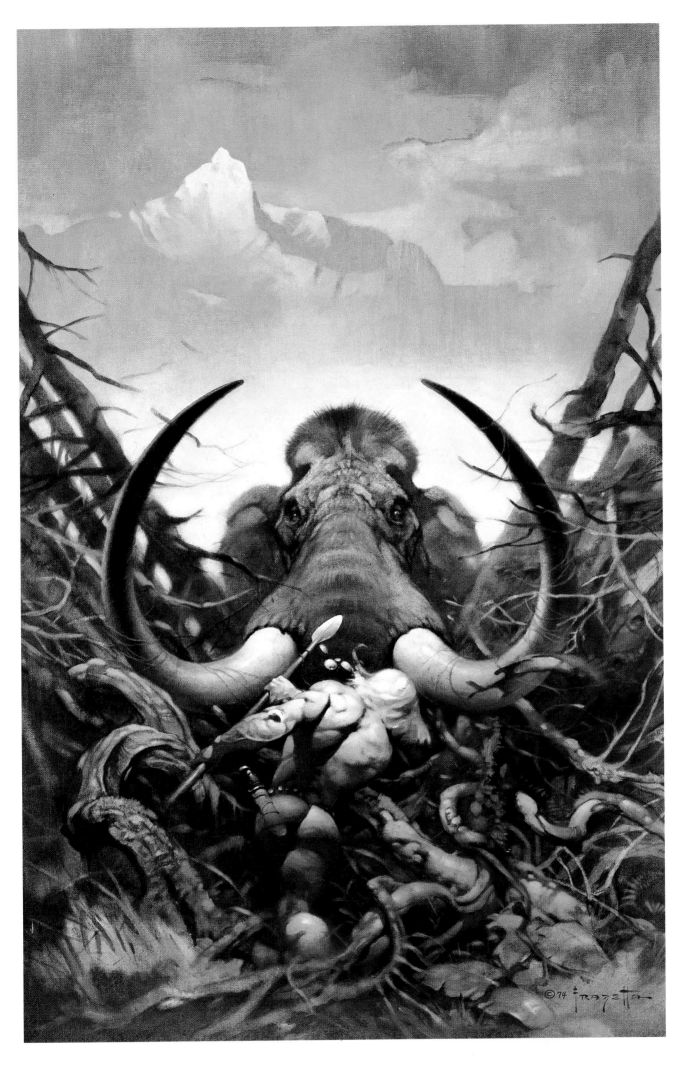

The Moon Maid

Revised cover to The Moon Maid *by Edgar Rice Burroughs, Ace Books [New York, 1974]. Oil on board, 16"x20".* At top left: *Cover by Roy Krenkel to the 1962 Ace edition of* The Moon Maid. At top right: *J. Allen St. John's 1926 interpretation.* At bottom left: *Frazetta's painting as it originally appeared on the 1974 Ace edition.*

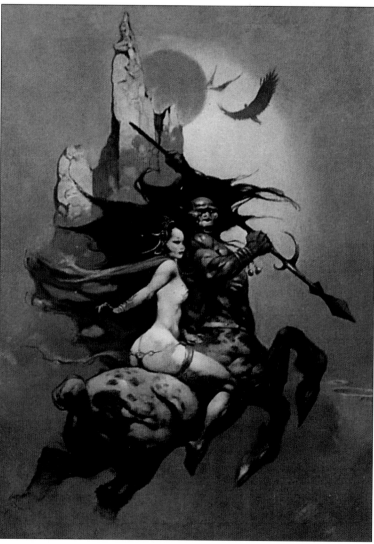

As the creator of Tarzan of the Apes, Edgar Rice Burroughs [1875-1950] is arguably the most popular action/ adventure writer of the 20th Century. His work has never been out of print, numerous popular films and TV series have been based on his books, and his characters have been widely licensed for everything from comics to statues to toys to Halloween costumes. While his interplanetary stories take place on Mars or Venus or the moon, Edgar Burroughs work is classified today as fantasy rather than science fiction. Unlike Jules Verne or H.G. Wells, there really isn't much scientific thought or extrapolation to be found in his books. He was far more interested in amazing the reader with his Victorian visions of darkest Africa, the Earth's core, or other planets (and their mostly nude inhabitants) than he was with plausibility.

J[ames] Allen St. John [1872-1957], an artist closely linked with ERB during the pulp era, provided the cover to the 1926 publication of *The Moon Maid*; Roy Krenkel created the art for Ace's paperback edition of the book in 1962. Frazetta's 1974 version takes the same scene, but infuses it with the trademark erotic tension and dramatic composition he had become famous for. Much of Frank's art explores the "beauty and the beast" theme, but perhaps none more effectively than this canvas. As was his habit, he reworked the painting into its present form after its original publication.

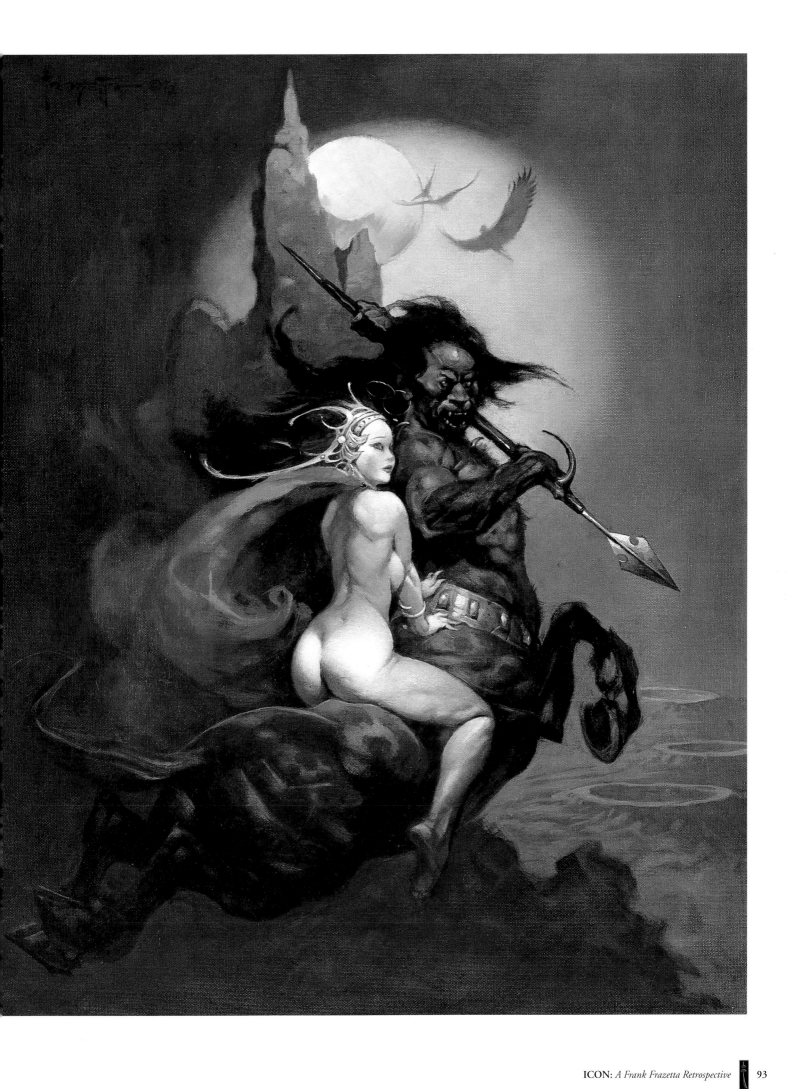

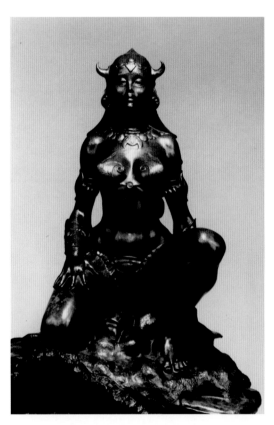

A Fighting Man of Mars

Cover to A Fighting Man of Mars *by Edgar Rice Burroughs, Science Fiction Book Club [New York, 1973]. Oil on masonite, 15"x23". At left: Limited edition bronze statue by Clayburn Moore inspired by Frazetta's painting [1996].*

 This lush painting, with its vibrant flesh tones and seamless blending of color, was a mature reworking of Frazetta's own *A Princess of Mars* cover. No less heroic but certainly more subtle. The original sold for $82,500 (plus the 10% buyer's premium) at an auction at Christie's East on Halloween in 1992.

 In 1996 popular Dallas, Texas sculptor Clayburn Moore released both a limited edition bronze and a cold-cast hand-painted statue of the female figure from this painting. Renowned in both fine art and commercial art circles, Moore was able to capture the "personality" of Frazetta's human characters perhaps better than any other sculptor to date.

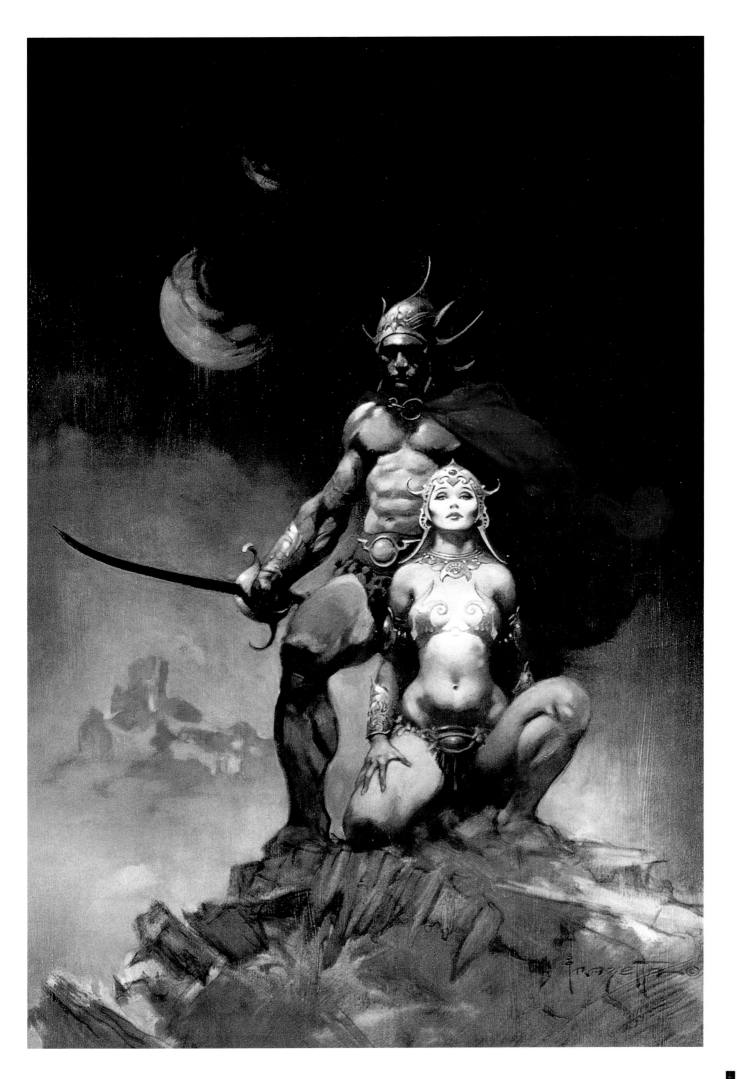

Captive Princess

Cover to The People That Time Forgot *by Edgar Rice Burroughs, Ace Books [New York, 1973]. Oil on masonite, 16"x20". At left: A sketchbook drawing, circa 1974.*

The cover to Burroughs' *The People That Time Forgot* is a painting of brute strength and rapid movement. Frazetta consciously minimized detail and color in exchange for a desired effect. This is a scene meant to be half-glimpsed, a blurred horrific memory; to have "finished" the female figure would have spoiled the illusion of motion. "A lot of new artists today put an awful lot of crap in their paintings. What they're doing is simply showing off their technical skill. And okay, that's all very nice. Somebody looks at · their work and thinks, 'Boy, this guy can do it *all*!' But when you really look at the stuff, you know something is missing. You just don't get that sense of mystery and wonder that you can get when the artist knows what to leave out or when to push something into the background.

"I try to keep a balance, I try to know what to leave out and what to put in—and in the final analysis the original painting can look very simple. But it really isn't. Making it *look* simple is very, very difficult. It's easy to pack a painting with detail, top to bottom, side to side—but it can be sort of a cover-up for mistakes."

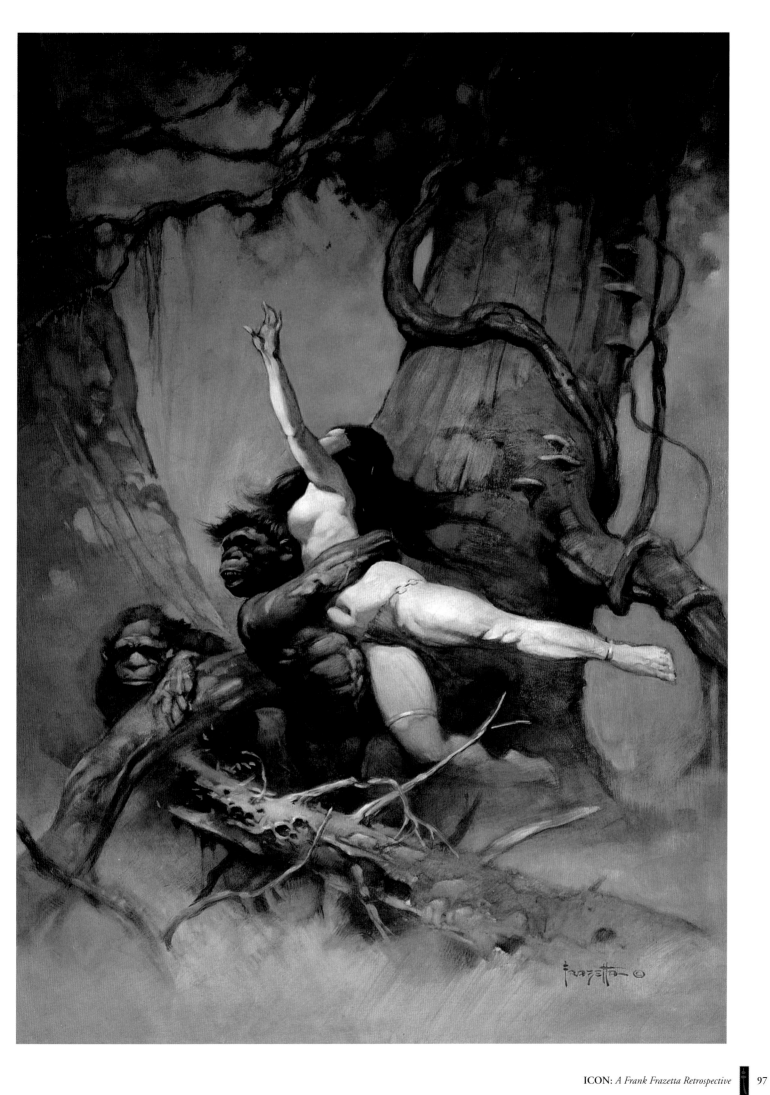

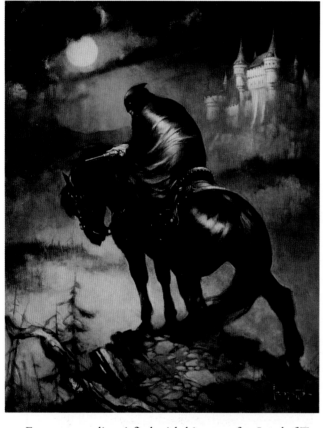

Land of Terror

Cover to The Land of Terror *by Edgar Rice Burroughs, Ace Books [New York, 1973]. Oil on academy board, 18"x22". At left: Frazetta's cover for* The Rider *by Edgar Rice Burroughs, Ace Books [New York, 1974]. Oil on illustration board, 16"x20".*

Critics that have accused Frazetta of excessive bloodshed and violence are always at a loss when asked to cite a specific example. "They're positive my work is bloody and terrible, and I say 'Oh yeah? Find it!' And they can't. There's merely the suggestion of it, a little splash of red on a sword, a spot in the snow, and that's it. I don't paint heads rolling around, or severed limbs. I've done *drawings* that have pushed the limits, but *paintings* are something else entirely. In spite of the subject or the violence, I want every painting to be a thing of beauty."

Frazetta was dissatisfied with his cover for *Land of Terror* in 1964 and took an entirely different approach with his 1973 assignment. While he has expressed an affinity for big cats, Frank's fondness for reptilian "villains" has been evident as well. His alligators, giant lizards, and dinosaurs all exhibit a unique mix of natural movement with a supernatural intelligence and malevolence. There's the illusion that, regardless of the improbability of the situation, they're moving the way a real animal might.

The cloaked, minimally detailed figure in the cover for *The Rider* [see above] is surprisingly expressive, the blue color palette effectively gloomy. It has been speculated that this canvas was the original source of Frazetta's popular "Death Dealer" painting. Frank, however, is not known for keeping very accurate records of when a work was created. But the two were painted in roughly the same time period and do share a dark and sinister quality.

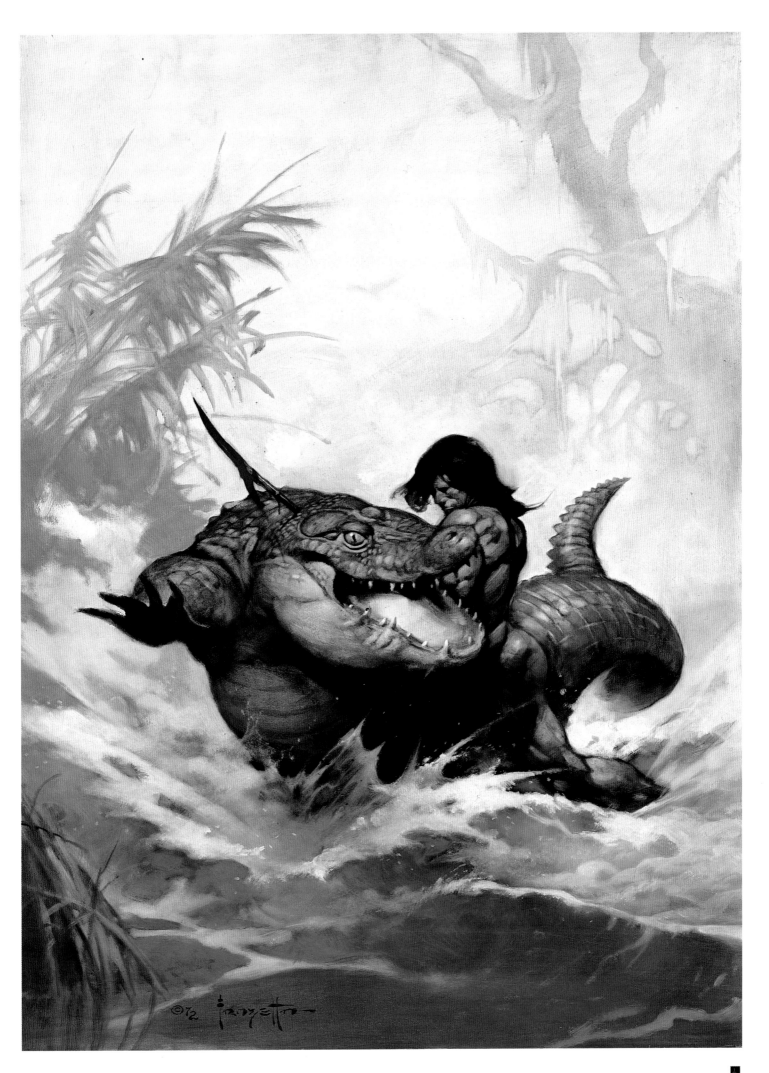

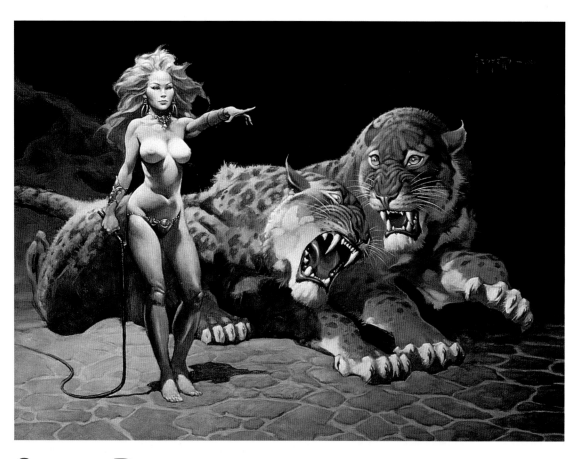

Swamp Demon

Cover to Witch of the Dark Gate *by John Jakes, Lancer Books [New York, 1972]. Oil on academy board, 16"x18". Above: "The Countess," a fine art print for the L. Ron Hubbard Library [Los Angeles, 1988]. Oil on board, 24"x16".*

Before finding his niche as a writer of multi-volumed historical soap-operas, John Jakes attained marginal popularity with a handful of heroic fantasy novels. Certainly more literate than many of his "sword & sorcery" competitors, some of Jakes' books also benefited from classic Frazetta covers. *Brak the Barbarian, Brak Vs the Sorceress*, and particularly *Witch of the Dark Gate* found an audience because of the artist's extraordinary visions.

"Swamp Demon," with its glistening nude figure, coiling serpent, and leering djinn, sizzles with an earthy eroticism and is one of Frazetta's many career highlights. That it was originally intended as a commercial illustration in no way diminishes its power or the strength of Frank's artistic convictions. The fact that his work transcends the pulp fiction genre for which it was intended either shows that he was simply *too good* for many of the works he was illustrating or that he desperately loved what he was doing and happily threw himself into an assignment with a sense of excitement and discovery.

Probably both are true.

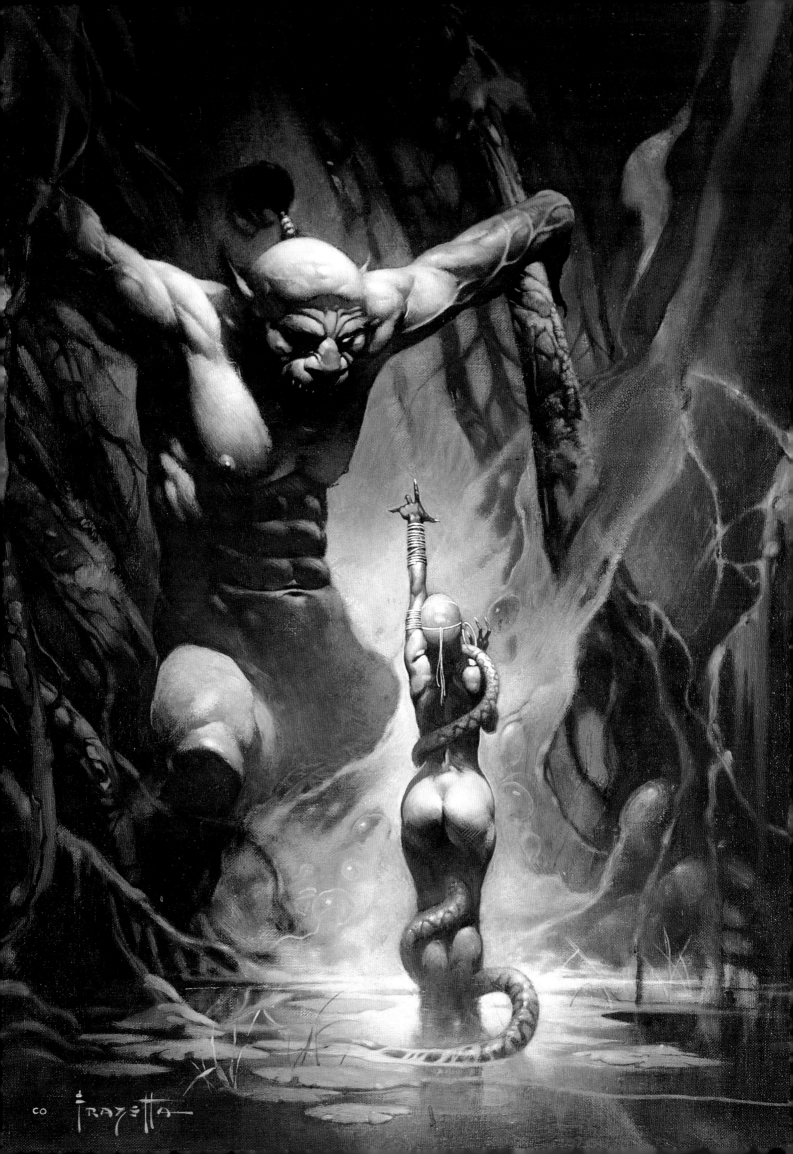

Strange Creatures

Cover to Strange Creatures From Time & Space *by John A. Keel, Fawcett Books [Greenwich, CT, 1970]. Oil on masonite, 16"x20". At left: A personal ink drawing, circa 1964.*

Before there was an *X-Files* and Agent Fox Mulder, there was paranormal investigator John A. Keel.

Really.

Chasing down reports of everything from UFOs and Men In Black (pre-Tommy Lee Jones and Will Smith) to Bigfoot and "Abominable Swamp Slobs," Keel wrote a series of articles exploring the subjects of aliens, the supernatural, and "cryptozoology" (the study of animals still unknown to science) for those 1960s bastions of investigative reporting, *Male, Argosy,* and *Saga.*

Strange Creatures From Time & Space was the compilation of Keel's articles—and it's a great deal of paranoid fun. About the only thing Keel doesn't attribute to flying saucer interference, give or take a sea serpent or two, is Kennedy's assassination. (Perhaps he was saving the identity of the alien gunman on the grassy knoll for his unwritten sequel...)

Frazetta's cover, with its plethora of shambling monsters, perfectly captured the flavor of the book and was reminiscent in tone of his covers for the early issues of *Creepy* and *Eerie.*

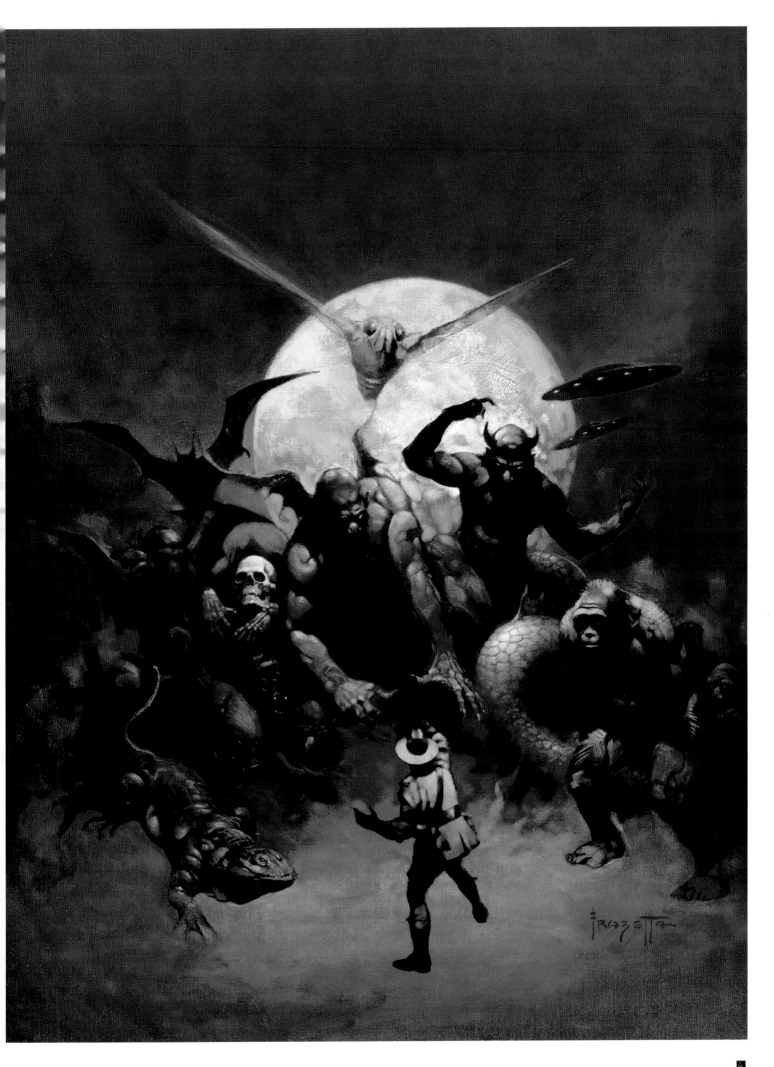

Atlantis

Cover to Atlantis Rising *by Brad Steiger, Dell Books [New York, 1973]. Oil on board, 16"x20". At left: Frazetta's watercolor rough, 5"x7".*

Interest in all sorts of paranormal-related subjects (like the Bermuda Triangle, the lost continent of Atlantis, and flying saucers) reached an all-time high in the late 1960s and early '70s. Frazetta did his share of illustrations for books and magazine articles exploring these themes, including one about surviving dinosaurs in the Congo jungles ("The Amali Legend") for the April, 1982 issue of *Animal Kingdom*, a publication by the New York Zoological Society.

His painting for *Atlantis Rising* is simultaneously majestic and melancholy. Beautifully capturing the lost glory of a forgotten civilization, with just a hint of decadence and decay, it is far superior to the book it was illustrating—not unusual for Frazetta. Frank's art would have been more appropriate to classics like *The Iliad* or *The Aneid*, but art directors refused to consider him for such commissions.

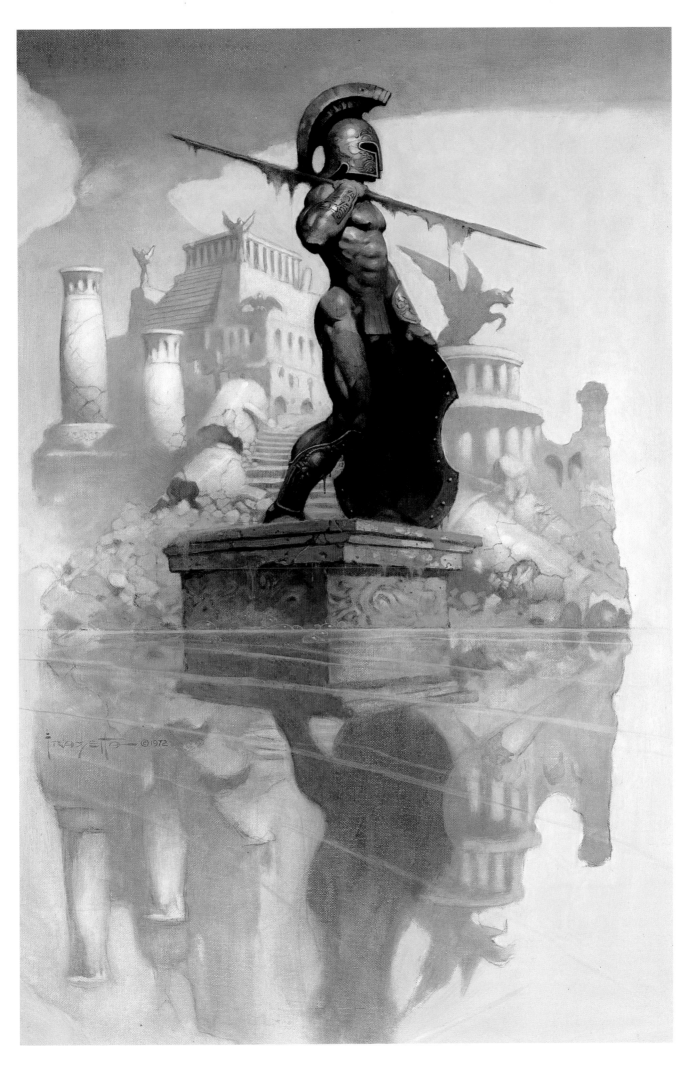

Mothman

Cover to High Times *magazine [May, 1980 issue]. Oil on academy board, 16"x20".* At left: *Cover painting for the EC comics science fiction paperback,* Tales of the Incredible, *Ballantine Books [New York, 1964].*

Knowing that "the truth is out there" (somewhere, anyway), John Keel energetically examined West Virginia's 1966 "mothman" alien sitings in an article for *High Times* magazine. Frazetta's painting (which was repeated on the inside) was appropriately hallucinogenic and was subsequently used as the cover for Keel's book-length expansion. Never mind that mothman, according to the "eyewitness" accounts, didn't much look like a bug (and didn't have arms or a *head* for that matter). Frank painted the creature as the readers might expect it to look from such a name.

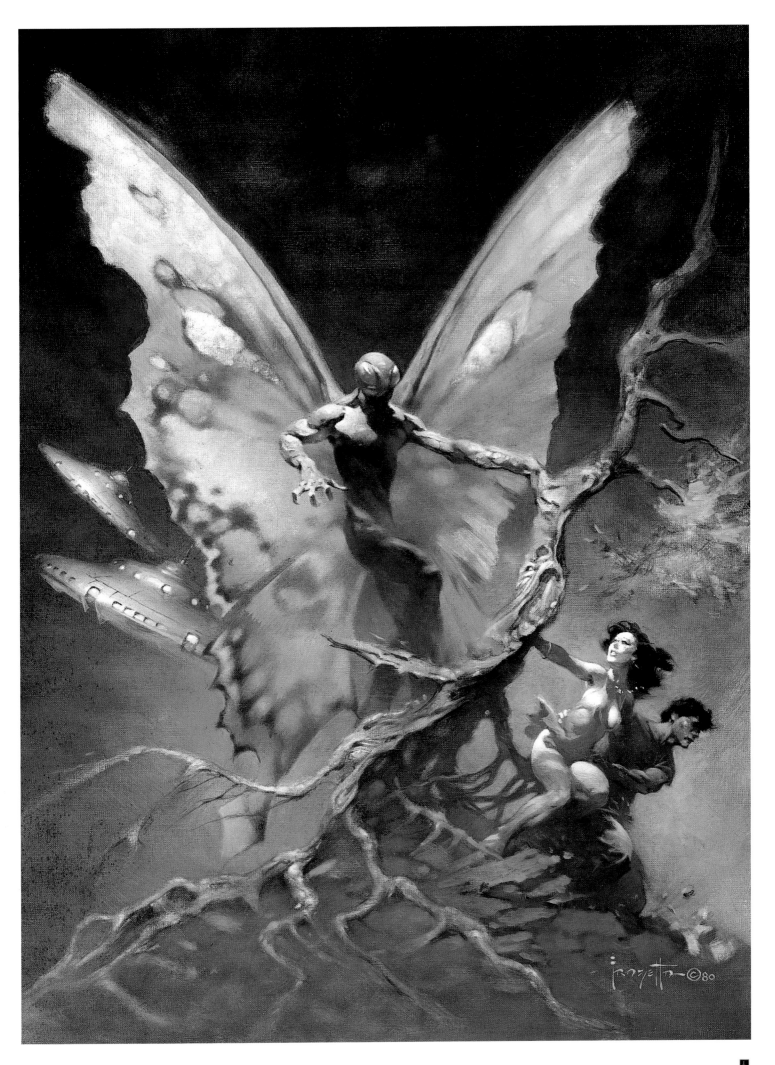

The Godmakers

Cover to The Godmakers *by Dan Britian, Pinnacle Books [New York, 1970]. Oil on masonite, 16"x24". Above:* One of the rarest of Frazetta's commercial assignments, *the cover for* To Catch a Crooked Girl *by Paul Fairman. Publisher unknown. Gouache on board, circa 1964.*

Frazetta's orgiastic painting for *The Godmakers* is an unusual blend of an abstract composition with a mass of realistic figures. The smoldering sexual activity, while apparent, is almost chaste because of his carefully chosen poses and broad slashing brush-strokes. Frank has let the viewer clearly understand what is going on without resorting to explicitness.

The Godmakers is one of the earliest published examples of the painterly technique that he would more effectively employ with his second series of Burroughs covers for Ace. Pinnacle was never known for their high-quality printing and their published version of this painting obscured much of Frank's subtle use of color.

In stark contrast to the fine art aspect of *The Godmakers* is Frazetta's cartoonish cover for *To Catch a Crooked Girl* [above]. Very reminiscent of Frank's movie poster technique, this piece is virtually unknown to collectors and its inclusion here is made possible by William Stout.

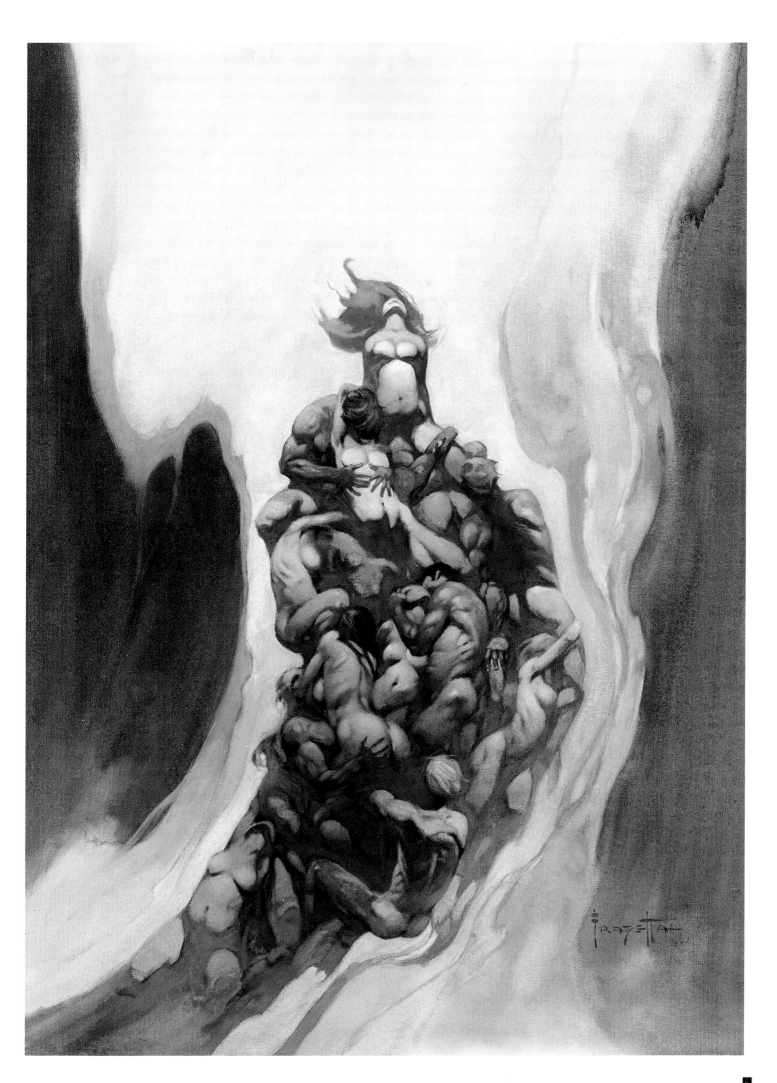

Desperation

Revised cover to The National Lampoon *[April, 1971]. Oil on masonite, 14"x16". At top left: The cover as it originally appeared. At bottom left: Frazatta's ink and gouache "cover" for the* Dragula *parody comic strip (illustrated by Neal Adams) for* The National Lampoon *[November, 1971].*

Never an admirer of the counter-culture or the underground comix movement of the 1960s and '70s, Frazetta hardly made a secret of being politically conservative. "I wasn't impressed by that silly crap. I guess I never really understood the hippies... that wasn't me. I mean, I played baseball, I got married, had kids, did my thing, was kind of Mr. Macho. Then these guys came along with long hair and they were stoned out of their minds half the time—a whole different breed. That just wasn't me. I'm sure they thought I was very square."

Little did he realize that the baby-boom generation, hippie, yippie, and otherwise, had embraced Frazetta as one of their own. They viewed his barbaric fantasies as the antithesis of the idealized 1950s squeaky-clean nuclear family—a rebellious reaction to contemporary society. Which naturally left Frazetta, who looked for all the world like the missing member of Frank Sinatra's "Rat Pack" and who had grown up on a steady diet of *Tarzan* and *Popeye*, scratching his head in wonder.

Given his conservatism, Frazetta's association with *The National Lampoon* is a little perplexing. A hilariously liberal champion of underground comix creators like Bobby London and Vaughn Bodé and bane of Republicans everywhere (particularly of Richard Nixon and Spiro "Spiggy" Agnew), *The Lampoon* was the *Mad* magazine of the anti-war movement. "Well, they loved my art and they paid well," Frank explains with a smile and a shrug. "I didn't tell them to grow up and they didn't lecture me about Nixon." Irreverent, merciless, and extremely funny, *The National Lampoon*'s list of contributors included P.J. O'Rourke, John Belushi, Gilda Radner, Doug Kenney, Michael O'Donoghue, Gahan Wilson, Neal Adams, Jeffrey Jones, and, of course, Frazetta. With the end of the Vietnam War and the exodus of many of its creators to TV's *Saturday Night Live*, the magazine seemed to lose its relevance. After changing ownership several times it eventually folded: the title has been kept alive as a marketing tool for a series of "vacation" movies starring comedian Chevy Chase.

The Lampoon's editors, tongues planted firmly in cheeks, described Frazetta's April, 1971 cover painting as an "interpretation of one of Rudyard Kipling's lesser-known classics, *White Man's Wet Dream*."

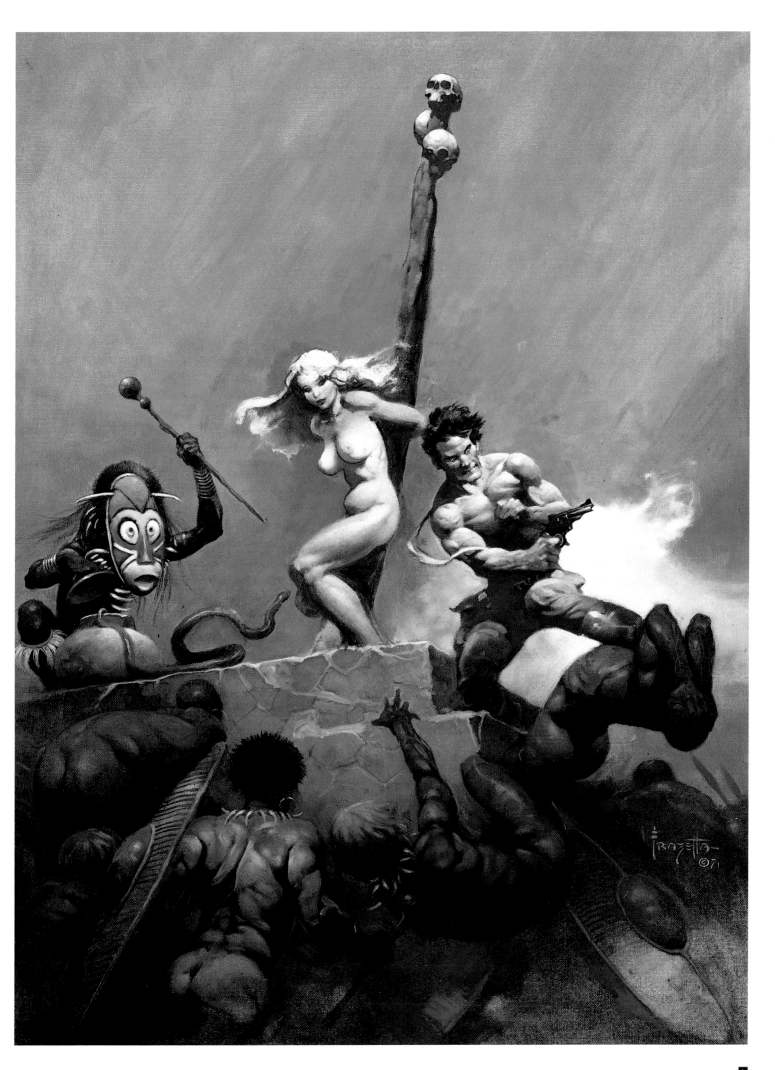

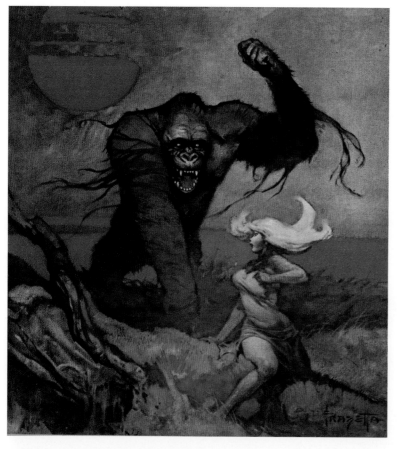

King Kong

Revised cover to King Kong *by Edgar Wallace and Richard Lupoff, Ace Books [New York, 1976]. Oil on academy board, 16"x20". At left: Frazetta's cover for* Creepy *[issue #11, 1966] which was the basis of this Kong painting.*

"An enormous influence in my life, which I think you can see in my work, is the film *King Kong*. The total work of art, the hazy, misty, wonderful quality of it is something I always shoot for. That mystery, that sense of wonder—that's what I try to capture. The power of Kong! I've seen it 4000 times and I never quite get over it. Dino DeLaurentiis came out to my house and he was trying to get me to do four new paintings for his remake of *King Kong* [1977]. Four paintings! That's a bit of overkill, you know. Why not just one really good one? So we dickered back and forth and nothing came of it. The money would've been nice, but I really didn't think Dino could improve Kong—and he couldn't."

DeLaurentiis eventually commissioned John Berkey to do a total of *six* promotional paintings for his version of *King Kong*. Ironically, Ace Books commissioned Frank to paint covers for both a reprint of the 1933 short novel based on the original movie [revised version seen opposite] and the softcover novelization of the screenplay for the DeLaurentiis remake.

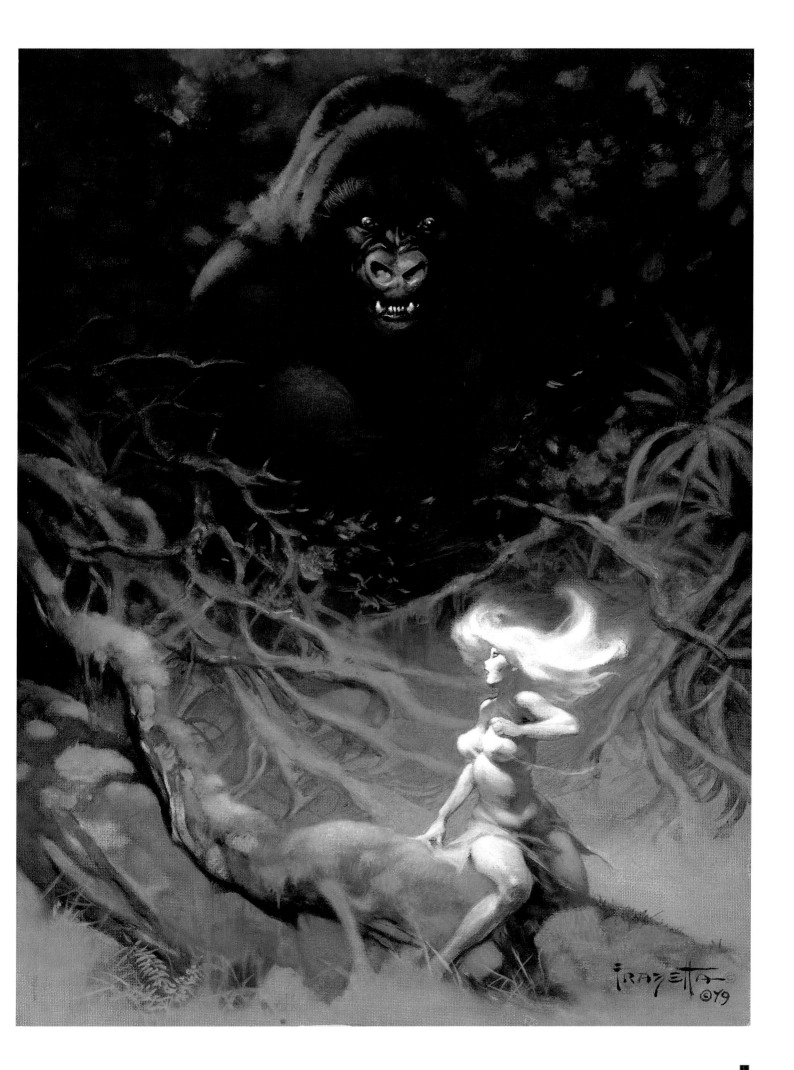

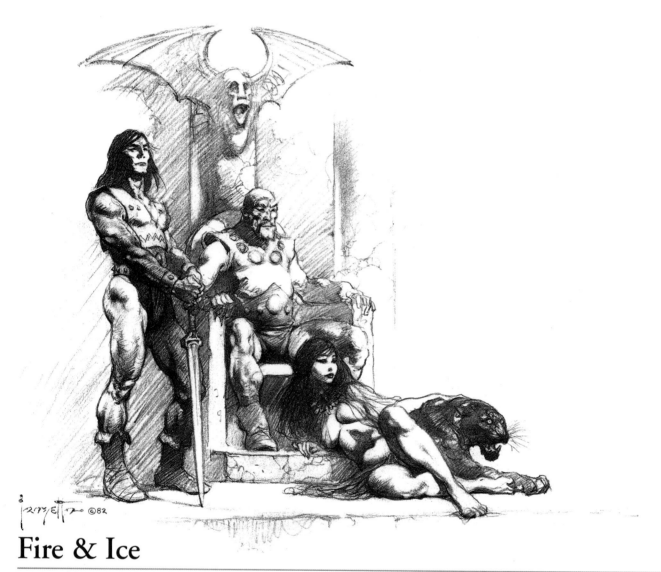

Fire & Ice

Movie poster for Fire & Ice, *Producers Sales Organization [1982]. Oil on academy board, 20"x26". Above:* One of the illustrations Frazetta completed for the opening sequence of his film, Fire & Ice.

Ralph Bakshi, with films like *Fritz the Cat* and *Heavy Traffic*, was the controversial wünderkind of "adult" animation during the 1970s. A long-time admirer of Frazetta's work (the director made references to the artist in his popular fantasy, *Wizards*), Bakshi approached him about collaborating on a movie, with Frank acting as co-producer. "He wanted to use all my established characters," Frazetta remembers, "like out of my paintings, Cat Girl and all the barbarians. I said, 'Wow, that sounds good. What's the deal?' He told me and, boy, was it *great*. All we had to *do* was to have had a successful movie and I would have been rich. Easy, hunh? It wasn't a bad film, but it wasn't perfect. I know it had some good points and I thought it had some bad points, but I won't take total responsibility for it. I think it was more than good enough to at least get the kids out to see it. It certainly had tremendous action. But Ralph couldn't get it into the theaters and the movie didn't go very far."

With a screenplay by comic book writers Roy Thomas and Gerry Conway, *Fire & Ice* was an ambitious attempt to translate Frazetta's imagination to the screen. He enjoyed working with the animators, actors, and stunt men, and reveled in the creative process of film making. But while *Fire & Ice* contained some attractive backgrounds (many painted by James Gurney, who would go on to great success with his *Dinotopia* books and prints) and some effective battle scenes, the movie was a financial failure. Frazetta's name couldn't make up for a banal script, uneven rotoscope animation, and Bakshi's lackluster direction. Achieving only limited distribution, *Fire & Ice* eventually realized a modest return as a bargain-priced video in 1984.

Frank had created a series of pencil drawings for a post-title sequence in the film that set up the action to follow; Ellie Frazetta turned the art into an attractive *Fire & Ice* limited edition portfolio in 1994.

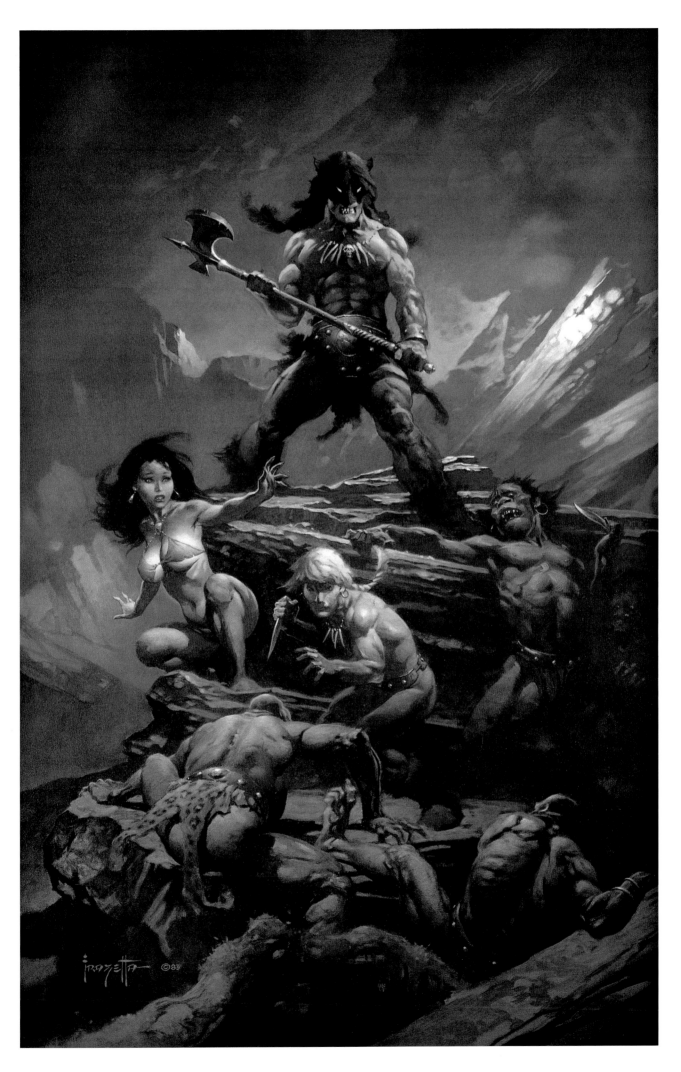

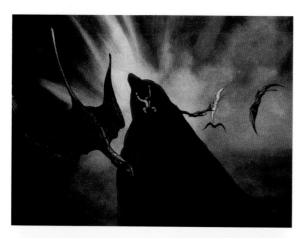

Against the Gods

Cover to Thongor Against the Gods *by Lin Carter, Paperback Library [New York, 1967]. Oil on academy board, 16"x20". At left:* Frames from the Jovan cologne commercial based on Frazetta's painting and animated by Richard Williams.

Frazetta's cover for Lin Carter's "Thongor" novel (a pale imitation of Howard's Conan) took on a life of its own long after the book was out of print and forgotten.

"Against the Gods" was licensed to advertise Jovan Sex Appeal, a men's cologne. The painting was used in a print advertising campaign and was the basis of a 30-second animated TV commercial by the Richard Williams studio. "So one of the fellows we had done Yellow Pages stuff for, Bill Pittman, was the creative guy on Jovan," Williams said in an interview with Milt Gray for *Funnyworld* magazine [issue #19, 1978]. "And since he knew me, he said they were going to have Arnold Schwarzenegger go up a mountain, and kind of matte in prehistoric birds and stuff. 'But do you think you could animate it instead?' And I said, 'Sure.' They had the Frazetta poster which Jovan had bought the [rights for], which they were going to run as their press ad...So I said, 'Gee, don't do it in live action, I could certainly animate it and I'd draw it in the style of Frazetta.' And Bill took a flier on me and said, 'Okay.'

"Apparently [Frazetta] was very enthusiastic. Either Jovan or J. Walter Thompson told Frazetta, 'We'll make an animated film of the poster,' and he said, 'Great, great!' I have had no contact with Frazetta...It was just me and the agency and his poster. So I went out and bought all the Frazetta books. I made a sort of scrapbook of his work, and I tried to do the commercial as he would have done it if he were an animator."

In the 1980s a California company would again license the image as the basis of a limited edition pewter figure sculpted by the artist himself. "I could think of plenty of other examples of my art that would've made a better statue," Frank notes, "but they had this 'vision' and never mind what the artist thinks."

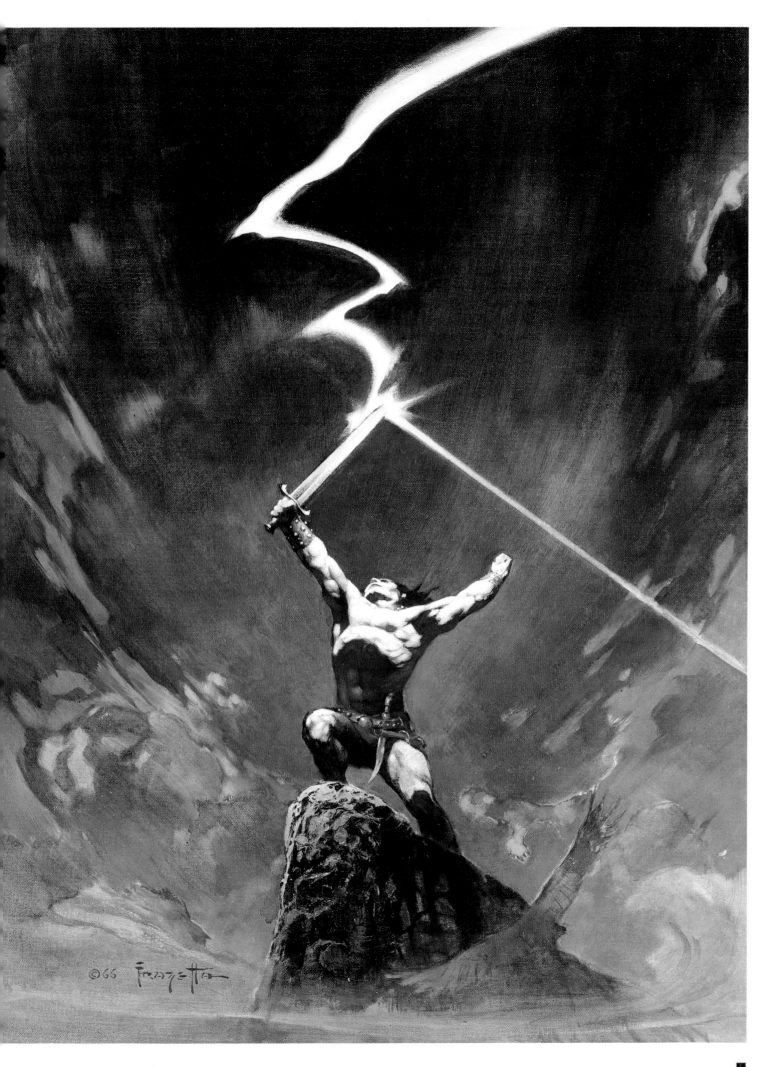

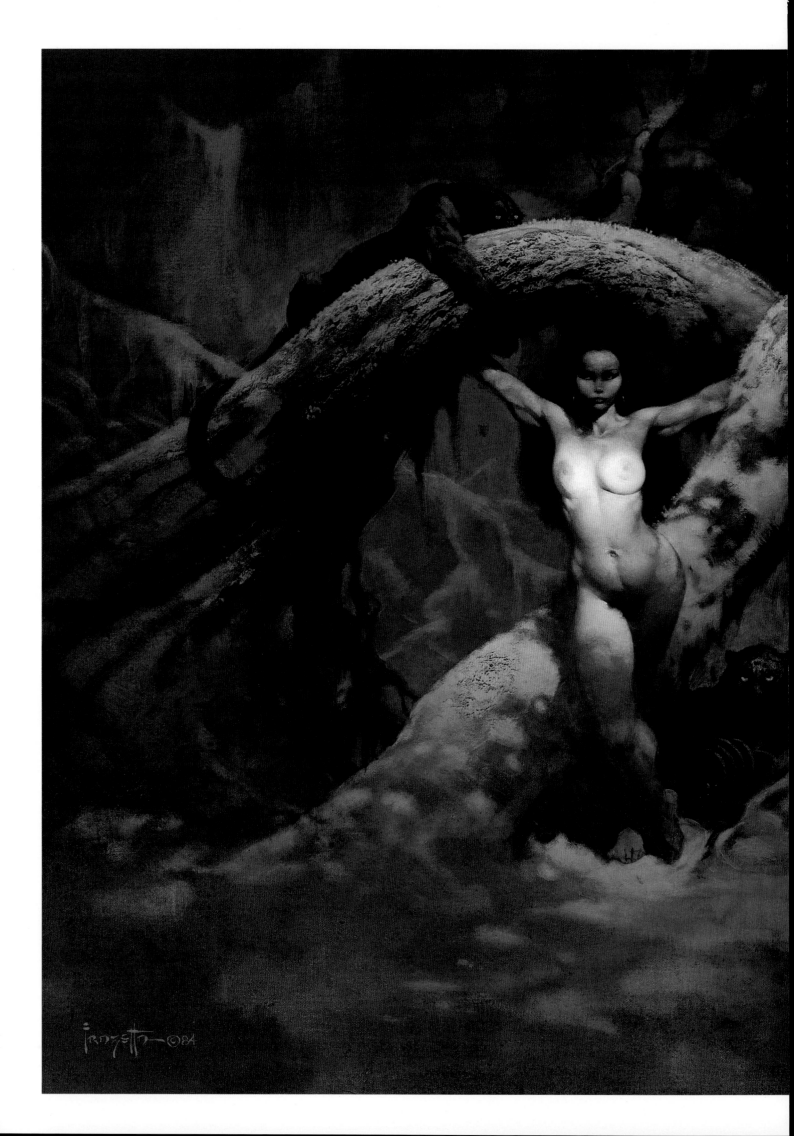

Cat Girl

Personal work, circa 1975. Oil on academy board, 24"x18". Above: *The original version of "Cat Girl," first published as the cover of* Creepy, *Warren Publishing Co. [issue #16, New York, 1966]. Oil on academy board, 24"x18".*

Certainly one of the most popular of Frank's paintings, "Cat Girl" was extensively revised from its initial incarnation. "I thought it had potential, but it was originally done for Warren and I had to be concerned with what they could show on the newsstand. She was blonde and was wearing a leopard skin; you know, the typical comic book jungle goddess. But it was an interesting composition and I thought, 'Hey, I bet I could turn this into something really special!' This version has really become a lot of people's favorite of all the work I've done. I think it really represents something of my inner being."

White Gorillas

Cover to Outlaw World *by Edmund Hamilton, Popular Library [New York, 1966]. Oil on academy board, 16"x 20". At left:* Sketchbook drawing, circa 1966.

 Throughout Frazetta's commercial art career he had to contend with the tunnel-vision of his clients. Book publishers, with rare exceptions, thought of him as a pulp-fiction artist; advertising agencies wanted him to bastardize Conan for beer ad campaigns; film-ad art directors only wanted his cartoon caricatures chasing each other across a poster. That he achieved an international reputation for excellence illustrating many works that were, at best, insignificant is a remarkable accomplishment. The fact that Frank was never commissioned to illustrate classics like *Beowulf* or *Macbeth* is disappointing, but does not diminish the quality and intrinsic value of his paintings or his importance to the world of art.

 Outlaw World was a paperback reprint of a 1940s "Captain Comet" pulp adventure. Frazetta's giant white apes and imposing mountain background were the most realistic aspects of Hamilton's book.

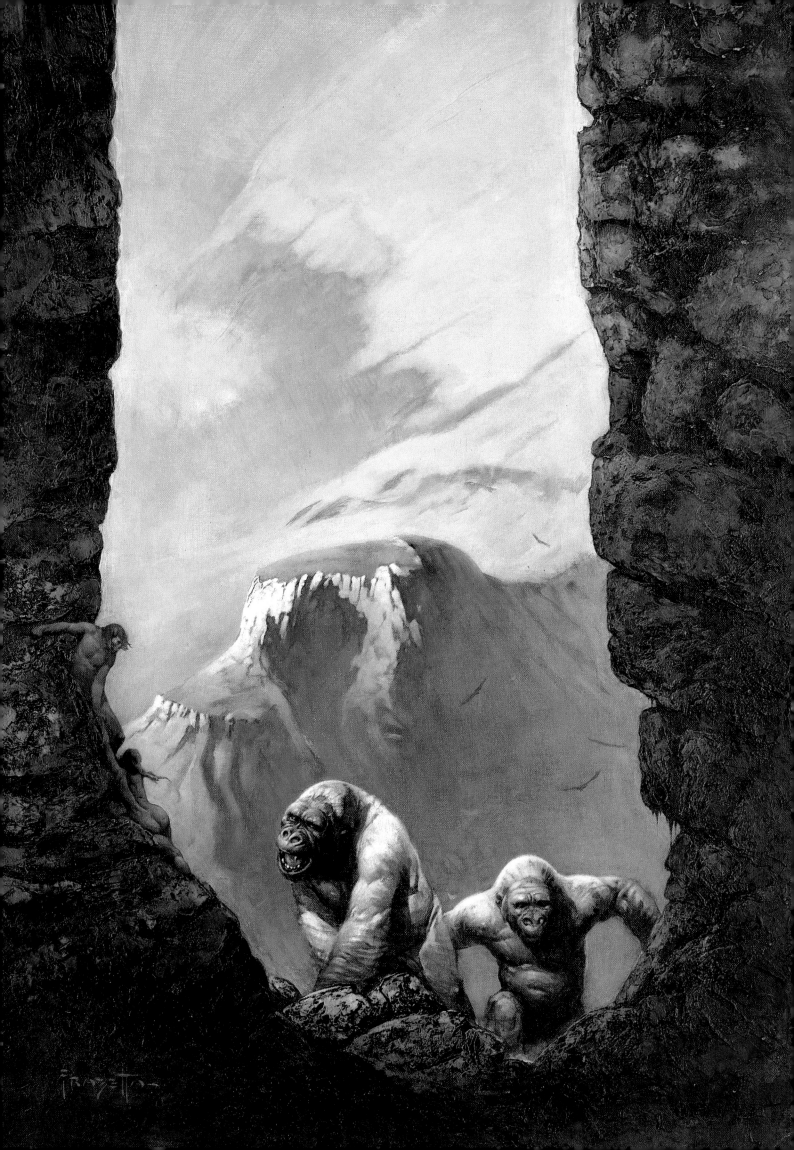

Tomorrow Midnight

Cover to Tomorrow Midnight *by Ray Bradbury, Ballantine Books [New York, 1966]. Oil on academy board, 16"x 20". At left: One of Frazetta's comic book "try-out" pages, circa 1948. Ink on paper, 16"x18".*

Ballantine Books produced a series of paperback reprints of EC's horror and science fiction comics in the mid-1960s. Frank was commissioned to provide new covers for the 5-book series and they run the gamut from garish comic book panels to fully-realized lush oil paintings. His cover for *Tomorrow Midnight* (one of two compilations of adaptations of Ray Bradbury's stories) is thoughtful and melancholy. The version shown opposite is the cover as it was originally published; Frazetta revised the painting to make the stranded astronaut more forlorn. [See *The Fantastic Art of Frank Frazetta Book 2*, plate 46.]

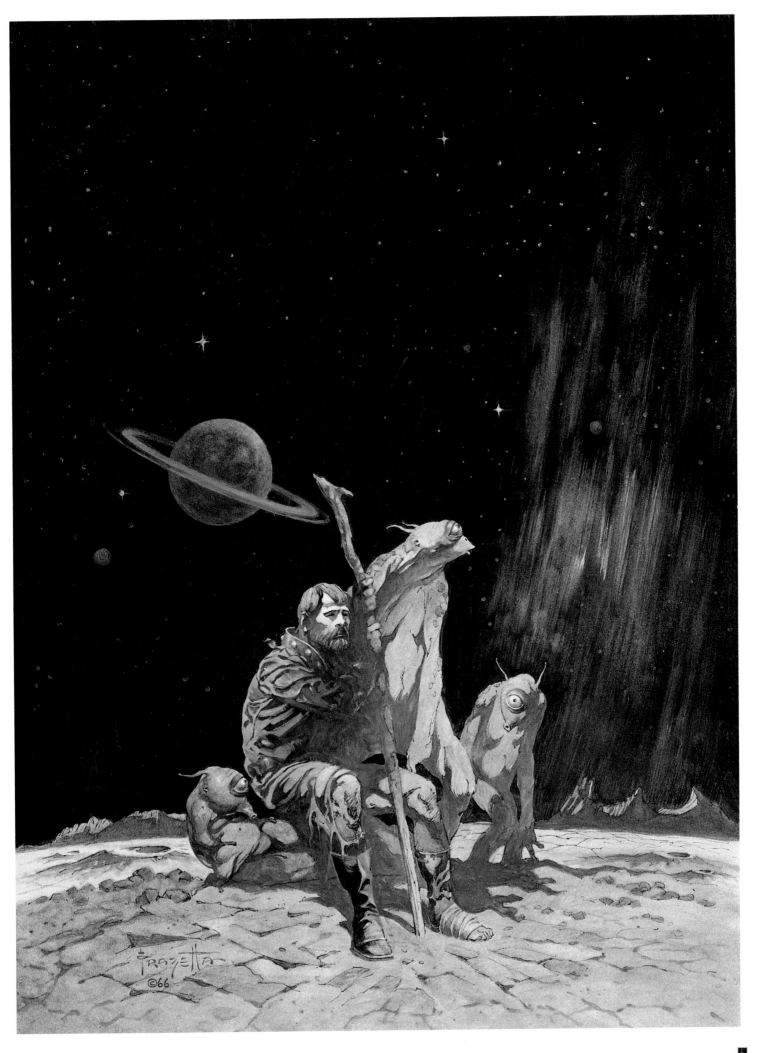

Geisha

Personal work, circa 1983. Gouache on illustration board, 10"x14". At left: *Personal work, circa 1964. Oil on board, 16"x20".*

This previously unpublished painting was created simply for the fun of it, without prior thought or sales consideration: its sole purpose is fun.

The Frazetta home is full of sketches, drawings, and paintings that few people outside of the family have seen and which exist for no other reason than Frank wanted to do them. Some of his portraits of Ellie, their children, and Ellie's parents, dating from the 1950s to the early '60s, are stunningly executed, very reminiscent of John Singer Sergeant, yet warm and personal. Frank's paintings of his wife are sensitive and non-exploitative, not only capturing her personality, but also perfectly exhibting his skill at realistic anatomy.

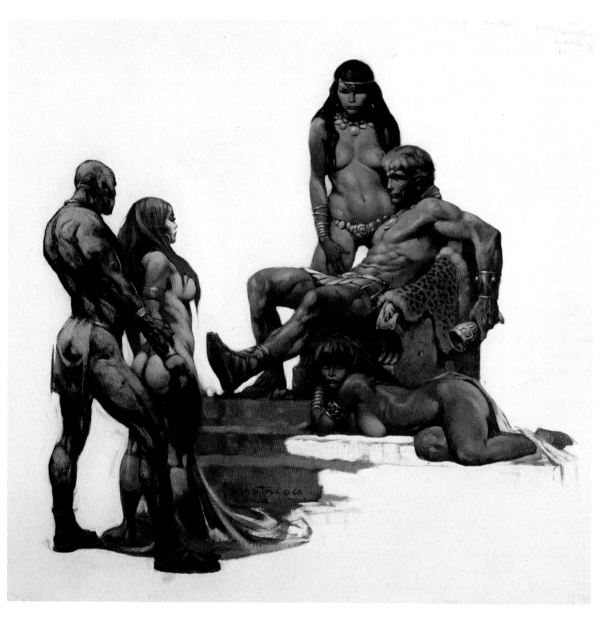

Rogue Roman

Detail from the cover of Rogue Roman *by Lance Horner, Fawcett Books [New York, 1965].* Above: *The complete* Rogue Roman *painting. Oil on masonite, 16"x18".*

Frazetta's vignette painting for the Jacqueline Susanne-flavored gladiatorial pot-boiler was done early in his paperback cover career, yet the lush brush work and strong composition exhibit a craft and maturity that wasn't as readily apparent in some of his Burroughs paperback covers of the same time period. The quickly blocked-in black figure on the left contrasted with the careful rendering of the dark-haired woman at the top of the dais—easily one of the artist's most captivating feminine figures—and left little doubt where Frazetta wanted the reader's eye to linger.

"Everybody knocks my female figures. They say they're overblown, that women don't look like that. And I agree. Certainly, not all women look like my paintings, but you can't deny *some* women do look like that! I don't want to paint just another woman. A painting, it's something important; you want to look at it, maybe, forever. Who wants to look at just an ordinary hero forever? You want the ultimate, you pull out the stops and do everything in extremes. The extreme in beauty, if it fits; the extreme in ugliness if it fits; the extreme in terror, if this is what's required. You know, I think that this is one reason that so many different people enjoy my stuff, because all of these extremes are jammed into it."

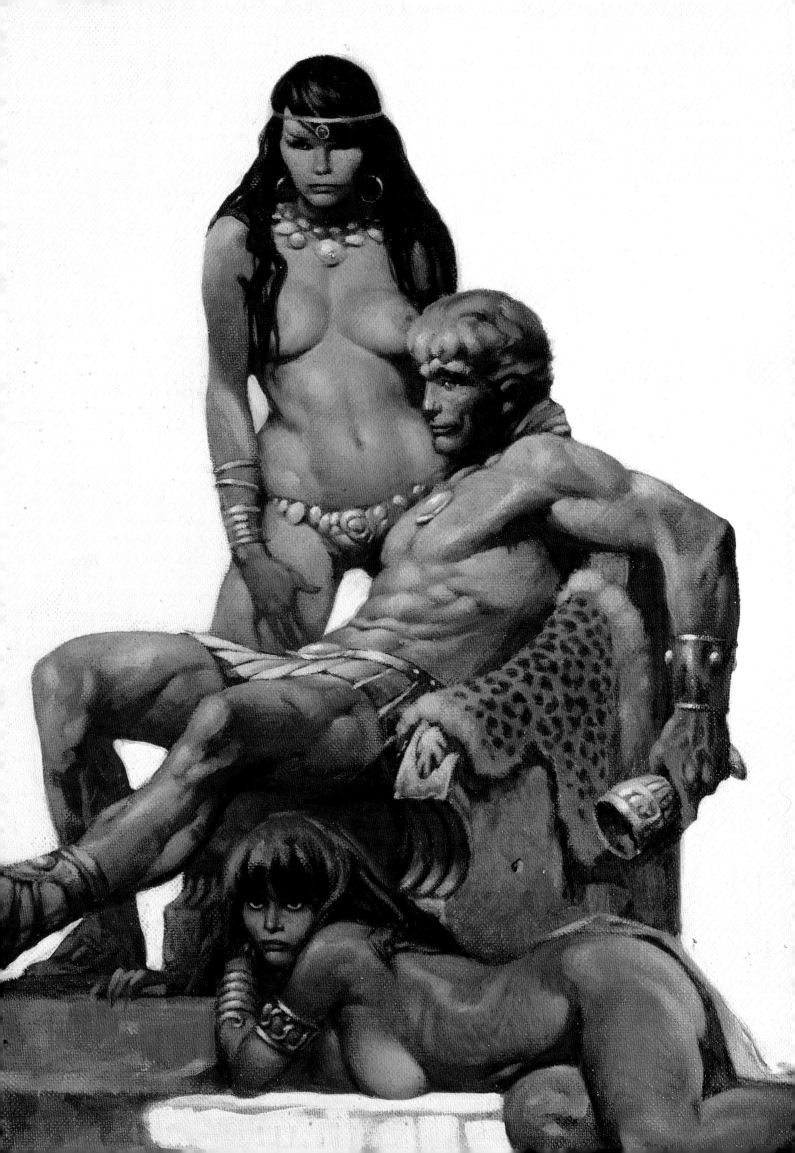

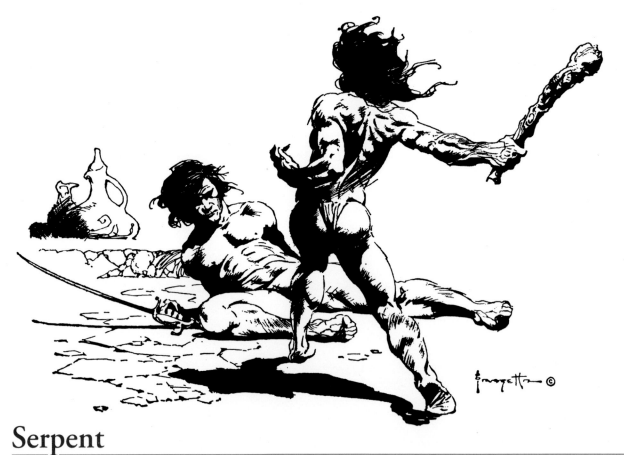

Serpent

Cover to Ardor on Argos *by Andrew Offutt, Dell Books [New York, 1973].* Above: *Interior illustration for* Mastermind of Mars *by Edgar Rice Burroughs, Science Fiction Book Club [New York, 1972]. Ink on paper. 12"x10".*

By the 1970s Frazetta was one of the most imitated artists since Howard Pyle. His instinctive design sense and natural talent left many of his contemporaries struggling to develop equally arresting covers. "I've been told by some of my imitators, 'Gee, Frank, we can't help but look at your work; that's the only way to go.' And I find that ludicrous, to say the least. What are they referring to, the colors? The way I apply paint? No, they're talking about just plain ripping off the figures and concepts. There is no such thing as 'the only way to go.' I just select a moment of peak action and paint it. You know, they have to find their own peak somewhere else. If you're going to claim to be an artist, then you have to be original, you've got to run your influences through the blender and come up with something that belongs only to you. If all you try to do is make your work look like the guy you admire, you're not an artist, you're a technician."

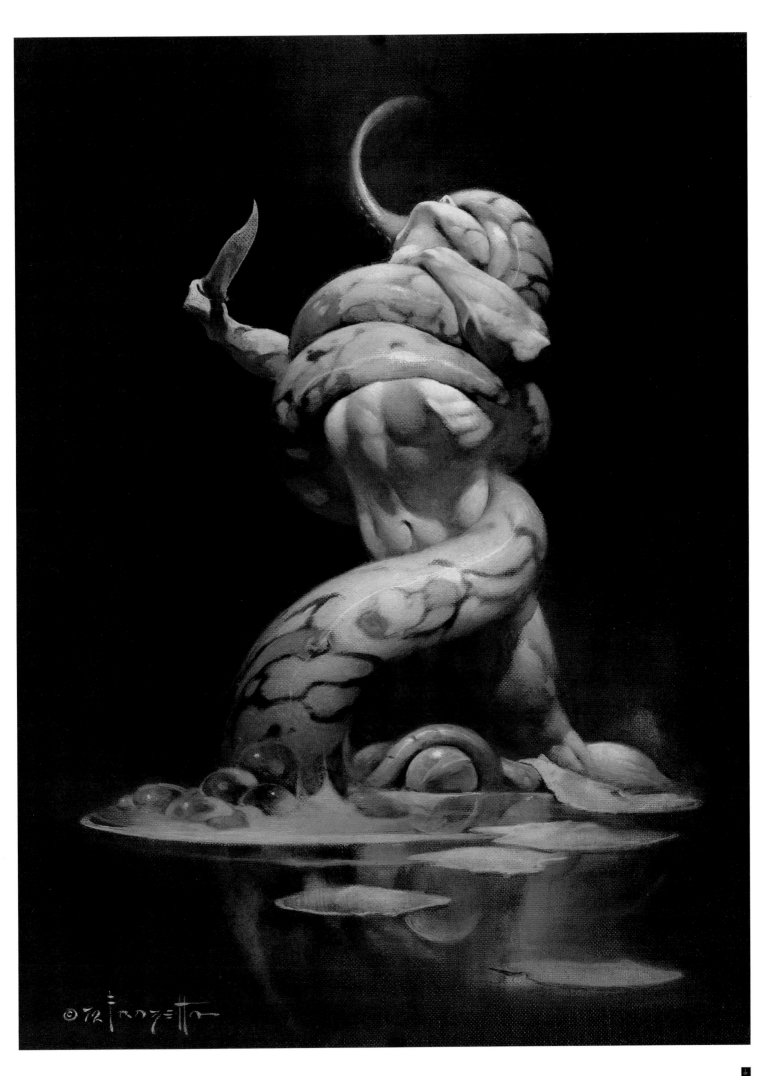

Silver Warrior

Cover to Silver Warriors *by Michael Moorcock, Dell Books [New York, 1973]. Oil on academy board, 16"x 20". At left: Ink and watercolor sketch that was turned into a bootleg print, circa 1974.*

A certain mystique surrounded Frazetta throughout the 1960s and '70s: his popularity and financial success outside of comics and science fiction polarized his fans. Some became cultish in their fascination with the artist and his work while others never missed an opportunity to deride his accomplishments. SF fandom, which had presented Frank with the Hugo Award for best artist in 1966, turned its back on him and never acknowledged his contributions to the field again. Not one to work the convention circuit or engage in extensive self-promotion, Frazetta led a private life with his family and tried to ignore the rumor mill and his critics, who were all largely unaware of his creative projects or personal problems.

"I've got my share of frustrations, sometimes more than others. I've tried not to show it. I'm delighted with my art and my talent; it has always come relatively easy and it's had such an impact on people—of course I love that. That doesn't mean I haven't suffered physically or psychologically at times. I get hurt, and it seems prolonged. I really believe the old cliche: artists are meant to suffer sometimes. It seems like I'm a macho guy and all that—people think that because I'm athletic and have confidence in my talent, I'm the tough guy nothing can dent, but I'm really super sensitive. There's a lot of *me*, my feelings, in my paintings. I think that's the reason for the art being what it is, but that means I overreact to things. When everything's up, I'm on top of the world, but when it's down...Jesus.

"When I painted 'Death Dealer' and 'Silver Warrior' back to back, I had been sitting on my laurels, just going through the motions. I could turn in a half-finished painting to an art director and they'd sing my praises; I didn't feel challenged. Then I became aware of a rumor going around that disturbed me—that I was washed up, that I hadn't done anything in years. My success was a fluke, just a matter of timing. These people who had been fawning all over me were suddenly chopping me up for dinner! In print! And I wanted to show them they didn't know anything, to let them see the old spirit. I think I needed that shot in the arm. I sat down and painted 'Death Dealer,' then 'Silver Warrior'—bang! As good or better than anything I'd ever done. All of a sudden my critics got pretty quiet."

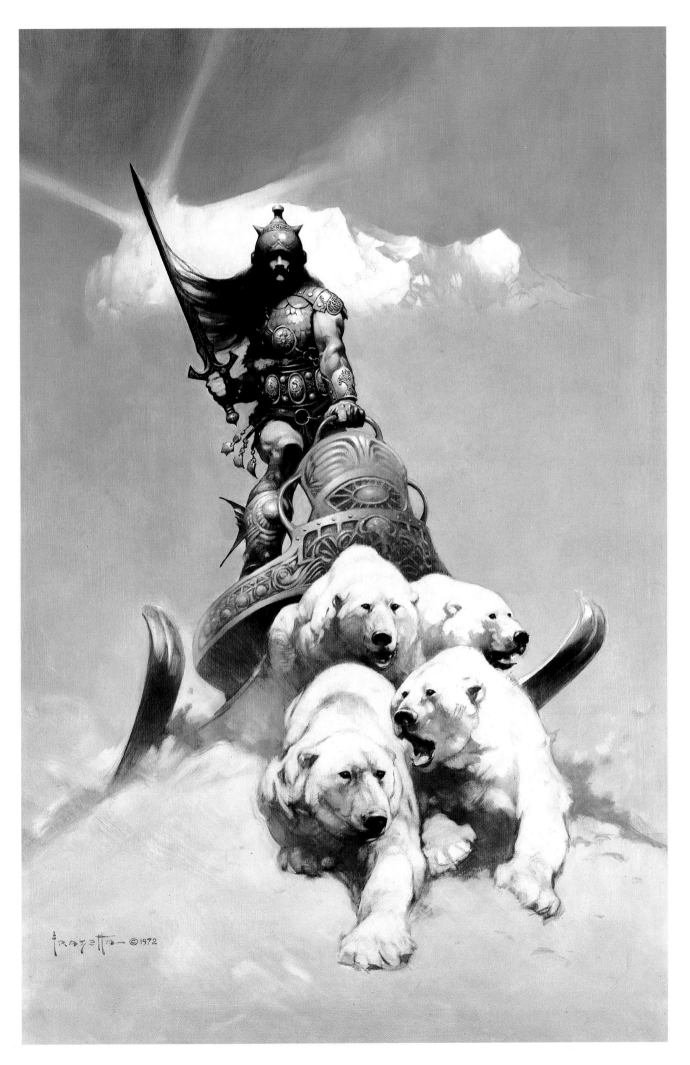

Dark Kingdom

Cover to Dark Crusade *by Karl Edward Wagner, Warner Books [New York, 1976]. Oil on academy board, 16"x20". At left: Sketchbook drawing, circa 1974.*

Aware of Lancer's phenomenal sales figures for the Conan series and Ace's success with the ERB reprints, Warner Books commissioned Frazetta to provide the covers for the "Kane" books by Karl Edward Wagner.

Essentially a fantasy interpretation of the Biblical "Cain," Wagner's dour and depressing novels about an immortal and amoral anti-hero were perfectly suited to the cynicism of the post-Watergate 1970s.

Before his untimely death in 1994 Karl Wagner was considered by many to have been the logical successor to Robert E. Howard (and, interestingly, he had written one of the best Howard pastiches, *Kings of the Night*, a Bran Mak Morn novel for Zebra Books). His fiction was well-crafted and original. His use of modern vernacular instead of mimicked medieval speech was refreshing and was perhaps an inspiration for the popular *Hercules: The Legendary Journeys* TV series.

Frazetta's cover for *Dark Crusade* is appropriately somber and grim, simultaneously heroic and unsettling and it prefigures his later "Death Dealer" series. The painting is an excellent visual metaphor for Wagner's character, portraying Kane's descent from light and reason into darkness, horror, and dread.

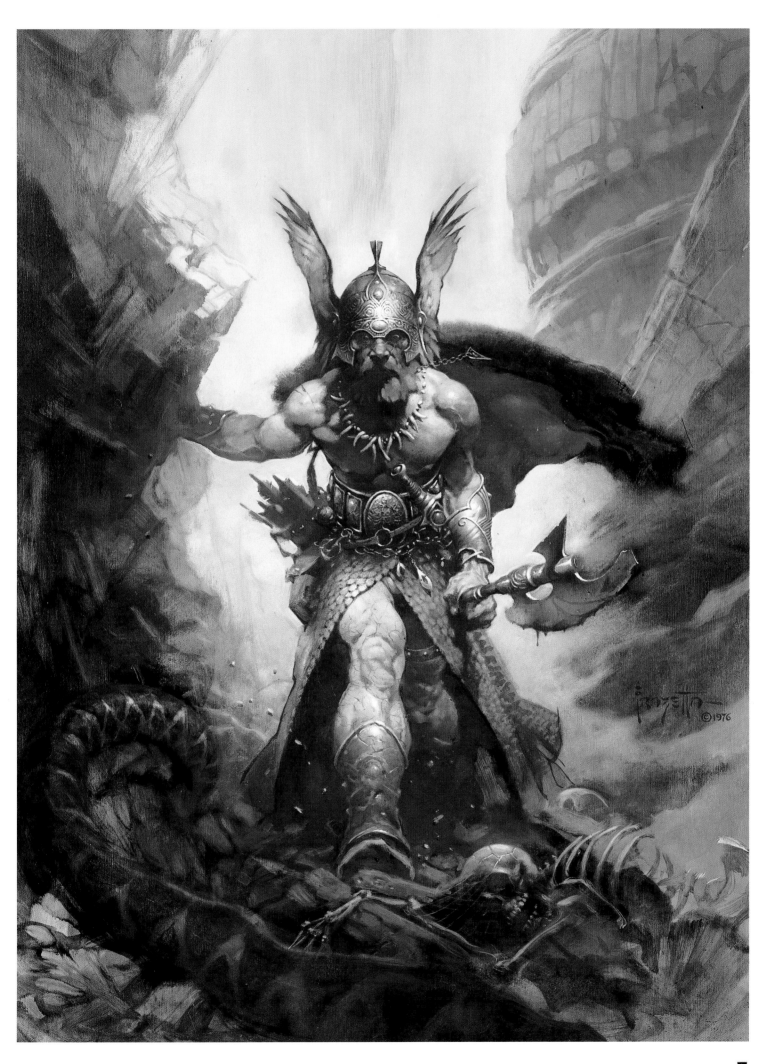

Princess & the Panther

Revised cover to Heavy Metal, *HM Communications, Inc. [Nov. 1990 issue, New York]. Oil on board, 16"x20". At left: Back cover art for* The National Lampoon Encyclopedia of Humor *[1973].*

In the introduction to an interview with Frazetta in the November, 1990 issue of *Heavy Metal* magazine the late Lou Stathis wrote, "No bullshit: Frank Frazetta is the Art God Incarnate. The guy rules, and there's no way around that essential, universal truth. His uncompromising vision—endlessly imitated but never equaled—has dominated the field, creating a sublime but arresting modern-classical style that's become the era's preeminent visualization of fantasy. Blessed with an uncanny, apparently innate ability to reproduce on paper anything his mind could conceive, this tough-but-nice Sicilian guy from Brooklyn effortlessly forged the paradigm against which every other fantasy artist has measured him/herself for the last twenty-five years. He imprinted his look onto the unreal estate of our collective imaginary landscape, and brought that world to lush, blooming life, fixing in the mass-mind's eye what had been the unsatisfyingly insubstantial dream images of others, inadequately conjured by clumsy words and reality-derivative pictures. There is no bigger sin in fantasy than being ordinary, and Frazetta's art kicked ass on the mundane."

The accompanying cover illustration was slightly revised after publication; Frazetta painted out the woman's necklace and bikini. "I don't care if it's been printed already," he insists. "If I see something that doesn't look right to me, I'm gonna change it."

[overleaf] Savage World *Cover to* Monster Mania, *Renaissance Productions [issue #2, New York, 1967]. Oil on canvas, 35"x22¹/₂".*

Loosely inspired by the Raquel Welch/Hammer opus *One Million Years B.C.*, Frazetta's art was used as the cover for the second issue of *Monster Mania*, a short-lived (only three published issues) competitor to *Famous Monsters of Filmland*. One of the artist's larger commercial works, it has been written that "Savage World" had been totally repainted in 1981 during Frazetta's stay in California while filming *Fire & Ice*, but comparisons of the two versions find very few differences.

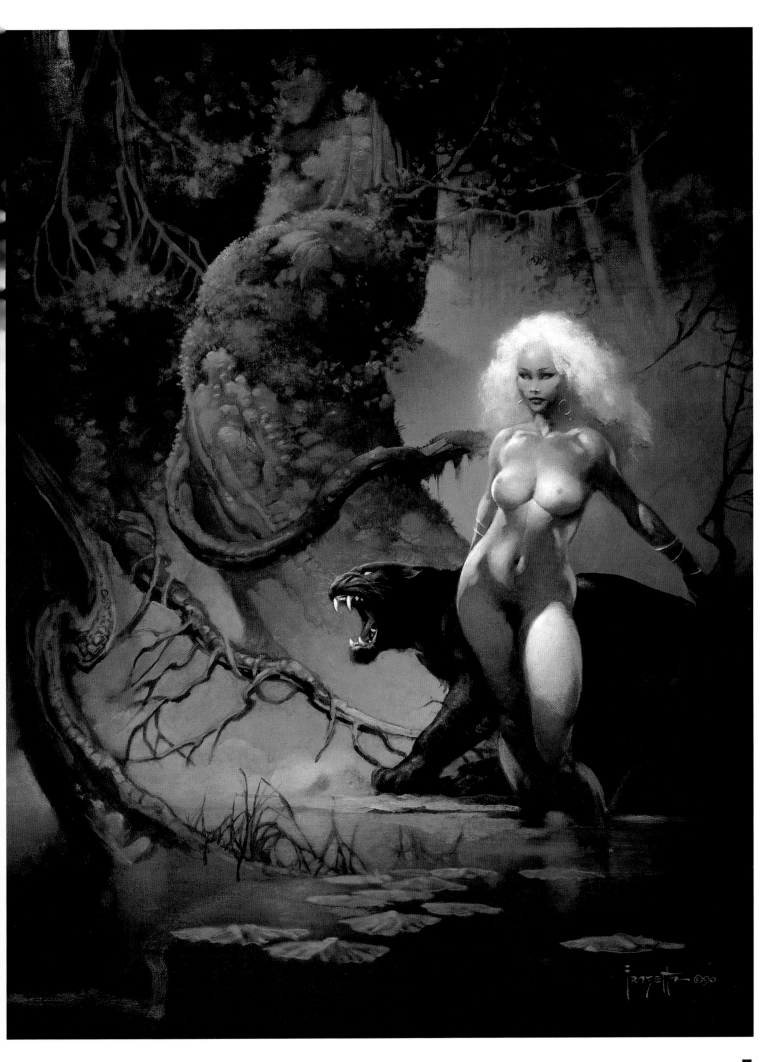

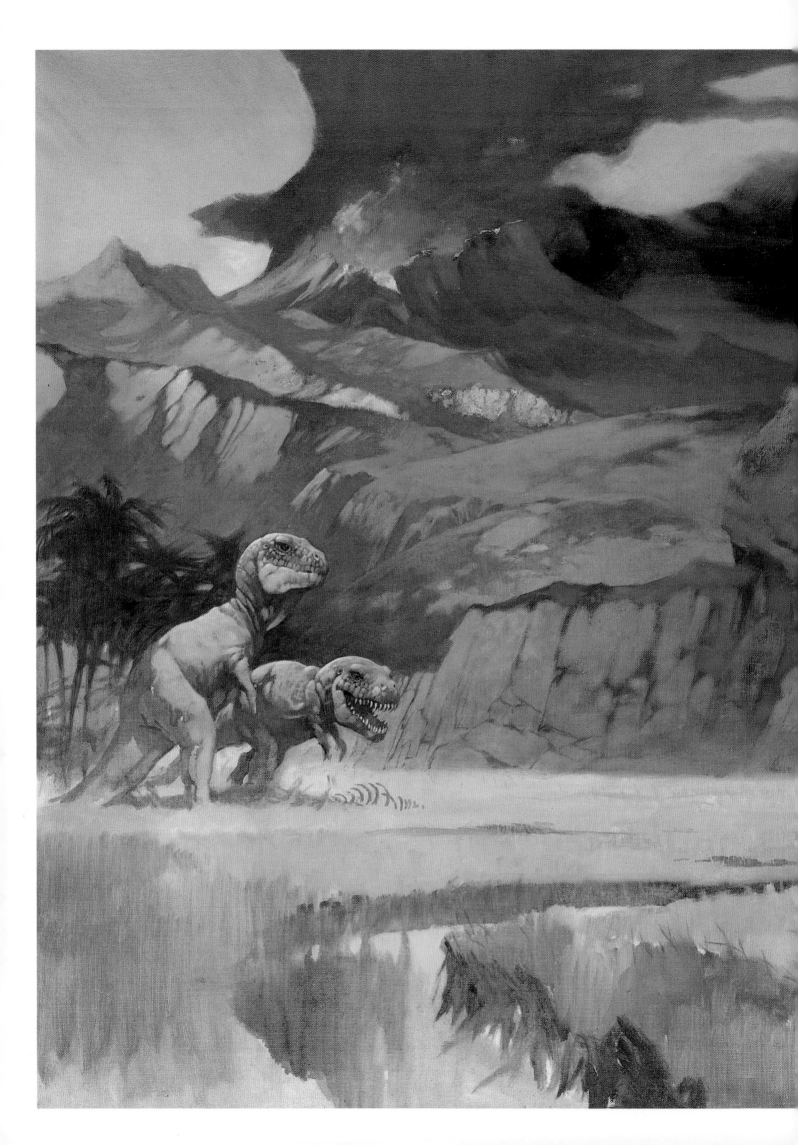

Primitive Beauty

Personal work. First published in Frazetta #1 *[House of Greystoke, Kansas City, 1969]. Oil on board, 11"x18". At left: Personal work, circa 1965. Ink on paper, 9"x11".*

For many years Frazetta was close friends with Vern Coriell [1918-1987], a renowned collector and founder of the first authorized Burroughs fan club. Coriell had always been a champion of Frank's talent and had tried unsuccessfully several times to persuade ERB, Inc. to give him a shot at drawing the *Tarzan* newspaper comic strip.

Coriell, a former circus performer, made his living lecturing and publishing *The Burroughs Bulletin,* as well as other amateur magazines (or "fanzines") and books. In 1969 he decided to start a Frazetta fan club and produced one issue of a fanzine devoted to the artist. As with most of Vern's projects, his plans were far more ambitious than his limited resources, short attention span, and meager distribution would allow. A "second" issue was published in 1973 as part of *The Burroughs Bulletin* [issue #29]. Despite an announcement that the "club" would continue under another fan's guidance, no other publications ever appeared.

This painting, one of many originals in Coriell's possession, was printed in black and white as the "centerfold" of *Frazetta #1* and was also released as a small full color poster in 1973. Vern Coriell's massive collection was sold off after his death and the current whereabouts of this original is unknown. The drawing above was completed around the end of Frank's association with the Canaveral Press. It was included in Camille Cazedessus Jr.'s Opar Press Portfolio, *Burroughs Artist: Frank Frazetta,* in 1968.

Sunset

Promotional painting for the Doubleday Western Book Club [New York, 1972]. Oil on masonite, 18"x24". At left: Frazetta's splash page (with assistance by Al Williamson) from John Wayne Comics #3, Toby Press [1951].

 This atypical Western painting was one of over a dozen book club promotional pieces Doubleday commissioned from Frazetta in the early 1970s. Usually printed in only two colors in various club circulars, the majority of these subtle and expressive works were never published as the artist originally intended.

 Those who think of Frank as only a fantasy artist are usually surprised when they encounter historical paintings such as "Sunset," but Frazetta is no stranger to the wild west. Early in his career he drew stories and covers for such titles as *John Wayne Comics*, *Tim Holt*, *Tomahawk*, and the highly regarded *Ghost Rider*.

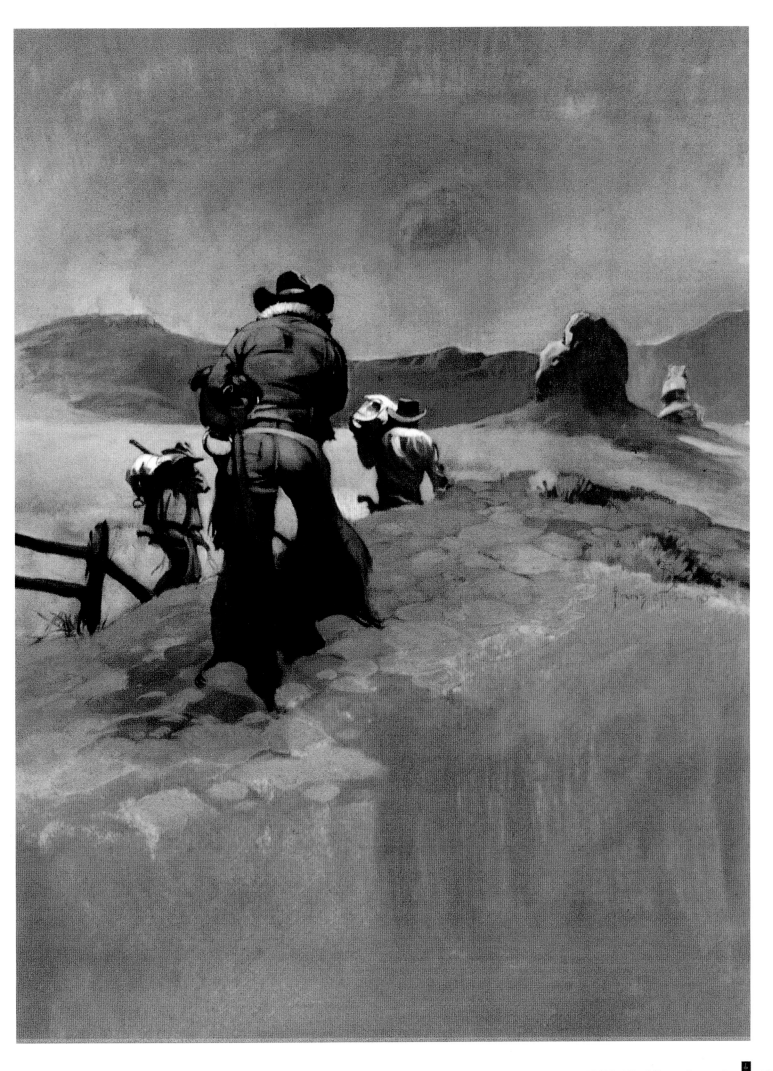

The Disagreement

Advertisement for Carlsberg Beer [1986]. Oil on board, 18"x26". At left: An ink sketch, circa 1975.

"The beer ad was just a silly little job I did for the hell of it," Frazetta says of his painting for the Carlsberg print campaign for a regional test brand. "I doubt if I'd have even considered it if they had wanted me focus on a beer bottle. But they said, 'Do a barbarian barroom brawl your way.' So why not?"

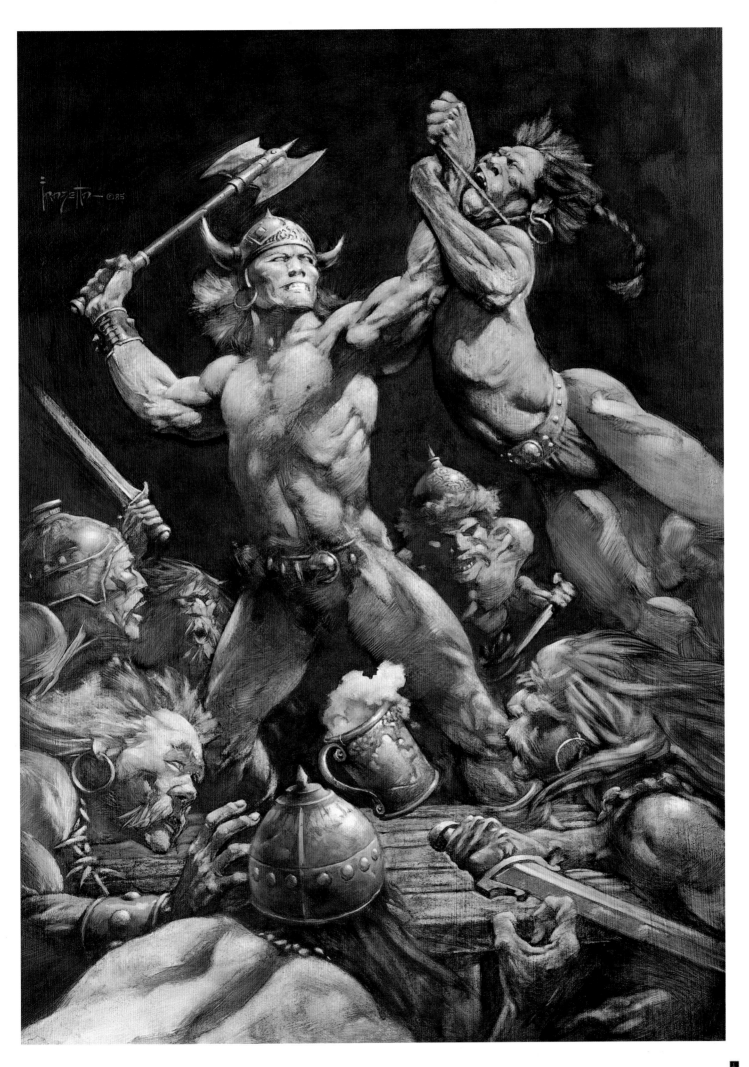

Familiars

Cover to The Frazetta Pillow Book, *Kitchen Sink Press [Northampton, MA, 1994]. Ink and watercolor on paper, 9"x11". At left: Sketchbook drawing, circa 1972.*

For those who were only aware of his lush oil paintings of barbarian combat, *The Frazetta Pillow Book* provided a surprising glimpse of a more whimsical (if no less erotic) side to the artist. Filled with a charming selection of nude gnomes, fairies, and nymphs, the book showcased Frazetta's proficient skill with watercolor. "Nearly all the paintings were done as gifts to me or for family," Ellie Frazetta explains. "They show the playful, fun-loving side of Frank I have known all my adult life."

[overleaf] Dawn Attack *Cover to* Writers of the Future, *Bridge Publications [Los Angeles, CA, 1991]. Oil on board, 24"x16".*

Frazetta was never particularly interested in modern science fiction and the very few SF paintings in his repertoire have a retro, Flash Gordon-feel. Ignoring the "new wave," "cyberpunk," "humanist," and "alternative history" literary movements of the genre, his covers featured anachronistic spaceships, near-naked heroines, and 1939 World's Fair-flavored robots.

They also sold books in enviable numbers.

Frazetta's painting for the Bridge *Writers of the Future* anthology [pages 146-147] is remarkably designed, engagingly colorful, and wonderfully archaic; so enthusiastically nostalgic that it's virtually hip.

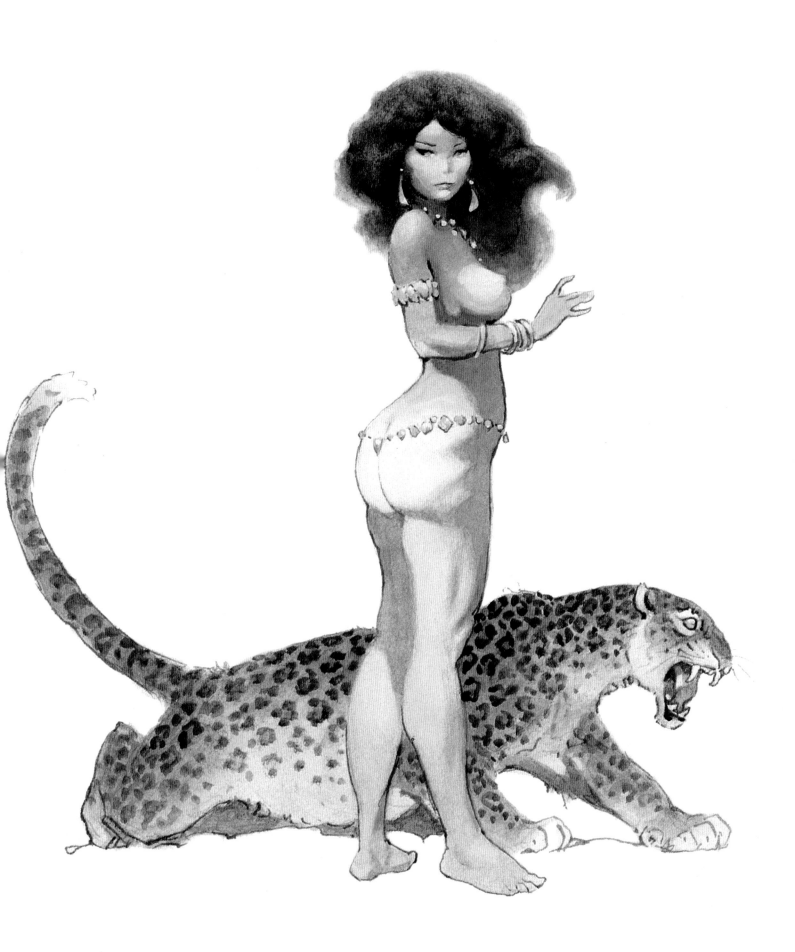

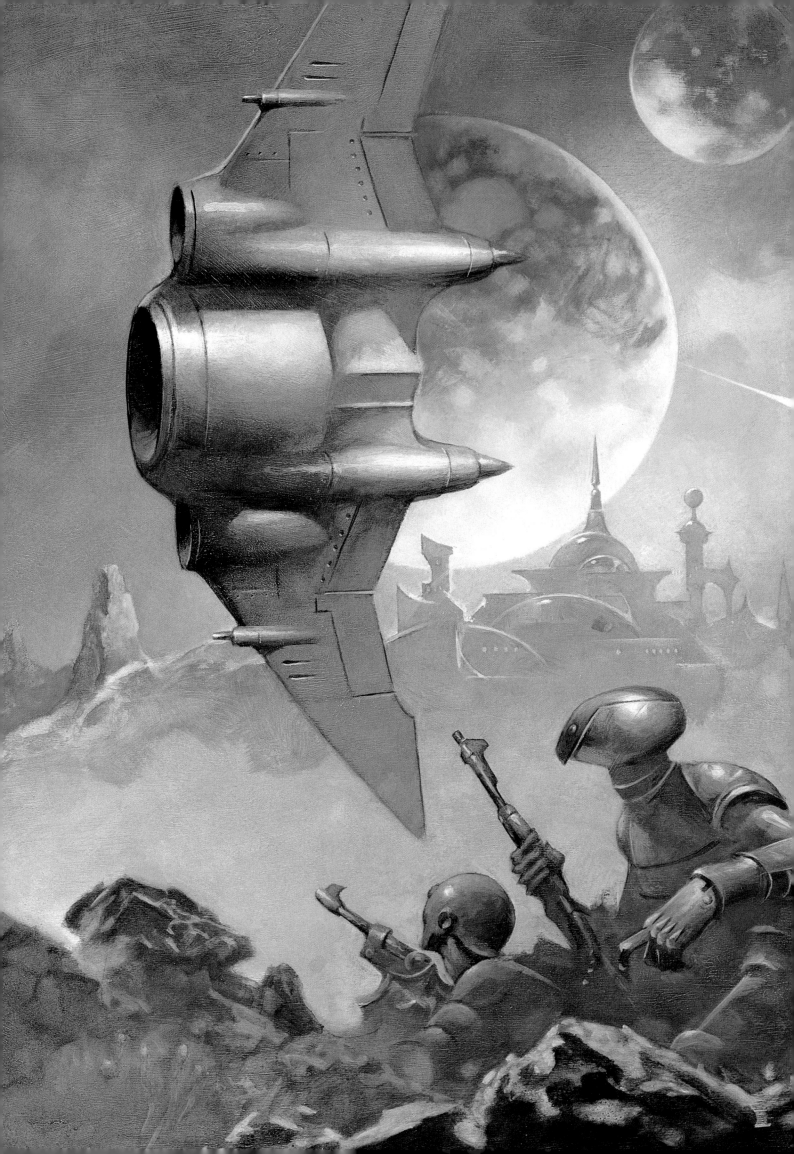

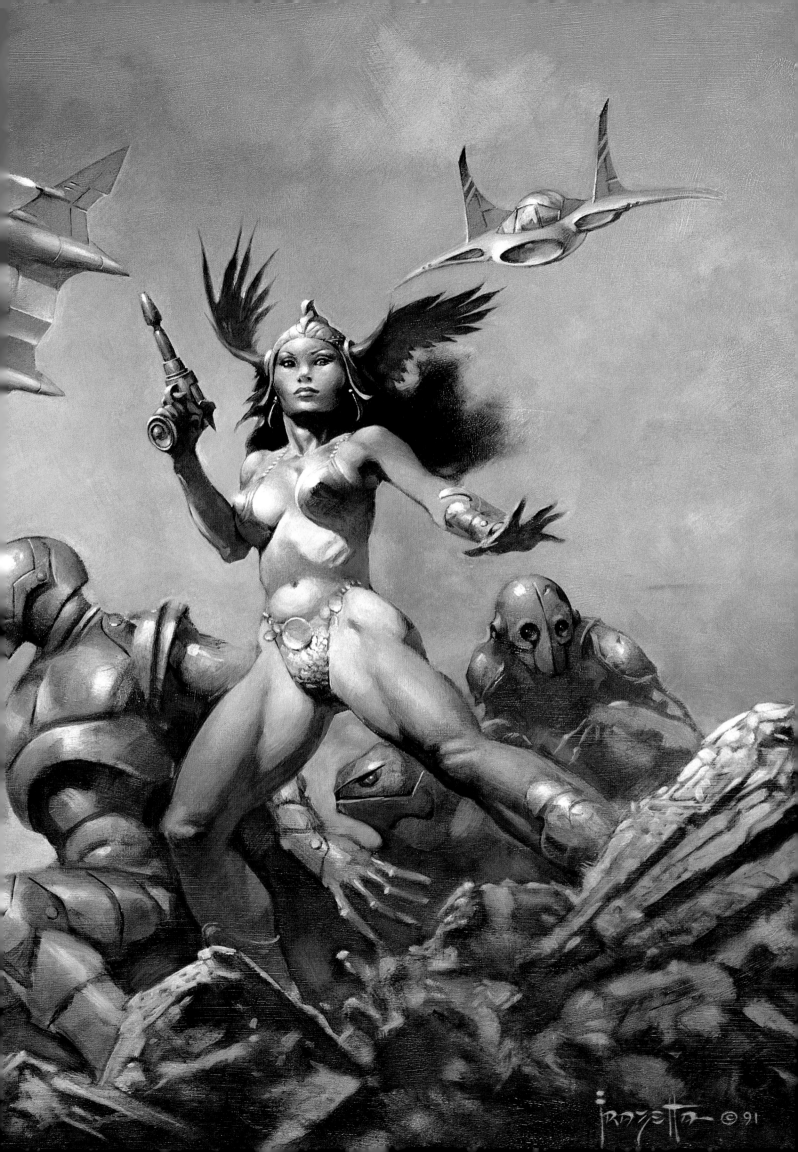

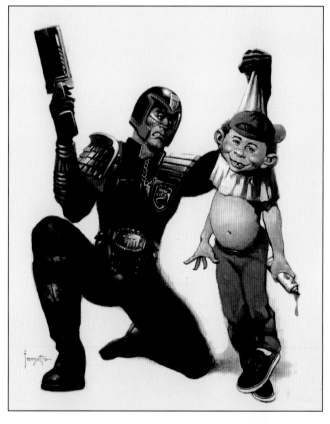

Shi

Cover to Shi-Senryaku, Crusade Comics *[New York, 1995]. Gouache on academy board, 16"x20". At left:* Frank's cover for Mad *magazine [issue # 338, New York, August 1995]. Oil on academy board, 16"x20".*

From 1994 to 1996 Frazetta engaged in a bit of nostalgia by providing covers for *Mad* [at left] and several of the new crop of non-traditional comic book publishers that had sprung up during a brief "boom" in the industry. His stark, fairly sedate gouache painting of William Tucci's popular female samurai effectively contrasted the bright and busy interior art.

But few people realized that Frank's "come back" was more of a display of personal triumph than it was an indication of a desire to return to his comics roots. An undiagnosed thyroid condition had played havoc with both his professional and personal life for nearly eight years. Batteries of tests, visits to a long list of specialists, and lengthy hospital stays eventually left the vigorous artist emaciated and clinically depressed. "I suddenly had no more of those wonderful images running through my head. And even though I could sit there and sort of work out a composition and a design, the actual application was gone. I noticed when I used the brush, nothing happened. Everything was flat. There was none of that spontaneity, none of that courage to sit there and ride it out and let things happen. It was very static and I'd look at what I'd done and think, 'What have I lost?' I thought it was because I was getting older and I knew that I'd lose some of my skills. Eventually. But it happened so suddenly. I tried everything: pen and ink, pencils, painting; they were all awful. I used to look at my old work and ask myself, 'How did I do that? I guess that's just what happens when you get old.' Obviously I realized that it was something in my brain that wasn't functioning right, it's just that neither the doctors or I attributed it to the thyroid."

Once Frazetta was able to find a physician who was willing to experiment with medication until they found the proper dosage to correct his hormonal imbalance, things immediately turned around. "The most wonderful and incredible thing is, the minute they got this thing adjusted, bang! It all came back in an instant. I never imagined that my skill would come back just as good as ever. That's *crazy*, but it shows that the brain is like a delicate computer and sometimes the circuits need a little soldering."

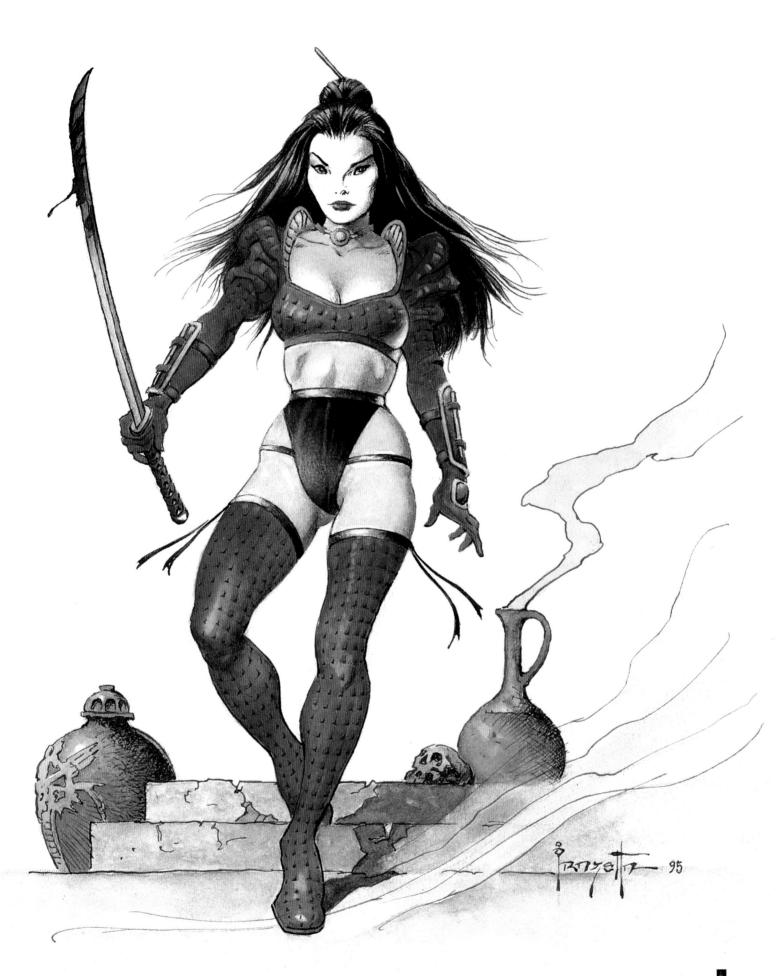

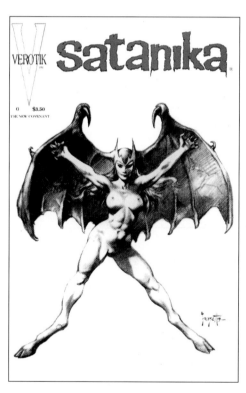

Sorceress

Cover to Verotika, *Verotik [issue #3, Los Angeles, 1995]. Oil on academy board, 14"x20".* At left: *Frank Frazetta's cover for Verotik's comic* Satanika *[issue #0, 1995]. Pencil on paper, 9"x12".*

Perhaps as unusual as his association with the *National Lampoon* has been Frank's working relationship with rock-musician-turned-comics-publisher Glenn Danzig's company, Verotik, throughout the mid-'90s. Similar to Bing Crosby inexplicably recording a version of The Beatles' "Hey, Jude," Frazetta's gem-like covers somehow seemed mismatched with the misogynistic carnage by other artists filling the interior pages. "I guess I'm old fashioned. Maybe I'm a little out of touch. The key word is 'taste.' And taste makes for beauty. When you start doing pornography, there's just no way it can be in good taste. And for the most part, it isn't beautiful. There's a big difference between sexuality and pornography. Pornography is just plain dirty. Sex can be beautiful. You can suggest it and you can do it so it's not explicit, and yet it's sensuous as hell. You can get great joy out of something that is beautifully done, that has some thought and feeling put into it—that's more stimulating than the trashy stuff. There's something really wrong with people who get excited by rape and murder. I don't think that my work shows that I'm a prude and I've done some art that could be called erotic, but I was surprised at some of the stuff that was going on inside some of the comics with my covers."

Regardless of the controversy surrounding the content of their comics Verotik featured work by many prominent artists, including Dave Stevens and Simon Bisley, both Frazetta admirers. Danzig published a book of Frank's exuberant pencil drawings, *Frazetta: Illustrations Arcanum*, in 1994.

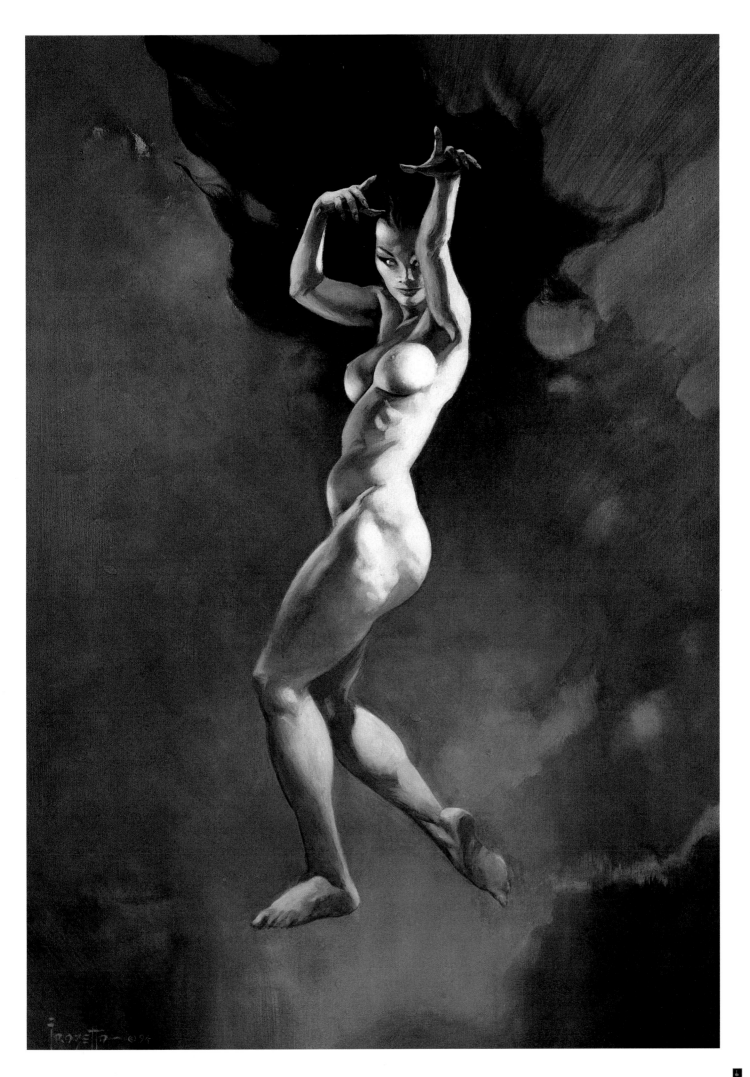

Death Dealer

Cover to Flashing Swords #2 *edited by Lin Carter, Dell Books [New York, 1973]. Oil on board, 16"x24". At left: Randy Bowen's bronze sculpture based on Frazetta's painting, which was released by Dark Horse comics as a limited edition collectible in 1995.*

Originally published as the cover for an undistinguished anthology of sword & sorcery stories, Frazetta's "Death Dealer" struck a chord with his audience and rapidly became one of his most celebrated works. The swirling smoke and flames on the left and his trademark vultures soaring on the right provide a moving frame for this suspended portrait of war personified. The carefully rendered armor and metal work led many of his fans to believe that Frazetta had labored over the painting far longer than usual, but, as with much of his most memorable art, "Death Dealer" was completed in a little over a day. "If I'm going to capture the excitement and the spontaneity of the image in my head, I have to do it with a great burst of energy and do it quickly! If you watched me just hacking right in from scratch, you could see that I'm having fun making an idea materialize in color right before my eyes. Toward the end, when the thing is maybe 85% done, polishing, getting the details in, slows the process down—that part's not as much fun."

Largely ignored by fine art circles in the past because of his comics/illustration roots and disparaged because of the fantastic theme of his art, Frazetta suddenly found himself at the center of attention in the 1970s. The May, 1976 issue of the very proper *American Artist* magazine featured "Death Dealer" on the cover and an intelligent profile of the artist by Nick Meglin inside. Examined by *Esquire* (June,1977), discussed in *Newsweek* (7/11/77), and suddenly courted by New York auction houses, art critics, and some of Hollywood's movers and shakers, Frazetta had broken out of the genre ghetto and become part of the mass-consciousness. Francis Ford Coppola tried (unsuccessfully) to convince him to fly to the Philippines and work with him on *Apocalypse Now*; Charleton Heston, Arnold Schwarzenegger, Sylvester Stallone, and Orson Welles contacted him either to buy originals, pitch projects, or both; and Bo Derek visited his Pennsylvania estate and commissioned him to paint her nude portrait for her production company's letterhead. While everyone could cite their own personal favorites among his work, it seemed that "Death Dealer" was the boot that had kicked the door to pop-culture popularity off its hinges.

In 1995 talented Seattle sculptor Randy Bowen was honored with a Gold Award from *Spectrum* for his bronze statue of the "Death Dealer" that he had created for Dark Horse Comics. In 1997 Bowen and Dark Horse released a more modestly priced, hand-painted resin version of the collectible to equal acclaim.

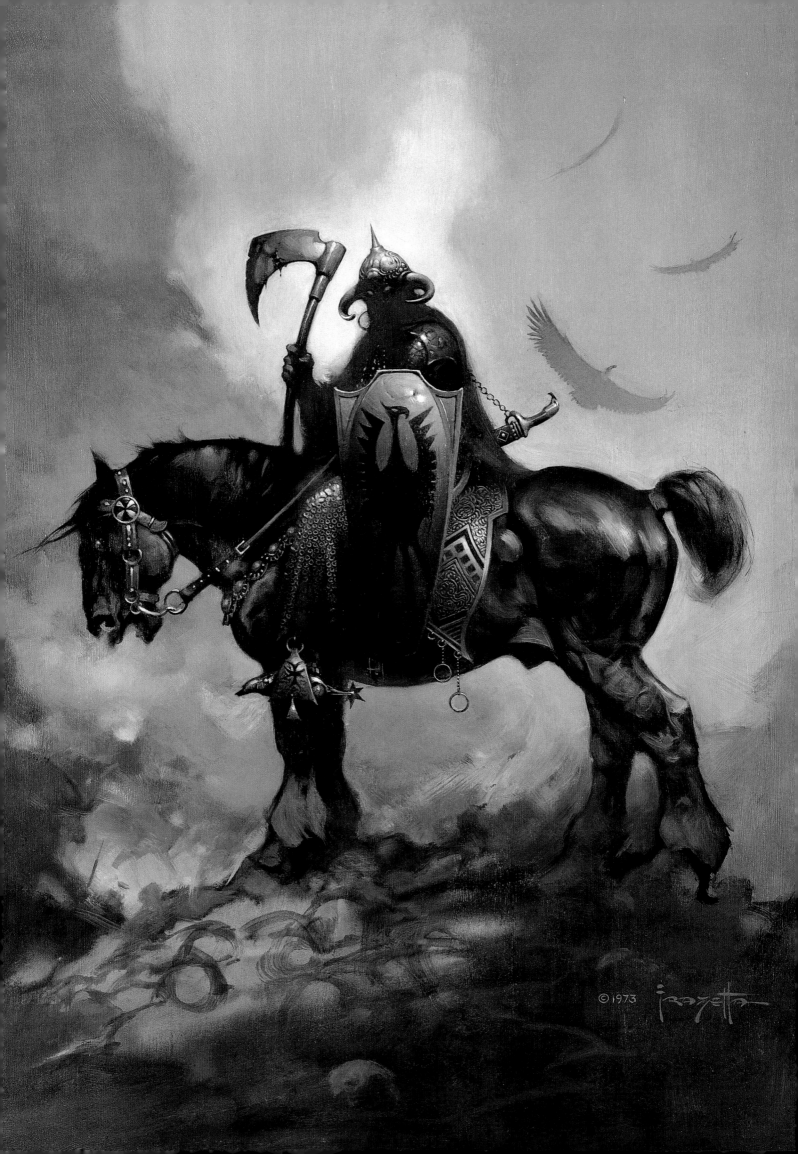

Death Dealer V

Cover to Death Dealer IV: Plague of Knives *by James Silke, Tor Books [New York, 1989]. Oil on academy board, 16"x20". At left: The cover to the Tor Books edition as published.*

The popularity of the original "Death Dealer" painting sparked the idea of a paperback series starring the character. "We had gotten this writer and that writer and I chucked a bunch of them out because they didn't understand what I was looking for. This character is unusual and difficult. Death Dealer isn't a barbarian, he isn't noble...hell, I hardly know what he is. And it was difficult to get a writer to translate that mood into words. But they were just intended as entertainment and if nothing else I did some damn nice pictures."

Tor Books produced four Death Dealer novels in the late 1980s, all written by James Silke. While fans were excited about Frank's new covers, tastes in fiction had changed and the series never really caught on with readers.

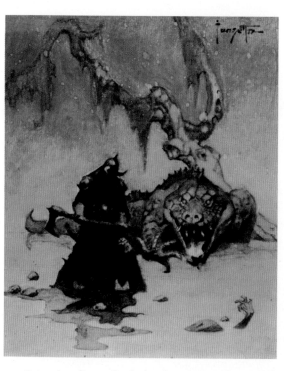

Death Dealer IV

Cover to Death Dealer II: Lords of Destruction *by James Silke, Tor Books [New York, 1987]. Oil on academy board, 16"x24". At left: Frazetta's pencil and gouache rough.*

Smarting from the lack of proper credit and the financial rewards his art had afforded others, Frazetta hoped that his "Death Dealer" would turn into a profitable franchise like Conan. "I want to work this guy 'death', if you'll pardon the pun. I think the problem is that I'm an artist, not a writer, and none of these guys are able to crawl in my head and see what I see. Death Dealer is a strange guy and he lives in a strange place and if anybody is ever able to put into words the ideas that are floating in my head, look out!"

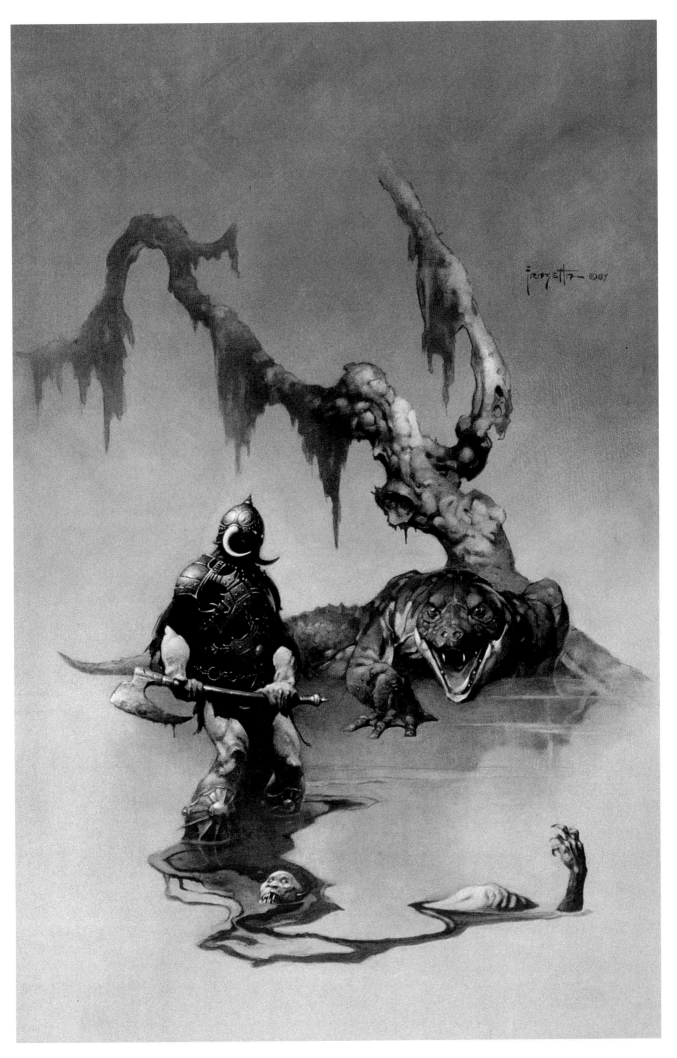

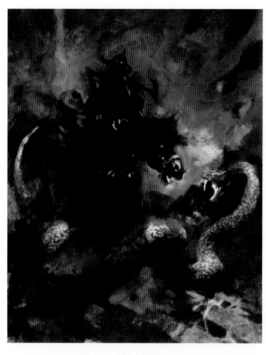

Death Dealer VI

Cover to Death Dealer, *Verotik [issue #3, 1996]. Oil on academy board, 16"x20". At left: One of Frazetta's gouache and pencil cover roughs, circa 1985.*

Rock musician Glen Danzig approached Frazetta with the idea of translating "Death Dealer" into a comics series. "He had been a fan for years and he came to the museum and Ellie let him come to the house. He bought some original art from time to time and started to woo me into doing this thing. He convinced me that it could be a big money-maker, so that's why I got involved. I agreed to let him use my covers, but I wouldn't do any interior pages. Glenn already had plans for a movie, blah, blah, blah."

Written by Danzig and illustrated first by Simon Bisley, then Liam Sharp, the *Death Dealer* comic is an ugly adolescent sex/power fantasy. Reveling in its imagery of severed limbs, fountains of blood, and subjugated nude werewomen, Verotik's interpretation quite simply misunderstood Frazetta's art, intent, and character. Danzig and his artists responded personally and viscerally to their source material, totally missing the intellect behind Frank's work.

"Sometimes I wonder what people really see when they look at my art. I mean, I know I exaggerate my figures for effect, make them move in ways they might not normally move, push things a little to heighten the excitement. And I can get away with the exaggeration and still make you believe in the reality of the scene because I know how to *draw*. I know my anatomy. I know how real people and real animals move. But these guys who are trying to 'do' me, boy! Arms and legs the size of trees; blood and guts everywhere! That's not what I do. My figures *are* muscular, but for chrissake, they're not ridiculous. And despite the violence in my art I want people to look at it and say, 'It's beautiful!' and forget about the situation. I want them to look at it for the sheer beauty and symmetry and the wonderful shapes and color and rhythm, and that's all they'll see. They don't think about the fact it's a battle scene. It's taste that separates the men from the boys. These kids are drawing the super merry Marvel characters hacking each other to bits and rubbing your nose in the gore and pretending that's the way I would do it. They're wrong."

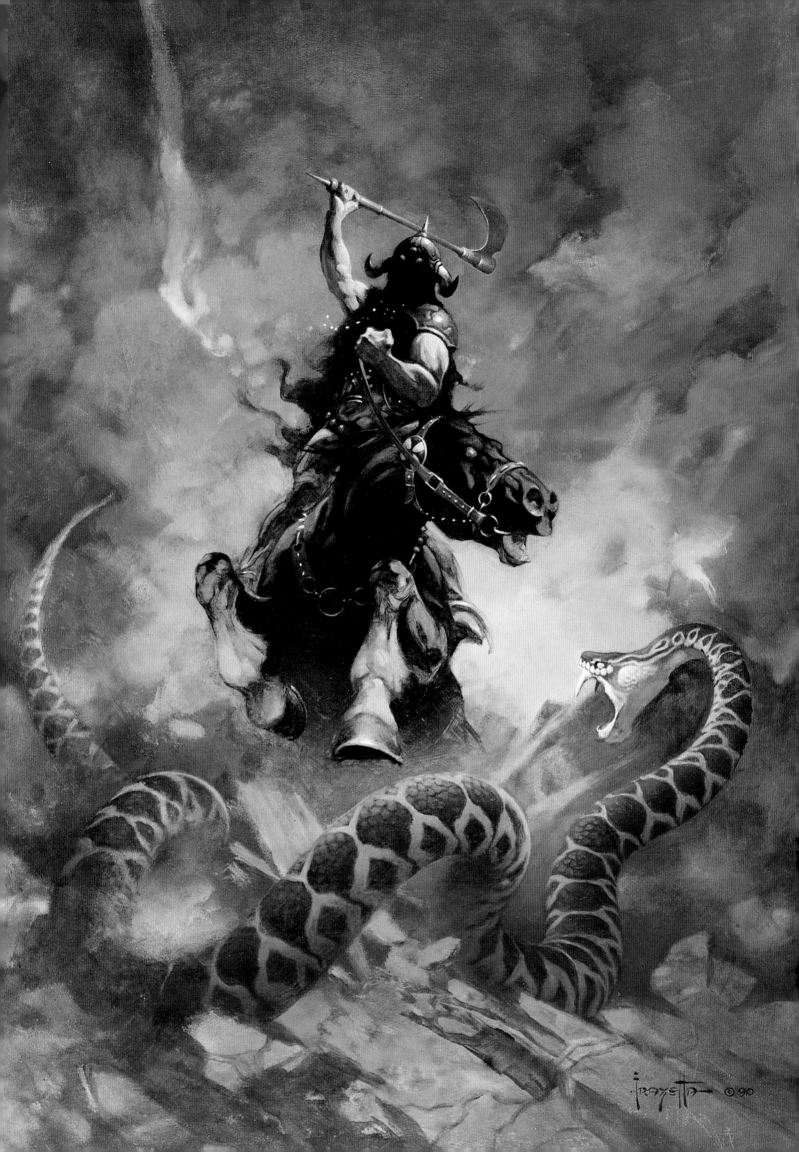

Death Dealer II

Cover to Death Dealer: Lords of Destruction *by James Silke, Tor Books [New York, 1987]. Oil on board, 16"x20". At left: Frazetta's ink & gouache character studies, circa 1985.*

Burne Hogarth [1911-1996], a founder of the School of Visual Art and legendary *Tarzan* newspaper comic strip artist, always looked for hidden symbolism in Frazetta's paintings. Contradictorily an atheist who was deeply spiritual, Hogarth thought the barbaric battles with flaming backgrounds and roiling clouds of smoke were Frank's nightmarish reactions to the possibilities of a nuclear apocalypse. "Well, that guy could talk!" Frazetta laughs. "Burne was a really great guy and a masterful talker, but, boy, he thought too much!"

Frazetta has said repeatedly that he thinks of himself as an entertainer, that his drawings and paintings are his "songs." If there *are* social or political messages in his work, if the "Death Dealer" panels *are* symbols of mankind's inevitable self-annihilation, it's news to Frank.

Any work of fine art is open to a number of interpretations. To try to neatly categorize any of Frazetta's finest works as one thing or another is a disingenuous attempt to contain their emotional content. "Death Dealer" can be viewed solely and successfully within the context of its title. But it is equally valid to examine the painting for subconscious meaning and to transform it with each such exploration. Is it, as Hogarth asserted, a portrait of man's innate brutality and ultimate race toward self-destruction? Or is it much more personal, a symbolic display of the artist's reactions to the frustrations of daily life? Are the "Death Dealer" paintings nothing more than well-done comic book imagery or are they aspects of the artist's personae and explosive expressions of the creative struggle? Whatever the answer, it's up to the viewer to decide.

Because Frazetta isn't talking.

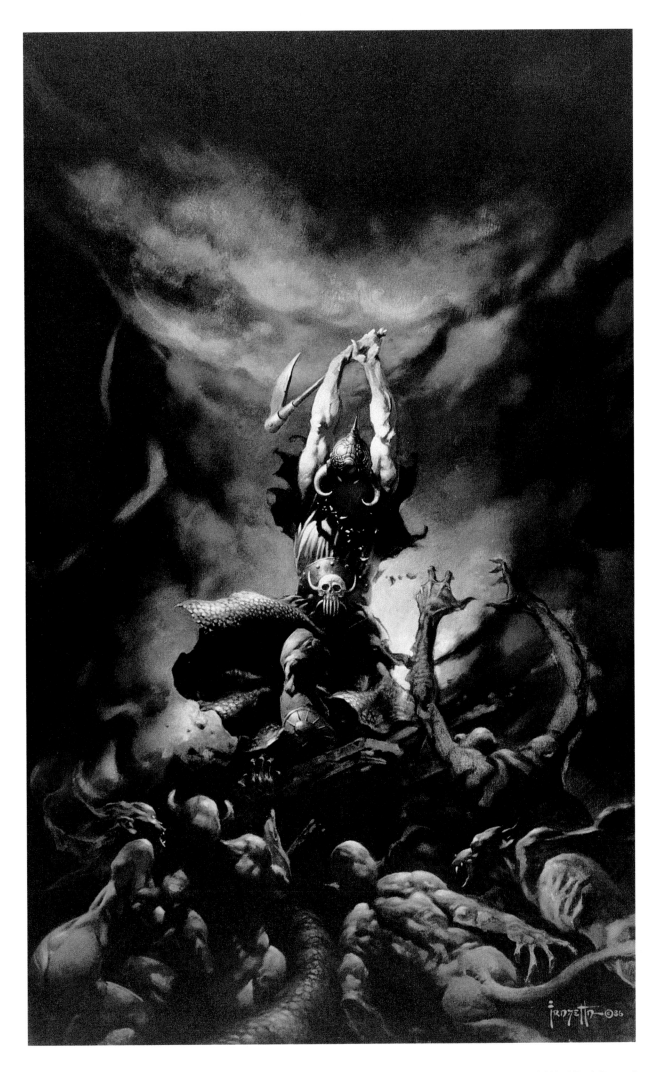

The Moon's Rapture

Personal work , 1994. Oil on academy board, 16"x20". At left: *Frazetta in his studio, 1997. Photograph by David Winiewicz.*

This cool and tranquil painting, with its voluptuous female figure and verdant jungle growth, was completed for Frazetta's first New York gallery exhibition. Subsequently published as the covers for both the gallery's show catalog and for *Penthouse Comix* [issue #4, Dec., 1994], it is so perceptibly "Frazetta" that a signature is unnecessary for identification.

Throughout his 50+ year career Frank Frazetta has been lauded and ignored, celebrated and disparaged. He's been called old-fashioned and visionary, labeled a panderer to male sexual fantasies and a champion of women's equality. He is a contradiction, fascinating and frustrating at the same time. Love his work or hate it, no one can be indifferent to it.

This may explain the enduring appeal of Frazetta's art: his personality is inseparably enmeshed in his work. Despite his speed of execution and his claims of being "lazy" and a "goof-off," Frazetta has never been able to hack out an assignment and forget about it. Each painting is an investment of his self, a glimpse of his soul. To react only to the conflict in his art is to miss that point; to believe that the work is a paean to violence and a reflection of the artist's brutishness or arrested adolescence is nonsensical and denies the reality of Frazetta's accomplishments and artistic intent.

Frazetta's art is an affirmation of aspects of the human spirit, a celebration of *life*. Frank's characters remind us again and again that an individual can triumph over adversity, can succeed through the power of their human presence.

That is why his imitators are unsuccessful: in their attempts to duplicate his magic they merely *reflect* their impressions of his art. Frazetta, on the other hand, *projects* his charisma and skill and intellect.

The realized projection of mood and personality—not technique or subject matter—is what makes "The Moon's Rapture" and his many other drawings and paintings so unmistakably the work of Frank Frazetta.

"Good or bad," Frank muses, "the one thing I can say about my art is, if I can quote Sinatra, 'I did it my way.'"

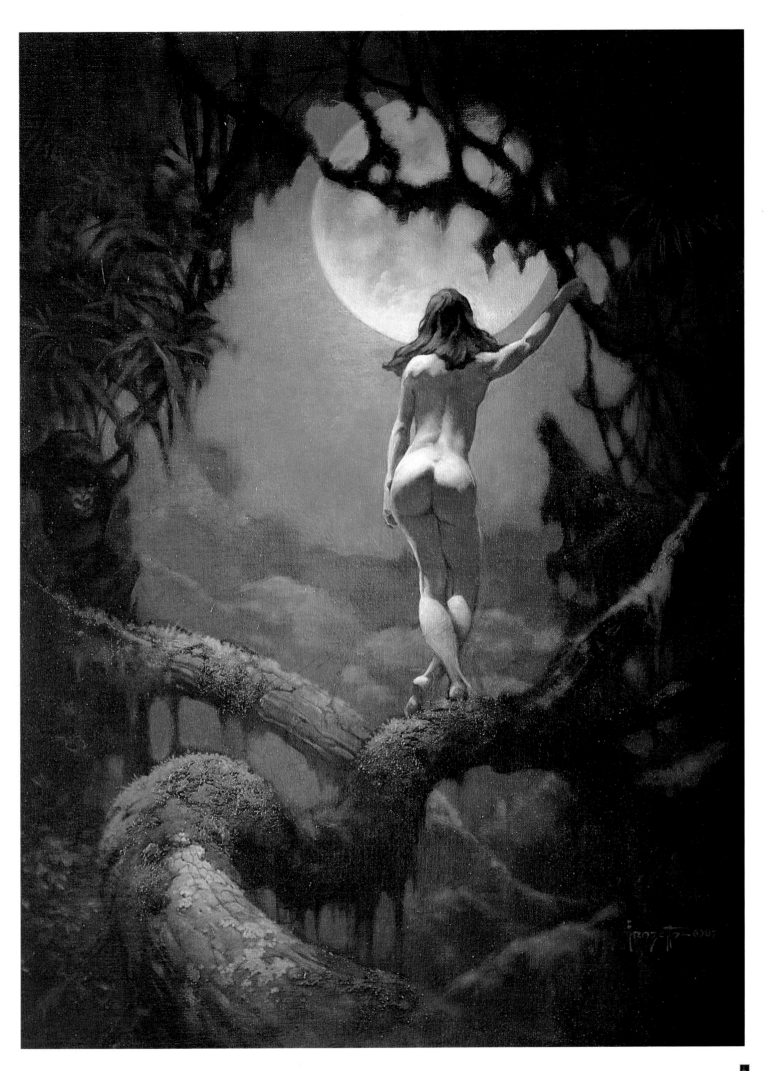

You Can Own a Masterpiece.

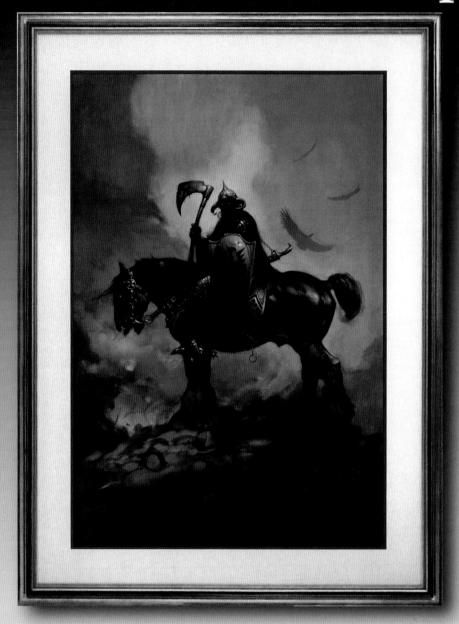

Very few of Frank Frazetta's masterful paintings have ever been sold and the few that *have* made it into the marketplace have commanded astronomical prices.

Now you can own them *all*.

"The Death Dealer," "Cat Girl," the covers for Conan and the works of Edgar Rice Burroughs, all are available as high-quality full-color frameable prints. With each proof personally approved by the artist, these are the most accurate reproductions of these influential paintings ever offered to the public.

But then, would you expect any less from the Grand Master of fantastic art?

Artworks in this book that are available as prints have a corresponding order number (*example: Print #42*) at the end of the descriptive text. Price per print is **$10**, plus **$5.00** postage & handling for five prints or less in the continental USA. (Additional postage required for all other orders.) A full color catalog of the Frazetta books, portfolios, and the complete print line is available for **$5.00**.

Make all checks and money orders payable to **Frank Frazetta**.

P.O. BOX 919, MARSHALLS CREEK, PA 18335